KU-689-966

THE SCULPTURE OF **DAVID NASH**

THE SCULPTURE OF **DAVID NASH**

THE SCULPTURE OF **DAVID NASH**

JULIAN ANDREWS

THE HENRY MOORE FOUNDATION

IN ASSOCIATION WITH

LUND HUMPHRIES PUBLISHERS, LONDON

AND UNIVERSITY OF CALIFORNIA PRESS

BERKELEY AND LOS ANGELES

730.92

91000 319

WESTERN ISLES LIBRARIES

LINICLATE
WESTERN ISLES LIBRARIES

Readers are requested to take great care of the item while in their possession, and to point out any defects that they may notice in them to the Librarian.
This item should be returned on or before the latest date stamped below, but an extension of the period of loan may be granted when desired.

DATE OF RETURN	DATE OF RETURN	DATE OF RETURN
	10 APR 2014	
1 0 APR 2014	2 6 MAR 2015	2 5 AUG 2018
	2 8 JUN 2016	2 APR 2020

WITHDRAWN

730.92
ANDREWS, J
Sculpture of

730-92

91000319

34134 00282291 1
Leabharlainn nan Eilean Siar

This paperback edition first published in 1999 by
The Henry Moore Foundation
in association with
Lund Humphries Publishers Ltd, London
and University of California Press
Berkeley and Los Angeles

The Sculpture of David Nash
© 1996, 1999 The Henry Moore Foundation
Text © 1996, 1999 Julian Andrews
All reproductions of works by David Nash
© 1996, 1999 The artist
Arshile Gorky, *Waterfall*
© 1996, 1999 ADAGP, Paris and DACS, London
Constantin Brancusi, *Bird in Space* and studio photograph
© 1996, 1999 ADAGP, Paris and DACS, London

All rights reserved. No part of this publication may be
reproduced, stored in a retrieval system or transmitted in any
form or by any means, electrical, mechanical or otherwise,
without first seeking permission of the copyright
owners and publishers.

Sold in North America through University of California Press
and in the rest of the world through Lund Humphries Publishers.

Lund Humphries Publishers ISBN 0 85331 777 1
University of California Press ISBN 0 520 22044 7

9 8 7 6 5 4 3 2 1

Designed by Ray Carpenter
Printed and bound in Singapore under the supervision
of MRM Graphics

Inside front cover: charred tamo
Inside back cover: detail of *Mountain Oak*, oak, 1990

Photographers

Julian Andrews
Noel Browne
David Garner
O.D. Grabham
Maria Hayes
Ben Johnson
Dr M.J.T. Lewis
David Nash
Susan Ormerod
John Riddy
Andrew Sproxten
John Webb
Sue Wells

CONTENTS

ACKNOWLEDGEMENTS

When this book was first proposed, within the Henry Moore Foundation/Lund Humphries 'British Sculptors and Sculpture' series, it was envisaged as a complete catalogue of the sculptures made by David Nash up to the year of publication, accompanied by a commentary. In the course of initial research, however, it became apparent that nobody – not even the artist himself – had any clear idea of just how many sculptures Nash has produced in the course of his thirty years' work so far. It soon became obvious that the total number of pieces would far exceed the capacity of one volume, so the focus of the project has changed.

The book now looks at Nash's life and major works to date, from sculptures made at art college, through his first period of working in Wales, and subsequent phases, to recent developments in the 1980s and 1990s. Divided into fifteen sections, for greater ease of reference, the book also includes commentaries on the various groups of 'environmental works' the artist has made, and for which he is particularly known – the *Ash Dome* and other planting pieces, the *Wooden Boulder*, and a number of outside installations, including his stoves and hearths. Lists of his exhibitions, a chronology and other bibliographical and reference information are given at the end of the volume.

During the initial period of research some 1100 sculptures by David Nash, made between 1965 and 1995, were identified and catalogued, though it became apparent in the course of the work that there are a number of other pieces from these years which still need to be traced. Of this total some 160 works have been selected for inclusion in this book, all of which are illustrated. As far as possible, care has been taken to ensure that descriptions of works in the text are given either on the page where a photograph of the relevant piece appears, or as near to it as possible, so as to reduce unnecessary searching and turning of pages. At the present time the catalogue – inevitably incomplete as the artist continues to work at his usual speed and intensity – is being held at his studio in Wales, where it will be regularly updated.

My first debt, therefore, is to the Henry Moore Foundation which has supported the project from the start. I am especially grateful to Robert Hopper, Director of the Henry Moore Institute, and to Penelope Curtis, Curator of the Henry Moore Centre for the Study of Sculpture, for their personal interest and support. But there are many more individuals and institutions who also need to be thanked.

Above all I must express my deep personal gratitude to David Nash who has been closely involved in every aspect of the project, and who has dedicated an immense amount of his own time to discussing his work with me, and answering my innumerable questions. In many ways it has been a joint exercise, and I count myself fortunate to have had a subject who has been prepared to go to such lengths to ensure that incidents from long ago, sometimes of a personal nature, have been properly recorded and that details of processes and sculptures described are correct. I owe especial thanks to David's wife, Claire, for putting up with my regular presence in their home over a very long period, and for so generously providing continual supplies of delicious food and coffee.

David's assistant, Maria Hayes, has worked indefatigably on the cataloguing, with valuable help from Jack Nash, and has also been responsible for ordering and sorting hundreds of photographs and slides. David Hubbard and Margaret Pedley of the Annely Juda Gallery have patiently researched a number of details on my behalf and have kindly provided catalogue information on sculptures I would not otherwise have traced. Clive Adams, Ian Barker and Norbert Lynton have all provided helpful advice, as has Steffan ab Owain of Gwynedd Archives Service. I am grateful to Sasha Andrews for assistance with photography and for the loan of her computer, and to Bärbel Andrews for providing kind hospitality on my research visits to London.

Valuable assistance in providing information both for the catalogue and for this book was provided by: Clive Adams; Ian Barker; Caroline Barker-Mill; Mickey Boel; Susan Brown, Laumeier Sculpture Park; John Burrows; Mary Byron; Gabriella Cardazzo, Venice; Penelope Curtis, Henry Moore Centre for the Study of Sculpture, Leeds; Kenneth and Judy Dayton; Anne Elliott, Sculpture at Goodwood; Dr Mark L. Evans, National Museums and Galleries of Wales, Cardiff; Louise Fong, Guggenheim Museum, New York; Hans Gercke, Heidelberger Kunstverein; Sarah Glennie, Kettle's Yard, Cambridge; John Golding; Akiko Harasawa, Nagoya City Art Museum; Gill Hedley, Contemporary Art Society, London; Auguste Hoviele, Galerij S65, Aalst; David Law, Camden Arts Services, London; Philip Long, Scottish National Gallery of Modern Art, Edinburgh; Seonaid McArthur, Museum of Contemporary Art, San Diego; Donald McNeil, General Mills Inc, Minnesota; Margaret Nab-van Wakeren, Rijksmuseum Kröller-Müller, Otterlo; Charlotte O'Connor, Douglas Hyde Gallery, Dublin; Ella M. O'Halloran, Arts Council Collection; Michela Parkin, Tate Gallery, London; Pawel Polit, Centre for Contemporary Art, Warsaw; Matthew Pritchard; Lord Renfrew of Kaimsthorn; Tara Sandroni, L.A. Louver, Los Angeles; Pippa Scott; Helen Simpson, Southampton City Council; Hiroya Sugimura, Tochigi Prefectural Museum of Fine Arts; Valmai Ward, Arts Council of Wales; Martin Wright, Compact Books Ltd, Sunderland.

Thanks for permission to reproduce photographs go to the Courtauld Institute, London; Gwynedd Archives Service, Caernarfon and Dolgellau; Kunsthaus Zürich, Switzerland; Dr Michael Lewis; David Nash; Tate Gallery, London; John Webb; Sue Wells.

I owe a special debt to Sarah Tibbetts who has painstakingly worked through a series of drafts in producing the initial typescript for this book. And I am extremely grateful to John Taylor, Lucy Myers and Charlotte Burri of Lund Humphries for being such understanding editors.

Julian Andrews

PROLOGUE

In the early summer of 1996, an exhibition of new work by David Nash was shown at the Mead Gallery, Warwick Art Centre.[1] Its title, *Green Fuse*, provided a useful key to the inspiration underlying the artist's work:

The force that through the green fuse drives the flower
Drives my green age; that blasts the roots of trees
Is my destroyer.
And I am dumb to tell the crooked rose
My youth is bent by the same wintry fever.

*

The hand that whirls the water in the pool
Stirs the quicksand; that ropes the blowing wind
Hauls my shroud sail.
And I am dumb to tell the hanging man
How of my clay is made the hangman's lime.

*

And I am dumb to tell the lover's tomb
How at my sheet goes the same crooked worm.

If Dylan Thomas's poem[2] (of which the above are the first and third stanzas and the final couplet) were a painting or a sculpture, the term *vanitas* would come to mind. A warning that all flesh is as grass and withers, the flower fades and the bubble bursts; in our very life is death. Thus, at first sight *Green Fuse* seems an unlikely title for a group of works by David Nash, although the artist's long sojourn in Wales makes Thomas a natural literary source. The curator of the exhibition, Sarah Shalgosky, in choosing the title with the artist, intended that the viewer should focus on the green, thrusting, sappy wood from which the sculptor fashions his work and from which grows the visual imagery. This is certainly suggestive, but an investigation of Thomas's text reveals, perhaps unexpectedly, that the poet provides us with a yet more powerful and paradoxical inspiration with which to reveal the sculpture of David Nash and the familiar, yet remarkable, materials from which it is made.

Thomas describes the concept underlying *Green Fuse* in a letter written in December 1933,[3] a few weeks after completing the poem. 'So many poets', he wrote, 'take the living flesh as their object, and by their clever dissecting, turn it into a carcase. I prefer to take the dead flesh, and, by any positivity of faith and belief that is in me, build up a living flesh from it.' Might David Nash, and other artists of his generation, have discreetly harboured similar thoughts about their younger contemporaries? For Nash, as for Thomas, the felled tree is dead, even though at the moment of its death, the 'green fuse' throbs within it, but the artist, by his vision and belief, his 'positivity of faith', his sympathy with the nature of his material, finds new energy in that carcase.

The renewed life which David Nash gives to his chosen timber manifests itself in different ways: the shape and form of the work, which relate, sometimes closely, to the natural state and yet which are extraordinarily diverse; the often surprising colours which reveal themselves as the freshly hewn wood encounters the atmosphere and the cracks and contortions which result from the passage of time and exposure to the environment. These enduring, but seemingly unpredictable qualities will only emerge successfully in the work of an artist who is perfectly in tune with the nature of his materials and whose 'positivity of faith' guides his eye and his hand.

With regard to his relationship with his chosen medium, Nash has proceeded far along a course charted earlier in the century. Consider the early work of Henry Moore. Like a number of his contemporaries in the 1920s and 1930s, Moore was a passionate carver, committed to revealing the true nature of the medium he had chosen – wood or stone. He was pleased to have the form of the work influenced by the material of which it was made. A good example is the large *Carving* in walnut of 1935.[4] The generous rounded form emerged naturally from the wood and the artist was no doubt delighted with the rich, dark colour which the deep polish revealed on its surface. Yet, seen today through the perspective of the sculptures by Nash illustrated in the present volume, that work in walnut conveys more of the quality of polished black marble than it does of hewn wood. Moore created a great sculpture of bold and powerful form, but the wood became fossilised. It was the medium for creating the sculptural idea, but that idea was the sole final purpose. In the work of David Nash we see something more like a balance between form and medium, where the artist has created works of great strength and subtlety, but has also, through his sensitive understanding of the medium, unlocked the life at the core of the carcase.

Tim Llewellyn

1. *Green Fuse: New Sculpture by David Nash*, Mead Gallery, Warwick Art Centre, Coventry, April-June 1996

2. Dylan Thomas, 'The force that through the green fuse', first published in *18 Poems* (1934)

3. Quoted in *Dylan Thomas Collected Poems 1934-1953*, edited by Walford Davies and Ralph Maud, Everyman's Library, J.M. Dent 1988, p.183

4. *Carving*, 1935, walnut wood, height 96.5 cm, The Henry Moore Foundation, gift of Irina Moore 1977; see *Henry Moore Complete Sculpture Volume 1 1921-48*, edited by David Sylvester with an introduction by Herbert Read, Lund Humphries, fifth edition 1988, LH 158

1

EARLY YEARS

In November 1995 David Nash reached the age of fifty. He has been a practising sculptor for over thirty years, his works being represented in museums, public art galleries and private collections all over the world, yet this is the first extended study of his work to appear in book form. He has frequently been selected for group exhibitions of British art shown on the international museum and gallery circuit, and there have been over eighty solo exhibitions of his sculptures and drawings since 1973. Two thirds of these, however, have been outside Britain. In this he resembles many other artists of his generation who are far better known and respected abroad than they are at home.

David was born on 14 November 1945 in Surrey, shortly after the end of the Second World War. His brother Chris had been born six years earlier and the two boys were brought up in the London commuter suburb of Weybridge. They attended a boys' preparatory school close to their home, and were then sent on to Brighton College, in Sussex.

At the same time, however, an alternative world opened up to them when their paternal grandfather, Frederick Nash, bought a house in the beautiful Vale of Ffestiniog in North Wales, inviting his sons and their families to spend their holidays there. Two years later David's father, Charles Nash, purchased a cottage for his own family close to his father's property, and from 1949 onwards David Nash and his brother spent every school holiday in Wales. So when in 1966, at the age of twenty-one, David finally established a permanent base for himself in the area, moving to the slate-quarrying town of Blaenau Ffestiniog at the head of the valley, he knew very well what he was coming to.

The Ffestiniog district had remained amazingly unspoiled through the early decades of the century. It had been a well-known stopping point for artists and other travellers making the British mini-equivalent of the Grand Tour in the eighteenth and nineteenth centuries. In the present century the district has attracted writers, with John Cowper Powys and, briefly, Arthur Koestler at

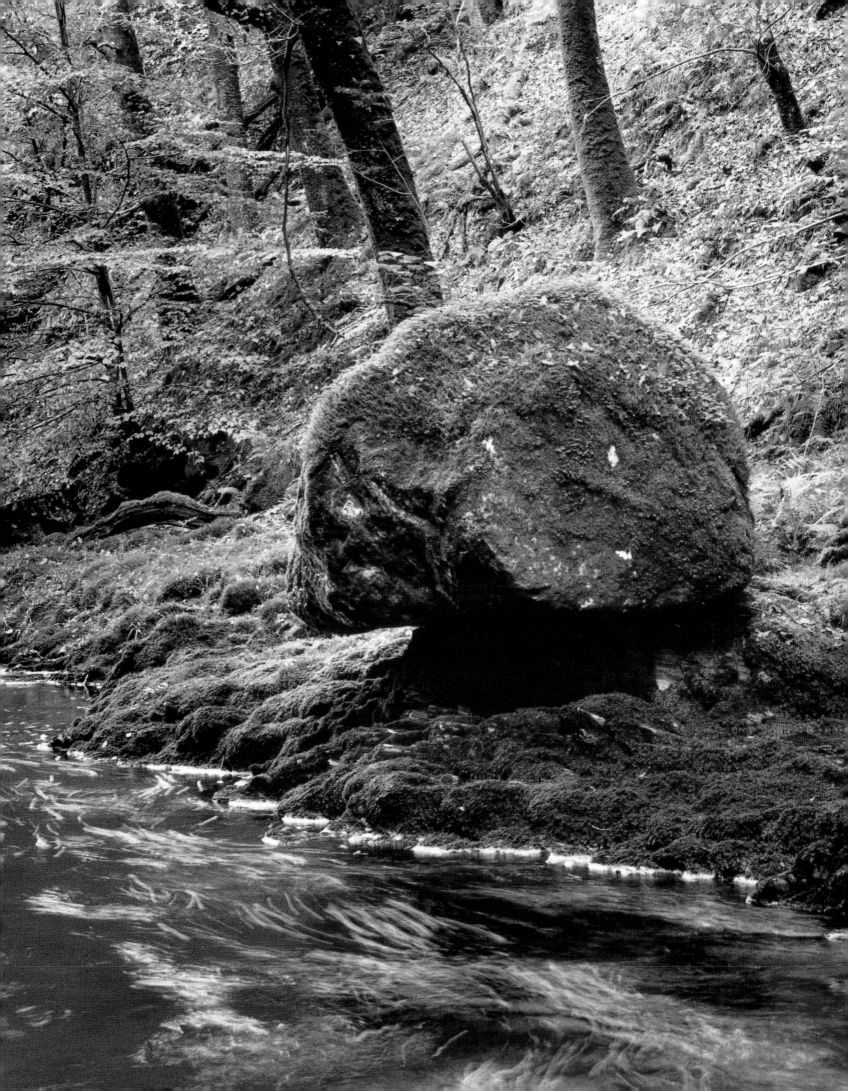

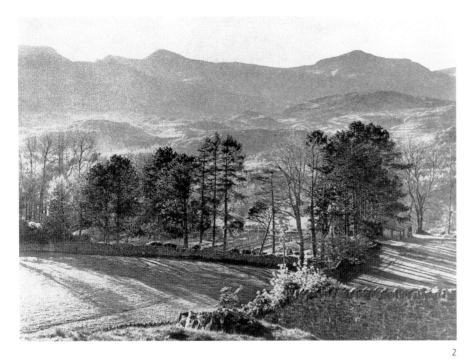

2

2 Vale of Ffestiniog, *c.* 1950

1 (overleaf) Boulder, Cynfal Valley, Vale of Ffestiniog

Blaenau, Bertrand Russell at Penrhyndeudraeth, Robert Graves at Harlech, and Richard Hughes on the Glaslyn estuary, opposite Clough Williams-Ellis' creation at Portmeirion. By the 1930s a certain Anglicisation of the area was taking place, but at the time when the Nash family began to settle in at the end of the 1940s the traditional life of the local Welsh villages and farms had changed little over several generations. Horses were still widely used both for ploughing and for transport, while most cottages and farms at any distance from the main roads still relied on oil-lamps for lighting and on local springs for their water supplies.

For the two boys the contrast between suburban Surrey and the freedom they were able to enjoy in the woods and hills of Wales gave a wonderful sense of release. Their grandfather, Frederick Nash, lived on at Llan Ffestiniog until 1959 when David was fourteen. He was a picaresque figure, who had led an up-and-down life as an entrepreneur, moving with bewildering rapidity between relative affluence and serious insolvency. His continual shifts in activity, and equally frequent moves of house in accordance with the current state of his finances, meant that for his son Charles he came to represent, in a very disturbing way, instability and insecurity. In reaction to this, and to the equally uncertain social and economic background of the 1930s in which he himself had grown up, Charles Nash sought financial safety and career security in committing himself to one of the major in-surance companies. Like so many others of his generation who had seen the effects of the First World War on families and on society, he took a commission in the Territorial Army, being immediately called up on the outbreak of the Second World War in 1939.

When the family re-established themselves in

Weybridge after the war, Dora Nash welcomed the support and help of David's godmother, Mary Peacock, in bringing up her two sons. Mary's husband was a professional designer, and she was to have an important influence on David Nash in his early years. She began taking him to visit museums and art galleries in London. She also encouraged his interest in drawing so that he learned perspective at an early age. Since his parents' artistic interests were mainly limited to conventional theatre, David was soon recognised as 'the arty one' in the family. His father paid for him to have extra drawing lessons at school, but this encouragement was tempered by regular reminders that art should be seen only as a hobby, not in any way as a career path.

In planning for his boys to move through the same public school that he and his brothers had attended, on to university, and then to a professional career, Charles Nash was simply following the Edwardian ethic which remained a basic prop of British middle-class society in the period following the Second World War. Men of his generation felt a strong need to re-establish 'pre-war standards' – which were not always defined. In the Britain of the 1950s, particularly after the return to power of the Conservative party in 1952, the arts – and most especially the visual arts – were seen as acceptable in terms of the entertainment they provided, but highly suspect in terms of the influence they might exert on the social, political and moral values of the younger generation. The social revolution of the 1960s was only a few calendar years ahead, but when it came it represented a shift of decades in terms of British class and family attitudes. David Nash, on entering Brighton College in 1959, had been awarded an Art Scholarship but was disconcerted to find that the curriculum he had to follow, with its emphasis on university entry, did not allow him to study art at all. He was not happy at the school, feeling he was being forced into a mould and frustrated at not being able to study the subject he liked. After a long struggle he was eventually allowed to drop other subjects and concentrate on art. He began studying for GCE A-levels in Art and Economics as his seventeenth birthday approached.

At Brighton College, David Nash benefited from the guidance of a gifted and influential teacher, Gordon Taylor, an ardent follower of Cézanne and the Bauhaus school. While the formal teaching involved drawing cubes, spheres and pyramids, the Oxford and Cambridge A-level syllabus also included a rigorous course in Art History. Here Taylor ensured that the students were introduced not only to areas such as Romanesque Art, the Renaissance and the nineteenth century, but also to Surrealism and to developments in post-war American art.

Taylor arranged for Nash to absent himself from school to go and see exhibitions at the Tate, the Whitechapel and the commercial art galleries in London. Nash also remembers being introduced to the works of

Camus, Beckett and other contemporary writers at this time. Gordon Taylor was an unusual teacher. While he might well have secured a position at one of the principal art colleges, he preferred to remain within this highly traditional institution because, working in what was effectively a subversive manner (as his students well understood), he was able to have more effect and get more interesting results. Students like David Nash quickly responded to the challenges and stimuli he threw at them: by the time he left school in 1964 Nash was aware not just of great American figures like Rothko and Rauschenberg but had also been introduced to the work of British artists such as Anthony Caro and Peter Blake.

Charles Nash made one more attempt to steer his son into the professions. Realising that architecture was one professional career open to students of art, he arranged for David to go and talk with the partners in a firm of architects known to him.

Their recommendation was that he should go to art college – a path his father had not anticipated but which was highly welcome to David. He was accepted for entry to Kingston College of Art in the autumn of 1963.

Throughout these years the holidays in Wales remained a regular part of family life, and as Nash grew older his knowledge of the district grew more extensive. The family now stayed at a pair of converted cottages at Bronturnor, near Maentwrog in the lower part of the valley. In his explorations along the river Dwyryd, which flows through grazing meadows just below thick woods surrounding the cottage, David Nash had discovered a magical place. Deep in a chestnut wood on the old Ffestiniog road, just above the point where the Cynfal stream joins the main river, a hidden valley winds upwards through the trees. A few hundred yards up, totally concealed from the busy road, a massive boulder sits beside the stream. About seven feet across and six feet high, almost perfectly squared off on one side while evenly curved on the other, it rests on a small plinth of raised ground that might have been made for it. Quite alone, with no similar boulders around it, there seems no logic to its being there. It is a powerful sculptural presence.

3 Boulder, Cynfal Valley, Vale of Ffestiniog

3

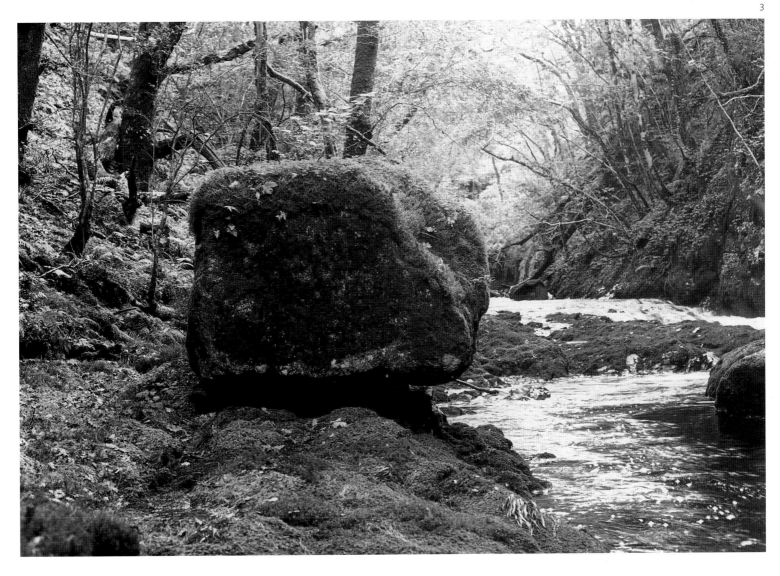

ART COLLEGE: FIRST SCULPTURES

The early 1960s were a revolutionary time for art colleges in Britain. The new Diploma course in Art and Design had been recently introduced, many of the colleges recruited a number of young part-time teachers who brought a breath of fresh air to these institutions, and there was 'a tremendous impulse for experimentation' as Nash remembers it.[1] The year 1963 was the first in which Kingston had run a Foundation course. Of the visiting lecturers Nash remembers especially hearing Huw Weldon talk about the making of his film on Edward Elgar. Also the composer Cornelius Cardew who showed, in complete silence, lengths of visual score for the students to interpret. 'I could hear the music with my eye and anticipate what the next marks were going to be' Nash remembers.

In addition to listening to modern composers such as Hindemith, Shostakovich and Bartok he had also discovered the excitement of Indian music through the recordings of Ravi Shankar and other performers. He listened to Indian music carefully and repeatedly to try and learn more about what was happening while a raga was being performed, and absorbed an approach to improvisation which was later to have an effect on his sculpture. He particularly empathised with the gentle and subtle way in which the musicians approached a raga, 'feeling it out', playing with the theme before launching into the full flow of improvisation. In his own approach to new themes and forms in his sculpture he came to see his practice as parallel to that of the raga-player, finding an archetypal form such as the *Tripod*, the *Sliced Block* or the *Descending Vessel*, and then improvising on it. Often variations would develop from working in new situations, and from the late 1970s on, Nash has taken opportunities to travel and work in widely different localities.

During his Foundation year there were some particularly significant exhibitions on in London. Nash remembers seeing Anthony Caro's first one-man show of steel sculptures at the Whitechapel Art Gallery, being impressed by *Early One Morning* with its powerful use of colour in space. In the following year he saw the huge

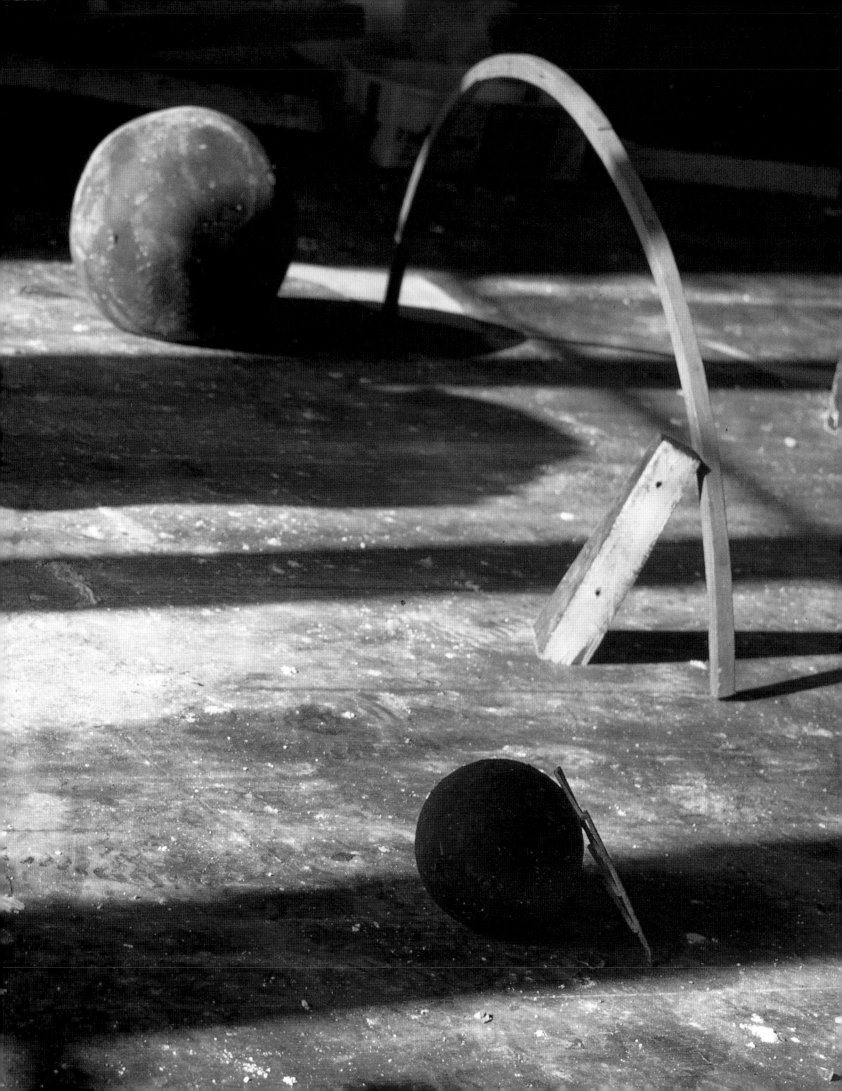

Gulbenkian Foundation exhibition *1954-1964: Painting and Sculpture of a Decade* at the Tate Gallery which gave many of the younger British artists their first real opportunity to appraise the developments that had been taking place in the United States.

An interlude in his immersion in contemporary art came when he accompanied his father on a visit to Italy. David was able to see Naples, Rome and the artistic treasures of Umbria and Tuscany. It was a revelatory experience for him: 'To see Italy at that age, the light, the Donatello sculptures, the progression of Michelangelo as a sculptor – seeing that as he got older he left his pieces rougher, but so much better. . .'. At Kingston he had been reading many biographies of artists, so seeing the Italian masters, reflecting on their development and their lives, made him aware that an artist must evolve through the whole course of his life and that his best works must themselves come out of that evolution, that whole life. This realisation was a key influence on his subsequent decision to move permanently to Wales and build there his own very personal way of life, as a basis for his art.

At the end of the Foundation year he was accepted by the Painting School at Brighton College of Art.

He initially enjoyed the painting course and was impressed, though also intimidated, by the powerful personality of one of the teachers, Peter Cresswell. He also made a very good long-term friend of one of the older students at the college, Rod Harman, a painter he greatly admires. During the year he saw a major show of the Blaue Reiter group at the Royal Academy and was excited by painters such as Nolde and Kirchner. 'They really enlivened me. I wanted to paint like that – so I did!' But overall he did not feel at home in Brighton and could not manage to fit into the social life there. In his own

painting, too, he felt lost and unsure as to the direction he should take. The effect was of an unguided talent in need of direction, and he was well aware of this. Nash decided to investigate the possibility of changing colleges and courses. He was re-interviewed for Kingston to take the Sculpture course, and was accepted for the second year. In view of his subsequent career it is interesting that he went into sculpture more or less by default – he admits to having even thought of trying to work in films at this time. His outside interests were broadening and he was discovering affinities with oriental philosophy and religions. Reading Chinese poetry in Arthur Waley's translations he became attracted to Buddhism, so totally different from the conventional Christianity through which he felt he had been frogmarched at school. (Nash remembers his headmaster telling the boys being prepared for Confirmation that 'we might have a spiritual experience – but we were not to take any notice of it'!)

In the summer of 1965, after leaving Brighton and before starting the Sculpture course at Kingston, he made a visit to France by car, with two friends. While the focus of their visit was the museums and art galleries of Paris, they also drove down to Chartres. Here Nash remembers the effect on him of the black darkness inside the cathedral: 'The quality of it – it was warm. Previously I had thought of black as a cold experience.' He was deeply moved by the stonework and bought a number of photographs of the carvings, with the result that some of the first sculptures he made at Kingston were imitations of the Romanesque. A more important moment for him was seeing, for the first time, the reconstituted Brancusi studio at the Musée d'Art Moderne in Paris. It was a powerful experience, not simply the effect of the sculptures but the atmosphere of the studio itself, redolent of a total commitment to art and a way of life. A few months earlier he had seen Bryan Robertson's exhibition *The New Generation* at the Whitechapel Art Gallery, London at which, in his own words, 'I saw "space" for the first time'. Now, seeing Brancusi's forms, he recalled Peter Cresswell describing the interaction that occurs when material meets space and realised that this was what was happening. He felt the same sensation when he saw Anthony Caro's aluminium sculpture *Hopscotch* of 1962: 'I could see him articulating space.'

Nash was painting as well as making sculptures at Kingston and was still very preoccupied with the question of how to present colour in space. At the same time he was anxious to achieve the relationship of an object to its environment, as observed in Brancusi, and articulation of space through a structure that he recognised in Caro's *Hopscotch*. The struggle to resolve these separate issues alienated him from some of the teaching staff who felt he was being over-ambitious. Whilst committed to regular studio-practice, Nash began to stay away from much of the formal teaching. He admits to having been a difficult student, rarely attending the complementary studies

4 (overleaf) *Through the Arch* in progress (detail), 1967

5 Anthony Caro, *Hopscotch*, 1962, aluminium, 250 × 213 × 475 cm (98½ × 84 × 187 in)

5

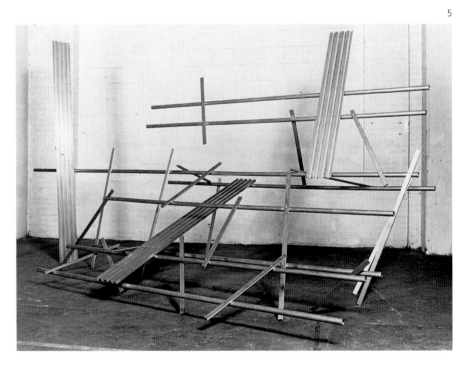

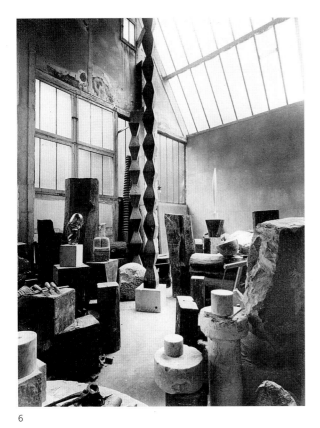
6

move out of the main premises to work at Combe Farm, a centre which belonged to Surrey Education Authority but which functioned as an out-station for the college. Here he was given the run of an old barn, stacked with desks, blackboards, medicine balls and other materials, and set to work to clear it out and make for himself a space in which he could work free of pressures from either peers or teachers. At this stage he was reading Henry Miller, who was in turn introducing him to the works of Lao Tzu and Jacob Boehme. In Miller's *Plexus* he recognised the analysis of fear – fear of being seen as a fool – as applying very directly to himself, and determined to try and face this as a challenge. His way of dealing with the situation was to collect a huge pile of junk material and bring it into the college studio. Several of the teaching staff at once objected to this, but Nash realised the process of trying to handle this material was helping him to work his way through his present impasse, and he persevered.

His confidence grew and this was soon reflected in his work, which grew in scale. One of the first of his sculptures for which a photograph exists is *Blue Place* (1966), now destroyed, approximately seven feet six inches high by fourteen feet wide by ten feet deep. Made of wood and glass, painted in dark blue, deep red and white, with touches of yellow, the initial impression of a resemblance to Caro is countered by the curved swirls of paint on the two large glass panels which leave spaces through which one might be expected to look right through the piece. In an undated note on the back of the photograph Nash has written: 'Intention, to explore the possibilities of direction and enclosure, of openings and counterbalance of diagonals. It developed into an environmental conception, predominantly blue.'

7

sessions or any of the special lectures on techniques. There was another reason for this: tools and equipment required for the courses were looked after by technicians who loaned them out to students and then took them back again at specified times of day. Technicians, understandably, could become martinets when dealing with awkward or forgetful students and after one or two brushes with them Nash decided to restrict himself to using materials they did not control. This meant he could not learn techniques such as welding and was therefore effectively barred from working in metal. Limiting himself to simple materials brought the advantage that he could throw himself into the immediate realisation of an idea, working fast. When he had an idea or when he saw in someone else's work an approach that attracted him, he went for it at once to see where it would take him: 'I've always been very eclectic – always responded to things I've been excited by. When I see something exciting I need to react to it, so quite often my work would look like somebody else's work which, among one's peer group at art college, was not particularly supported.' At the same time he was encouraged by the fact that the Whitechapel *New Generation* sculptors had in many cases been breaking away from traditional sculptural methods with innovative materials such as plastics and fibreglass, and had been making strong colours an integral part of their work – 'shades of "swinging London"', as one writer described it later.[2]

At the end of his first year back at Kingston, Nash was one of a number of students who had the opportunity to

7 *Blue Place*, 1966, wood and glass, 225 × 420 × 300 cm (90 × 168 × 120 in)

Nash was making works which in many cases were attempts to create physical metaphors for ideas he had been absorbing from books. One of the books he had been studying which still has continuing influence on him was the novel *Under the Volcano* by Malcolm Lowry, originally published in 1947, though its genesis was a short story that Lowry had written some ten years previously. The key to the book is that it operates like a film, in which sections are cut and interposed with each other so that the 'narrative' can be picked up at any point and followed round in a circle until the reader's starting-point is reached once more. The book is therefore circular in structure, divided into twelve sections in which 'the four main characters are intended to be aspects of the same man, or of the human spirit', and it can – and should – be interpreted in a number of different ways. Each rereading reveals a different level from the one just concluded, and the process can be repeated until a number of levels have been explored.

Nash recognised that Lowry's formal structure, in which small sections of the book can be seen as microcosms of the whole, is paralleled in the work of certain artists, particularly Arshile Gorky. Exactly when Nash first encountered Gorky's paintings is not certain (probably while he was on the painting course at Brighton) but he read up on Gorky's life, being interested and reassured by the fact that the painter had spent some years consciously producing works in the style of other artists such as Miró and Picasso. It was in such paintings as *Cock's Comb* and *The Waterfall* that Nash felt Gorky had succeeded in creating a work which reflected in its entirety the multiple facets of which it is composed, while simultaneously revealing the whole through one facet or passage. The influence of Gorky on Nash, and the parallels with Lowry's novel, are examined further on in this text.

Among the other intellectual and artistic influences on Nash at this time was Surrealism. Nash had first been introduced to the Surrealists, notably Duchamp and Magritte, by Gordon Taylor while still at school, precisely at the time when he was becoming aware of the work of writers such as Beckett and Anouilh. Two aspects of Surrealism appealed to him instantly: the fundamental seriousness of the absurd, and the power of subversive activity within a formal institutionalised system. In one sense his mentor, Gordon Taylor, who had opted to remain within the confines of the English public school system rather than teach in an art college, personified one pole of Surrealism. It was natural that Nash, desperate to break out of the confines of a mould that seemed to be growing ever tighter as he grew older, should have seen Surrealist activity, and a surreal edge to his art and his life, as being signposts towards freedom. A sense of the Absurd enlivens much of the sculpture he was to make from the 1970s on and this, in turn, in a suitably surreal kind of irony, was to lead to some

8

misunderstanding as to what his art was about. The materials he had available at Combe Farm included such fragments as windows, doors, seats of chairs, medicine balls and wooden hoops. This profusion of ready-mades led him to pursue possibilities of Duchamp-like constructions and he was still applying colour in a fairly wild manner. These experiments, driven by the support and encouragement of his tutor Eddie Pickett, helped him to gain in confidence, using simply a bowsaw, a hammer, a box of nails and some pots of household paint to make his work. But in his final year at Kingston, arrangements were changed and he moved into a studio room in the main farmhouse. Here he began to make sculptures of a different kind which reveal the influence on him of two important exhibitions held at the Tate Gallery – that of David Smith in 1965 and the Giacometti exhibition the same year. With David Smith: 'I was much more interested in the more surrealist works – little rooms to contain objects. Then these objects began to rise up, to grow their own structure, and eventually metamorphosed into the "cubis".' He also realised that what appeared as a simple progression in the exhibition represented a long, difficult struggle over many years – 'he took his whole life to get there'. This was a reminder to him of his own tendency to rush into things seeking instant results, and he remembered Eddie Pickett criticising artists who were 'trying to get straight there – trying to get to that very simple form without having really found their own way there'. The result was to be some more considered and reflective works, influenced by his thoughts on David Smith and by early Giacometti sculptures that he had seen in the Tate Gallery exhibition, notably the *Project for a Piazza* of 1931: 'A plateau, and a zig-zag moving across it, and a ball on it, and a sort of pool or hollow, and an obelisk, which is leaning. These three or four objects represent a very pragmatic description of movement across a surface.'

The sculpture *Through the Arch* (1967) shows Nash's growing interest in exploring space and perspective, and the illusion that occurs when one looks out at a landscape from the narrow confines of an arch or doorway, when 'perspective works in reverse from the way one is taught

8 *Through the Arch*, 1967, wood and perspex, 75 × 240 × 240 cm (30 × 96 × 96 in)

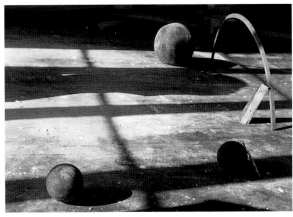

9

it, in terms of vanishing point . . . through an opening, say, three feet wide you can see a mile of horizon, so there is actually an expansion of space'. In this piece and in *Three Planes of Distance* (1967) Nash was working on a much smaller scale, using boards and plaster to create miniature vistas through which he can peer to achieve the effect of great distance. *Three Planes* was one of several works in which 'the progression of three kept coming back – it was like looking at landscape, with foreground, middle-ground and distance'. But he also felt these effects led into another dimension: 'It was as though *you* were at the vanishing point and it was all opening up in front of you – it was like a crossing-point. Whereas one focuses into something material you can actually cross over and go into the spiritual which is lying behind it.' These works, which were inspired in physical terms by the space-frame and boardgame sculptures of Giacometti, seem to have been the starting-point for Nash's attempts to create sculptures with resonances beyond the physical exploration of space that had occupied him thus far. They look forward to his concern to bring the element of time into his art, a subject he had tried to explore in a written thesis and which was to reappear in his subsequent work in Wales.

At the end of his course David Nash took what was to prove a beneficial decision not to enrol for a further course, but aim to support himself for a few years in order to develop his ideas. To do this meant finding a place where he could afford to live and have the necessary space to work. His thoughts turned more and more towards Wales.

On his visits to the district during 1966 he moved up to the head of the valley to look for a house where property was decidedly cheaper: in the slate-mining town of Blaenau Ffestiniog. During the summer months he found a semi-detached cottage on the end of a small row, high up on a rocky outcrop known as Fuches Wen. With it came a separate, derelict, detached cottage which he knew he could convert into a studio. The price for the two was £300, and he was able to get a grant to improve the main cottage. Bit by bit, he moved materials up there, getting a bonus when the barn he had worked in at

Combe Farm was pulled down and he was able to acquire all the timber from it. Even more important, he had been able to line up some employment locally. During one of the Wales visits he learned that a friend of his, Alan Evans, had access to some machinery and to an outhouse in the village of Llan Ffestiniog. Evans was keen to set up a small business making domestic and ornamental items out of slate. He proposed to Nash that they should go into business together, David providing the artistic and design ideas, Alan Evans covering the business side, and a third friend, Will Seymour, helping on the practical side. 'Slate Products' was formally established as a company. After a brief visit to Paris, where he once again visited Brancusi's studio, David Nash moved to Blaenau Ffestiniog in the summer of 1967.

9 *Through the Arch* in progress, 1967

10

10 *Three Planes of Distance*, 1967, plaster 15 × 76 × 228.5 cm (6 × 30 × 90 in)

1. Unless otherwise attributed, all quotations from David Nash have been taken from a series of interviews given to the author during the summer and autumn of 1995

2. Lynne Cooke essay 'New Abstract Sculpture and its Sources', in Whitechapel Art Gallery catalogue, *British Sculpture in the Twentieth Century*, 1981

THE MOVE TO WALES

David Nash had no illusions that the quality of life in Blaenau would be similar to the pastoral ideal he had enjoyed in the Vale of Ffestiniog. He had always thought of Blaenau, as do most locals, as 'a grey wet hole', and his reason for living there was first and foremost an economic one. He had seen the constant problems that artist friends had in London paying high rents on a flat and a studio. All their time was spent covering these overheads, before they could even start working. 'I had decided to work out what was the bottom line for me, for a life. To have enough time for a life you needed low overheads.' With rates on the cottages at £12 a year he had certainly achieved this.

In its surroundings, climate, history and complex socio/linguistic mix of people, Blaenau is an unusual community. Most of the tourists who pass through it get a shock when, having followed the A470 up the scenic Lledr valley heading for the sea, they surmount the Crimea Pass to find themselves confronted by a black moonscape of abandoned quarries and slate tips.

Winding their way through seemingly endless rows of small terraced cottages with curiously blank façades, grey slate roofs gleaming in the wet (the rainfall is 120 inches a year on average), they, too, tend to refer to the place as 'a hole' as they head off down the valley. Few of them realise that Blaenau is, officially, a 'hole': a hole in the National Park. The Ordnance Survey map of Snowdonia shows Blaenau neatly ringed round, since presumably the planners who established the Park boundaries felt they simply could not include an industrial area.

In the period since the Second World War the town has suffered from severe economic depression. The population has dropped to less than half its peak level and the three quarries still partially open probably employ more people on tourism than on the production of slate. A sad side-effect of the changes was that the strong Welsh cultural life that had evolved around the quarries was also devastated. But the people of Blaenau still have a strong sense of identity, even incomers such as David Nash and his family feeling part of a special community.

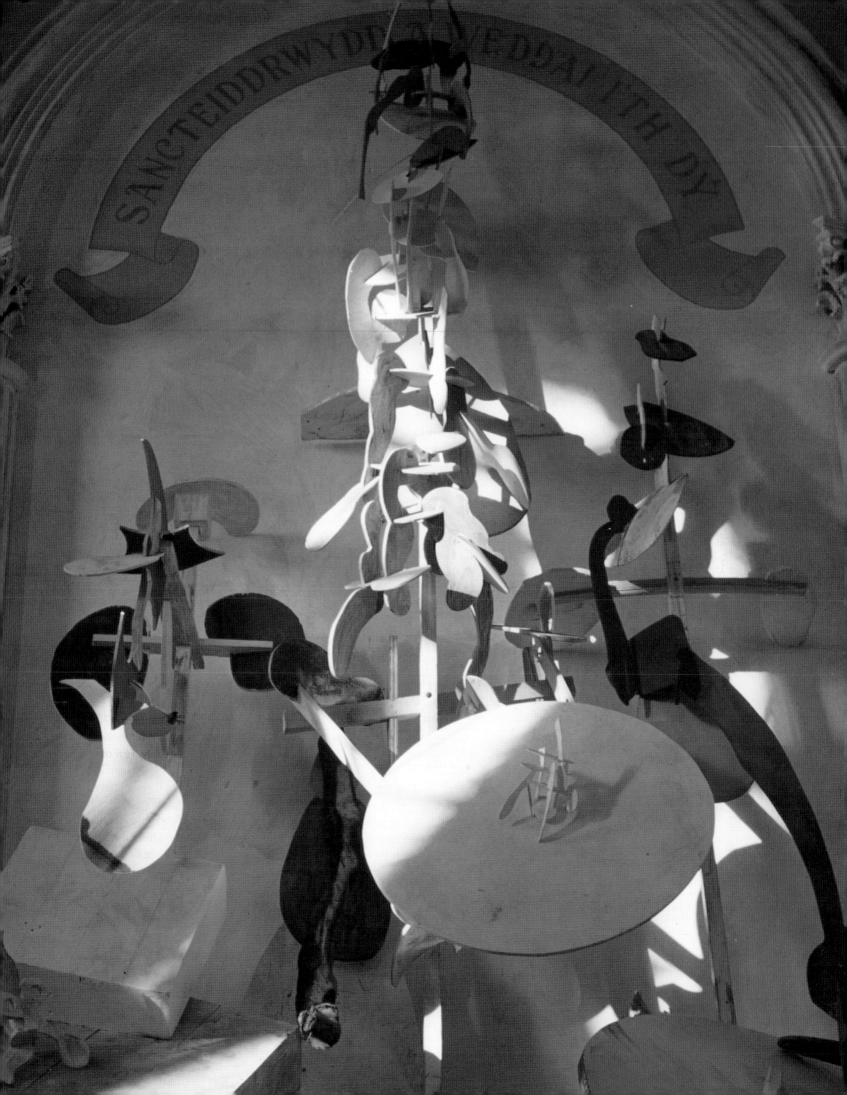

Slate is extracted by three basic methods, all of which were extensively practised in and around Blaenau.[3] In an open quarry a series of terraces, or 'boncs', would be cut into the side of the mountain, but if the vein of slate dipped deeply into the bottom of a valley then a pit would be excavated with terraces within it. The third method was to drive tunnels directly into the side of the mountain and extend galleries, or 'adits', out on either side of these to exploit the veins. The effect of such devastating activity on the landscape can be imagined yet, curiously, when approaching Blaenau from a distance, particularly up the Ffestiniog valley, few signs of this exploitation appear until one is actually entering the town. This is because the mountains themselves are composed of so much solid grey granite, loose scree and tumbling boulders that it is difficult at first to distinguish where the natural features end and man-made excavations begin. So although Blaenau itself is a jumbled mass of terraced houses with glistening roofs, the town is so dominated by the surrounding masses it gives the impression of crouching at the head of the valley like some cornered animal. Approaching from Llan Ffestiniog on the old road (the only one at the time when the Nash family first came to the district) the view is dominated by the vast bulk of the Manods which lie to the east of Blaenau. Manod Mawr, a great curved dome of rock, appears to be looking down the valley like the head of some huge hawk; it has romantic associations, since beneath its bulk, in a cavern so large it is known as 'the cathedral', the entire contents of London's National Gallery were safely stored away during the Second World War in response to a terse instruction to the Director, Kenneth Clark, from Winston Churchill: 'Bury them in the bowels of the earth, but not a picture shall leave this island. W.S.C.'[4]

Immediately below the Manods lies the raised point of Fuches Wen, where Nash had his cottage and studio. From here the twin peaks of the Moelwyns, opposite, present a dramatic silhouette. One writer who knew this scenery well, having retreated there for the last twenty-five years of his life, was John Cowper Powys who describes 'the El Greco – like Blaenau of slate and granite quarries piled up high towards heaven'.[5] With his companion, Phyllis Playter, he occupied a pair of cottages just below David Nash's base. Powys had died in 1963, shortly before Nash moved permanently to Blaenau, but Phyllis Playter was still there and still very active. From her kitchen window she watched with increasing curiosity the strange construction that had begun to grow on the hillside just above her.

One of Nash's reasons for coming to Wales had been the possibility of finding a suitably large space in which he could try out ideas that simply would not have been possible within an art school situation. With the studio cottage and the quantity of material he had brought up from Kingston he was now in a position to start work on

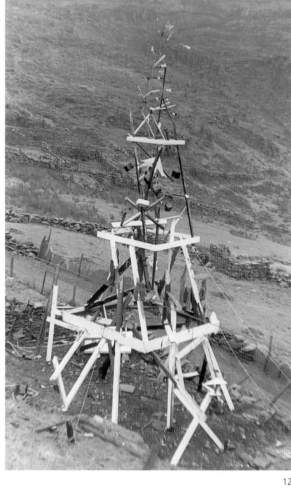

12

his first really ambitious work. *Tower 1* (1967) was built on a piece of rocky, sloping land adjacent to the cottages. Nash had been rereading Lowry's novel *Under the Volcano* and, in his construction, was attempting to create a physical metaphor for the complex structure of the book. But the tower was based also on the human figure (though not in a figurative sense), consisting of three stages corresponding to the legs, or supporting structure, the body or central section of the tower, and the head or top section. On another level it could be seen as representing living space, with a basement, a living area and a bedroom or attic. Nash saw the progression upwards as pointing towards a higher, cosmic reality or understanding: an invisible space beyond our material existence. *Tower 1* was constructed from painted wood, once again predominantly in blue, white and red like the Kingston pieces, and reached a height of thirty feet. But at this stage he had not mastered the technical skills necessary to secure such a large construction and in due course it was blown down by a strong wind. For an artist trying to communicate his ideas there was a certain irony in the fact that when it fell the tower broke a cable carrying television signals for the otherwise inaccessible Blaenau Ffestiniog district. Undeterred, Nash began work on a second tower at the same spot.

11 (overleaf) *The Waterfall* (detail), Capel Rhiw, 1970/1, painted wood, 720 × 540 × 360 cm (288 × 216 × 144 in)

12 *Tower 1*, 1967, painted wood, 900 × 750 × 600 cm (360 × 300 × 240 in)

13 The Oakeley slate tip, Blaenau Ffestiniog (Capel Rhiw bottom left)

14 View of Blaenau Ffestiniog from Fuches Wen

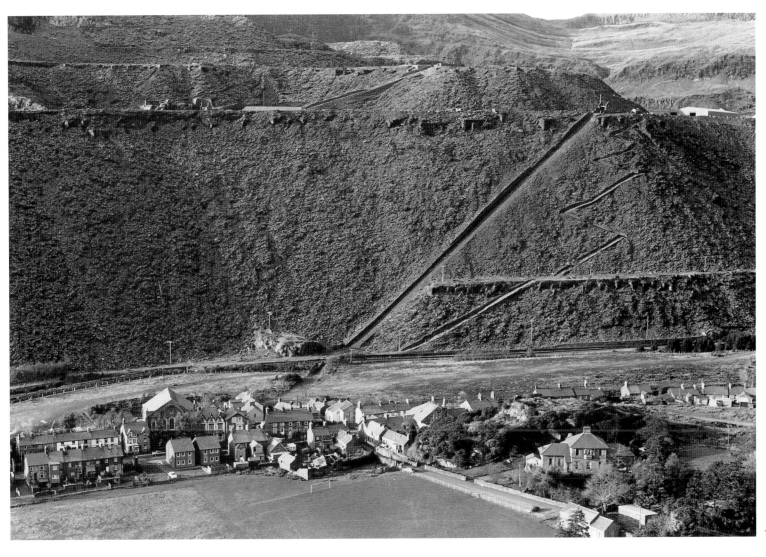

13

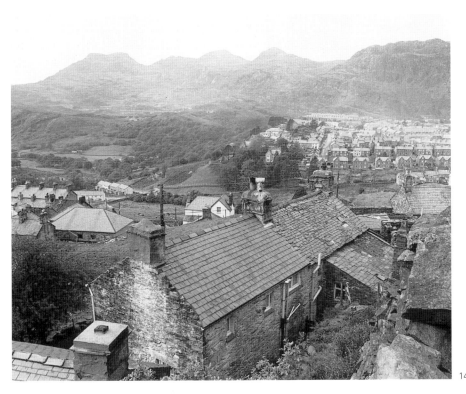

14

In addition to building the towers Nash had been continuing to work in the studio, and had managed to sell several paintings locally. One of his first patrons was Powys' companion, Phyllis Playter. A tiny woman, dressed in black, wearing a huge hat which made her appear like a large mushroom, she took an instant liking to Nash who was impressed by her knowledge and understanding of art and the interest she showed in his work. He remembers her talking about Odilon Redon, and his wish 'to place the visible in the service of the invisible'. She also introduced him to the aphorisms of Brancusi, translating them from the French for him. Brancusi's succinct comment that 'simplicity is complexity resolved' remained in Nash's mind.

One of the paintings he completed in this period, which is closely related in concept and structure to the towers, is called *The Peaceful Village* (1967). The title derives from a passage in Lowry's *Under the Volcano* in which the main character, the Consul, has one of those moments of terrifying clarity that accompany an onset of 'delirium tremens': 'A picture of his soul as a town appeared once more before him, but this time a town ravaged and stricken in the black path of his excess, and shutting his burning eyes he had thought of the beautiful functioning of the system in those who were truly alive, switches connected, nerves rigid only in real danger, and in nightmareless sleep now calm, not resting, yet poised: a peaceful village.'[6] This image, of balance and equilibrium, physical, mental, spiritual, informs Nash's work over several years, linking also to the sense of unity and completeness that he felt when looking at the later paintings of Arshile Gorky. In his attempts to achieve a similar synthesis with the various towers, in the sculpture version of *The Peaceful Village*, completed later that year, and in a major piece called *The Waterfall* of 1970/1, Nash was, perhaps, attempting the impossible, since he was trying to create epic works which 'would have everything in them'. Yet the process of making them was extremely important for him, and the ideas he developed at this time, derived from his reading of Henry Miller and Jacob Boehme, were to serve as preparation for the time – some fifteen years later – when he would encounter the ideas of Rudolf Steiner. Without this preparation, this thinking and working out of his own ideas, he feels he could easily have been overwhelmed, later, by the philosophy of Steiner and the force of the an-throposophical movement. 'Since meeting it I've always treated it with caution . . . it can swamp you, and overwhelm your individuality. But the whole point of an-throposophy is to develop your individuality.'

The 'Slate Products' business venture soon folded, so for a number of months Nash worked for the Economic Forestry Group, planting trees, digging ditches, burning gorse and doing other odd jobs. He also began teaching for the first time, taking evening classes in art at Penrhyndeudraeth and then, later, a Workers'

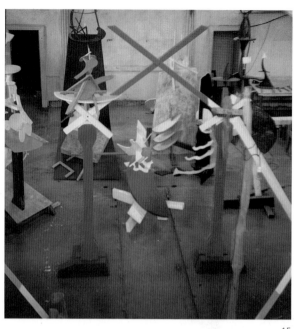

15

Educational Association class in Blaenau.

In the summer of 1968, needing a larger space than the cottage provided, Nash rented the basement and disused restaurant of a local hotel. There he began work on *Broken Archway*, which was his first three-dimensional version of *The Peaceful Village*. He was also making parts for his second tower at Fuches Wen. But this, too, was destined for demolition. He was approached by a Planning Officer, who asked Nash whether he had obtained permission to build the tower. David replied flippantly that he had permission from God, to which the officer replied: 'unfortunately you have to have permission from the Council as well.' The components of the tower were stored away for recycling, in due course, into other sculptures. It was at this point that he heard about a large chapel, recently abandoned by its dwindling congregation, which was up for sale at the north end of Blaenau.

With the growth of population in Blaenau in the nineteenth century had come a rapid increase in the number of nonconformist chapels opened in the town by the various denominations. By the turn of the century Blaenau had twenty-one different chapels. Of those remaining today very few are still open and a number have been demolished. Built in 1863, Capel Rhiw was the biggest of all – indeed it is still one of the largest buildings in Blaenau. A substantial Sunday School house, which also acted as the vestry, was built immediately behind the chapel. Services were held for almost exactly a hundred years, but by the autumn of 1968, when Nash heard it was being sold off for the value of the scrap material it contained, most of its pews and more personal fittings had been removed. Nash learned from the agent handling the sale that a scrap-metal merchant had already put in a bid of £50 for the premises. From the

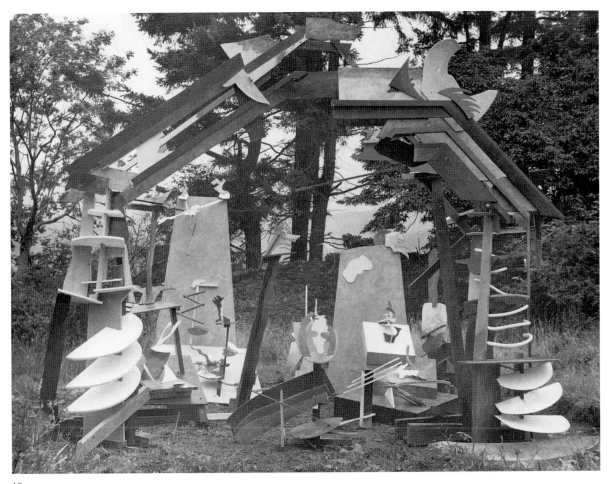

16

16 *Broken Archway*, 1968,
painted wood,
360 × 750 × 750 cm
(144 × 300 × 300 in)

jagged slate waste of the Oakeley tip which lies immediately behind the building he looked down on its enormous roof, dwarfed by the height of the tip. It was a big decision for a young man of only twenty-two, but he made up his mind and put in a higher bid. His rival bid him up for a while but Nash finally secured the building for £210.

Seen from the front, Capel Rhiw is forty-five feet high from ground level to the roof ridge, the top fifteen feet comprising a vast attic space above the main interior. The building is fifty-five feet long by fifty-one feet wide with a broad curved balcony around three sides. The enormous beams holding the ceiling and attic space span the entire gulf in one stretch. On the western end wall, above the position where the pulpit used to be, a curved painted scroll still contains the words: 'Sanct Eiddiwydd a weddai i'th dy' (Sanctify this house with prayer).

Buying this building was an important step for Nash and the possibilities it offered him to work indoors on a large scale were to have a deep influence on the development of his sculpture. While starting to make a living space in the chapel, he remained for a further six months in his basement studio at the Lyndale Hotel, where he was well advanced with *Broken Archway*. He continued to support himself with teaching, forestry work and the occasional building job.

In *Broken Archway*, and in its reworked version *The*

Peaceful Village (1968/9), Nash was once more reverting to the practice he had started at Kingston, of making self-supporting forms which presented strong colours in space through an evidently geometric structure. (This had also been the case in the first *Towers*, to some extent.) Geometry had been the subject he had most enjoyed at school, partly because of its obvious visual element and partly because the forms and proofs being realised were not simply intellectual abstractions but had real practical applications. There was also a deeper level to geometry which seems to have struck him at an early stage: he has never forgotten the sensation of excitement he felt when his maths teacher demonstrated, by the simple method of using a compass to make crossing-points above a straight line, how a right angle could be constructed. What fascinated him was the fact that the distance from the base-line to the crossing-point could be any length, but the crossing-point itself was very precise: 'I've been working with this ever since I've been conscious of what a "point" was . . . I can remember some sort of a sense of recognition, a thrill at this, actually a physical experience. I've often thought about this and I've used it as an example of one of the things I'm really interested in, in my contribution to art. It is for something to be very specific, but loose. And all through my college years I had a great problem with feeling that an artwork had to be very precise . . . And I remember looking at Chagall and

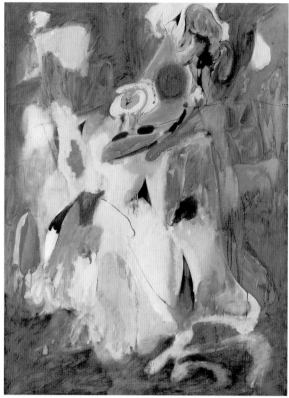

17

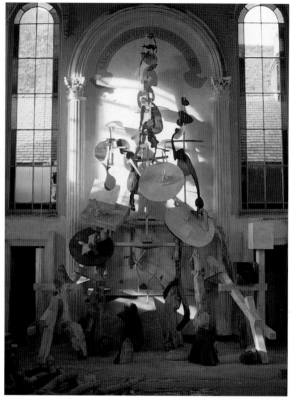

18

17 Arshile Gorky, *Waterfall*, 1943, oil on canvas, 153.5 × 113 cm (60½ × 44½ in)

18 *The Waterfall*, Capel Rhiw, 1970/1, painted wood, 720 × 540 × 360 cm (285 × 216 × 144 in)

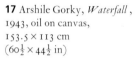

19 *The Peaceful Village*, 1967, gouache, 51.5 × 42.5 cm (20½ × 17 in)

realising that "that blue could have been a bit lighter or a bit darker" or "that shape could have been a bit larger or a bit smaller" . . . it wouldn't have made much difference to the actual painting – looseness!' Watching a spider making a web produced the same reaction: 'There was a casualness about it, as well as a precision.'

Later on, while working on his first large sculptures in Wales, Nash began to realise that the abstract and intellectual truths of geometry 'represented spiritual truths which were always manifesting themselves in a new and different way, and that art is always refreshing itself because it is always finding new ways of saying the same thing'. He also saw a connection with 'the spiritual truth which is origin. And then I realised that that's what *originality* was all about – that it wasn't about innovation. It was about connecting oneself with origin.'

This concern with geometry, which had been evident in his Kingston piece *Blue Place* with its emphasis on the counterbalance of diagonals, is clear in the surviving photographs of *Broken Archway* and *The Peaceful Village* (which were both subsequently destroyed). They also repeat the pattern of looking through a space or window that had been a feature of the early Kingston sculptures: 'I also learned with these constructions about something developing its own logic that the viewer can enter into . . . it could have an integrity and a truth that one could feel. And also how a worked object developed its own scale – how it could go beyond the material, go beyond the colour, to have a sense of its own scale which the beholder entered into . . . which is actually different from

its physical scale.' All of this relates closely to the themes in the Malcolm Lowry novel. As a parallel to the pattern whereby small incidents and sections of the book act as metaphors for the whole, he began making a series of small works which reflected parts of his large sculpture – studies for *The Peaceful Village*. With the completion of this work he felt, inwardly, that he had reached a synthesis, a reconciliation which echoed the extraordinary level of self-knowledge reached by Lowry's Consul in the passage quoted earlier. 'One can still be essentially at peace, even in that terrible tunnel of emotional chaos . . . At rock bottom you can get right through to how he describes a peaceful village. That intrigued me very much, the duality between the outer chaos of material life, and a sense of inner peace.'

3. For information on slate-quarrying, and on the history of Blaenau Ffestiniog, the author is indebted to the following:
J. G. Isherwood, *Slate from Blaenau Ffestiniog*, 1988
Merfyn Williams, *The Slate Industry*, 1991
Steffan ab Owain, *Blaenau Ffestiniog Market Hall*, 1995
Alun John Richards, *Slate Quarrying in Wales*, 1995
Gwynedd County Planning Departments, *Blaenau Ffestiniog Town Trail*, n.d.

4. Quoted by Kenneth Clark in the second volume of his autobiography, *Another Part of the Wood*, John Murray 1977

5. John Cowper Powys, *Letters to Benson Roberts*, p.98

6. All quotations from Malcolm Lowry's novel, *Under the Volcano*, have been taken from the 1967 edition published by Jonathan Cape

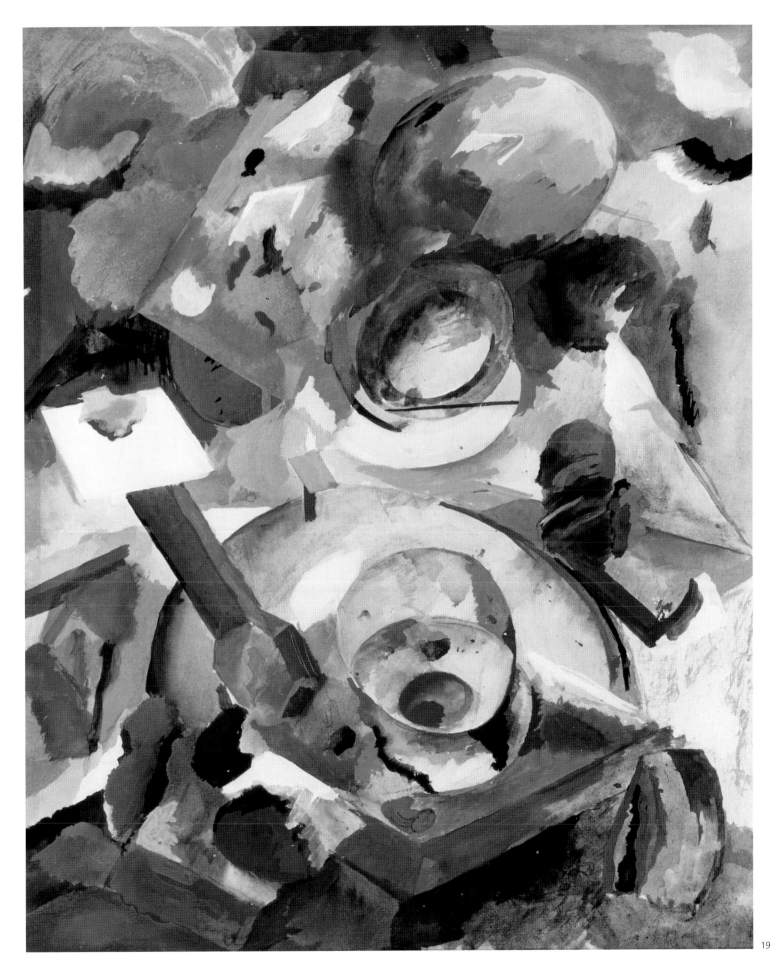

4

CHELSEA 1969-70

During the winter months of 1968/9 Nash applied to do a postgraduate course at Chelsea School of Art. The staff expressed some surprise that he should want to do this, given that he already had his own studio and seemed to be maintaining himself quite well. Nash explained that he was anxious to learn not only technical skills but the disciplines lying behind a more professional approach to making art. He was accepted and moved down to London in the autumn of 1969.

This was the second year in which Chelsea had run a post-graduate course, and only six students had been accepted for it. The Head of Sculpture, George Fullard, explained at the start that they would not be undergoing formal tuition but were being given an opportunity to work as artists. In direct contrast to his experience at Kingston, Nash now worked closely with the technicians, who responded to his energy and commitment, ensuring he had access to the materials and equipment he required. From the start he was clear as to what he wanted to do: build further towers on the lines of the

ones in Wales, but this time with proper engineering techniques and with a properly worked-out structure and colour scheme. This meant learning the correct application of paint to wood, making full use of primer and undercoats, and making proper bolts for fastening the various elements together, turning the threads himself on a lathe. He was now covering all the subjects he had 'almost deliberately' missed out on at Kingston in the sculpture department. His 'post facto' rationalisation of this was that while art colleges tended to emphasise technique, rather than ideas, he had always felt the need to work directly from ideas, acquiring the technique from the experience of seeing what the idea required. He still believes in this principle. Before long, the elaborate structure of *Chelsea Tower 1*, rising to over twenty feet, was visible to passengers on buses travelling along the King's Road in Chelsea, and during the second term a second one rose beside it, so that Nash was now occupying almost the whole of the college courtyard. But the skill with which these towers had been constructed

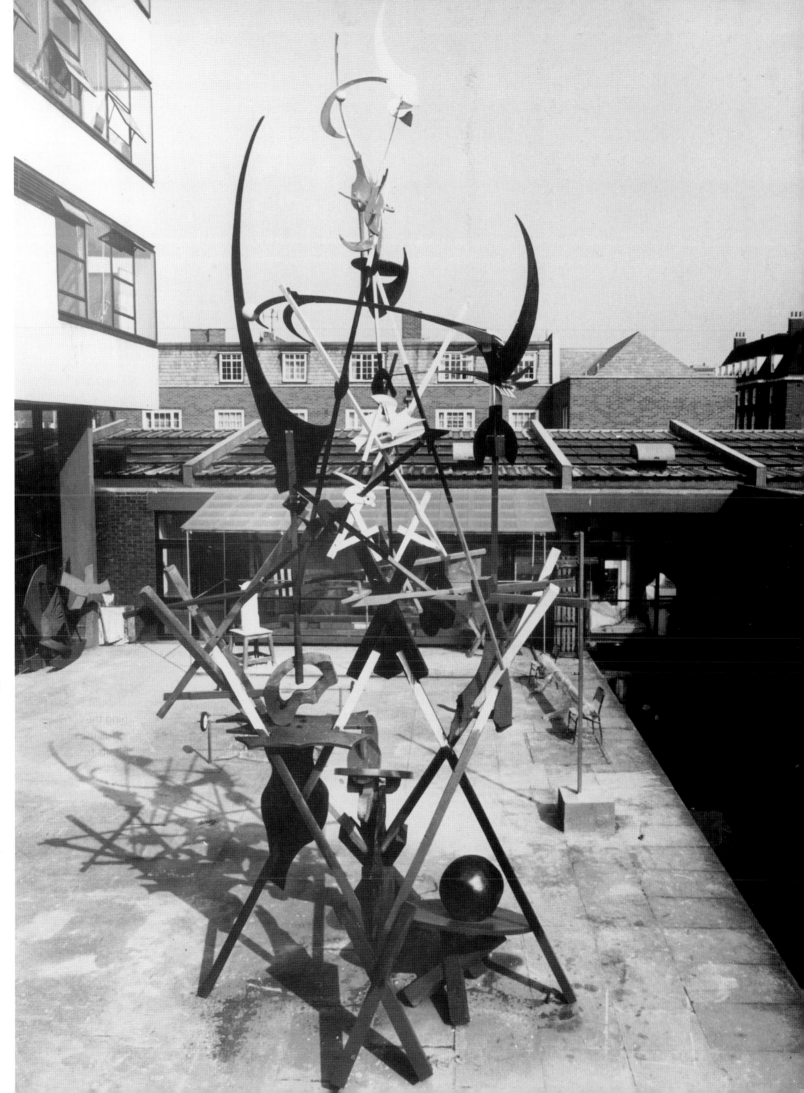

meant they could easily be dismantled, moved, and re-erected in another place. This was to prove useful when he came to build *Chelsea Tower 3* in the summer term of 1970.

With so much more confidence, Nash was able to take advantage of other facilities the college had to offer, in a way he had found impossible at Kingston. A formative experience was listening to a lecture by the American sculptor Claes Oldenburg. Nash was interested to find that this major avant-garde figure showed concern for formal, classical approaches to art, stressing that artists have always worked with objects from their own surroundings and that the domestic imagery he used reflected his own twentieth-century urban environment. His comment that certain objects would only 'read' as artworks if they were made sufficiently large gave Nash an important message which was to show up in his work in the 1970s, when he began to make domestic objects on a large scale, notably tables and ladders.

Nash worked hard on the three major pieces he completed at Chelsea, following a rigid routine whereby he rose at 6 am each morning and was at the college by 7.30 am, staying until it closed at night, and working every Saturday morning. His only break from this timetable was at lunchtime when he would make museum visits, mainly to the Victoria and Albert Museum which was within walking distance, where he regularly studied the Indian miniatures and the Cézanne water-colours. He also looked carefully at Indian sculpture in the British Museum. An odd by-product of these visits was a work he made at Capel Rhiw after his return from Chelsea, *Hanging Towels*, which appears in a photograph of the chapel interior. Based on a tiny miniature which showed towels hanging from the ceiling of a Persian barber's shop, it is a one-off in Nash's work. Made of sheets of painted aluminium, it hung from the ceiling of the chapel, giving him the reassurance that he had not allowed the vast space to dominate him completely.

The third tower he built at Chelsea was more formal and geometric in structure. The few photographs that exist of *Chelsea Tower 3* were taken in Hyde Park. The work was shown outside the Serpentine Gallery at a special exhibition – the first held at the gallery – of works by students following the new Higher Diploma courses at Chelsea, Birmingham and Manchester. The 'human figure' basis of this tower is more clearly visible than in the other *Chelsea Towers* and Nash had worked out an ingenious method of raising its various sections into place by means of ropes and pulleys, thus avoiding the need for scaffolding. Because it arrived at the gallery in 'compressed' form, the exhibition organisers did not realise how large it would be when erected – some twenty-five feet high. But before reaching this stage, Nash found himself in dispute with the gallery director, Sue Grayson, who warned him off when she saw him starting to cut holes in the turf for the feet of the tower.

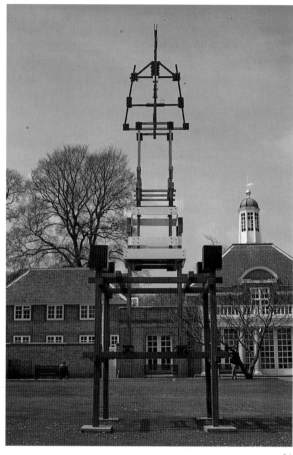

21

Nash was anxious that the bright red legs should rise directly out of the green grass, making a vivid contrast, but was frustrated by the director's insistence that no turf could be cut since it belonged to HM The Queen. So the tower had to rest, instead, on paving stones, which he found obtrusive. Nearly fifteen years later the question of the precious turf was to arise again over the installation of a very different work.

The stimulus of having a major piece displayed in an important public venue crowned what had been a positive year for Nash, a period of consolidation in which he had improved his technical skills, broadened his contact with a range of contemporary art, and absorbed ideas which were to emerge in his own sculpture at a later stage. He had one offer to show works in an Arts Council touring exhibition together with several other artists, but turned the opportunity down, feeling he did not want to commit works which were still connected to the art college experience. It was still too early.

No sooner had he returned to Blaenau from Chelsea than Nash received an invitation to give a lecture at Maidstone College of Art, in Kent. The occasion was to have important consequences. He took a lot of trouble over this talk, preparing a series of slides showing the Blaenau landscapes in parallel with his own works, and explaining the principle of how sections of a work could be seen as a microcosm of the whole. His talk was well

received, and he was invited to come and lecture at the college for one day a week, on a regular basis. Given the distance involved, Nash made an agreement with Maidstone whereby he could do his lecturing in a four-day 'block', once a month, and from the spring of 1971 he began this pattern of work. For three weeks of every month he was now free to concentrate on his sculpture.

The last major work he made which links to the pieces immediately before his Chelsea year (*Broken Archway* and *The Peaceful Village*) was *The Waterfall*. A direct homage to Gorky's painting of the same name *The Waterfall* was completed in the autumn of 1970 on Nash's return from London. It was a complex work, made of stained and painted sections of wood (most of which came from the earlier works, now dismantled), and marked the culmination of Nash's efforts to realise, in three dimensions, the microcosm/macrocosm synthesis which so fascinated him in Lowry's novel. Photographs of the piece show a tumbling series of discs and segments, linked together by vertical and horizontal struts, forming a sequence that widens out in its lower sections. The movement of the piece is very clearly from the top downwards, in direct contrast to the towers which had all been pointing upwards. Discussing the significance of this later, Nash has suggested that the downward movement could be read as symbolising that which descends from above or, in a more overtly religious sense, divine inspiration. It could also be seen as a parallel to the annual cycle of the seasons where spring conveys a sense of burgeoning and upward movement, while autumn signifies decay and falling – yet these energies are held in balance, like the elements of the sculpture.

One has to recognise that at the time he made *The Waterfall* David Nash, then only twenty-five, would have been reluctant to discuss it in such terms, although he was aware of these resonances. He was emphasising them in his decision to place *The Waterfall* at the crucial end-point in the chapel, where it is framed by the religious text that fits it so perfectly as to appear, almost, an integral part of the work. It was significant, too, that he chose to leave the piece in this position over a period of several years during which, working in close proximity to it, he was to find quite a different language of material. Although it was long ago dismantled, *The Waterfall* is a key work in Nash's sculptural *œuvre*, looking forward to a period nearly twenty years ahead, in the late 1980s, when he began making works that have a much clearer spiritual significance, combined with simplicity of form and function: bowls, chalices, shrines, thrones and the ascending and descending vessels.

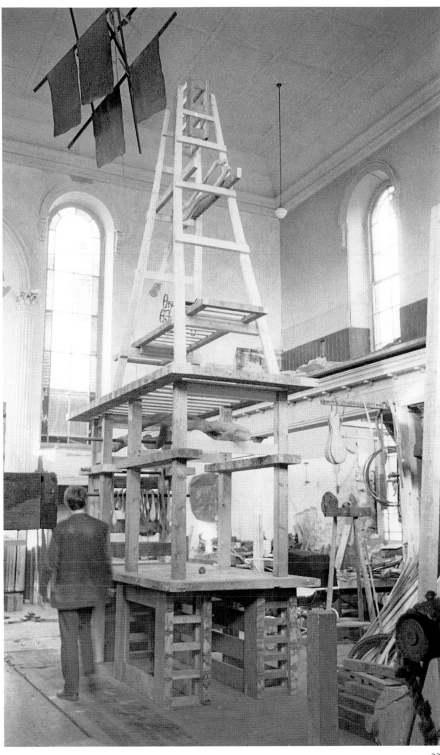

22

22 Interior of Capel Rhiw, 1973, showing *Hanging Towels* (1970) and *Cellar, Room and Spire* (1973)

THE LANGUAGE OF MATERIAL

The relative security he had achieved through his teaching, combined with the growing confidence he felt working in the chapel, meant that Nash now had more time to get to know his immediate surroundings in Blaenau Ffestiniog. In his searches for waste timber that could be used for sculpture he explored many of the slate-tips and went into abandoned quarries, where apparently solid rock concealed enormous spaces, huge mountains being honeycombed with tunnels and chambers on many levels. In small works like *Inner Space* (1972) and *Sound in an Inner Recess* (1972) the influence of these explorations is evident: seen on their own they appear to be no more than experimental abstract carvings into pieces of wood, but against photographs of the actual quarries they can be read almost literally as depictions of those spaces. Echoes of the surrounding landscape recur over the years: even the surfaces of *Two Rough Balls* (1984) hark back to the terraced 'boncs' of quarries such as Penrhyn or the Oakeley, immediately behind Capel Rhiw. In these and other pieces of the early

1970s Nash was no longer relying on ready-made lengths of timber or on the technique of construction. He was beginning to use simpler, rougher pieces of wood, carving and chiselling rather than carpentry methods. He also made some deliberate experiments at Brancusi-like columns, not so much to imitate Brancusi as to try to gain a deeper understanding of how the columns actually functioned as sculptures.

The uneven dimensions of the sections of *Rising Falling Column* (1971) were an attempt to create a vertical sculpture which would give a sense of movement downwards, at the same time as upwards. He was poaching wood from the chapel to use in the construction of a staircase and upper floor in the schoolhouse, so the processes of sculpture and simple carpentry were overlapping. *Rising Falling Column* was carved using a chisel with a six-inch blade (adapted from a 'floor-board bolster'), and Nash was becoming more and more conscious of surface texture and the marks the tool was making: 'that was the problem with painting,

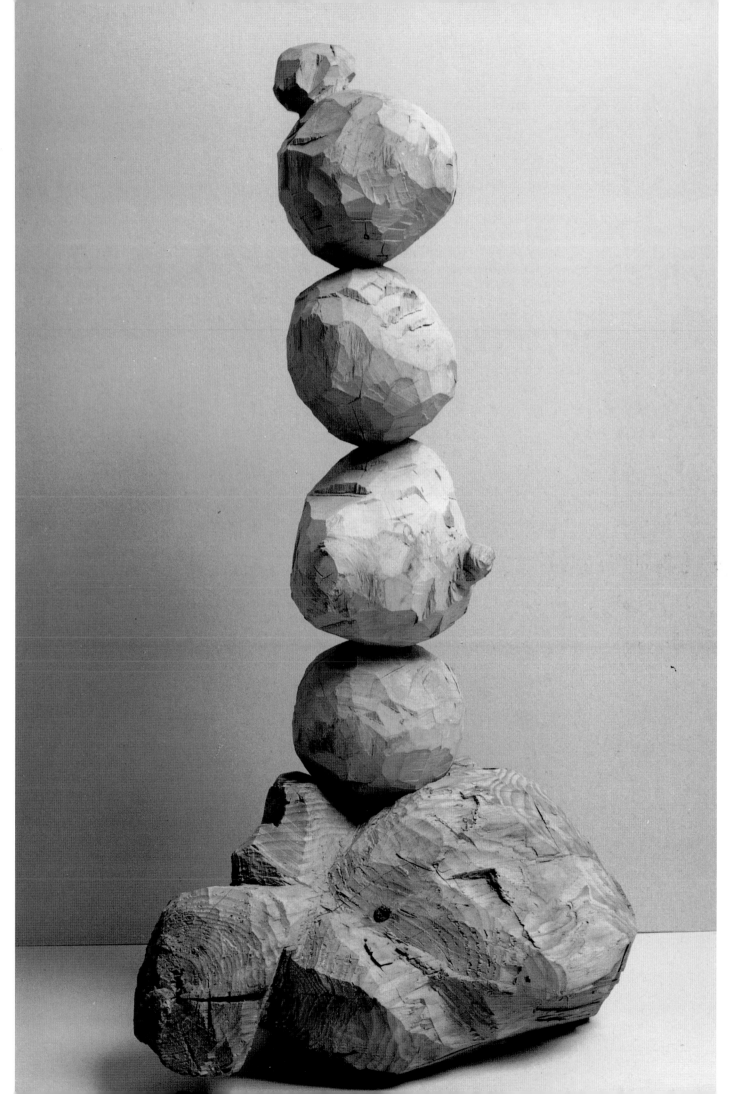

23

23 (overleaf) *Bonk Pile 1*,
1971, ash, 84 × 50 × 32.5 cm
(34 × 20 × 13 in)

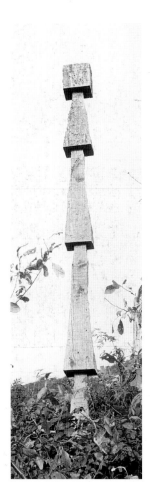

24

24 *Rising Falling Column*, 1971,
pitchpine, 300 × 25 × 25 cm
(120 × 10 × 10 in)

losing the surface'. He also remembers the marvellous wood-chips that leapt off this piece as he was cutting it, which he saw could have their own aesthetic effect, making use of this in a group of tower shapes which had the rough chips stuck onto the exterior, almost like the coat of an animal. Increasingly the use of natural wood was beginning to replace his former practice of painting on smooth wooden surfaces. He was also starting to use axes, of different sizes, to chop the wood instead of cutting it with a saw. This was a deliberate attempt to work at a primal level – the simplest action of striking wood with an axe to produce an unselfconscious object.

One day in 1970 a friend dropped the trunk of an ash tree, stripped of its branches, over the fence into Nash's backyard. Looking at the truncated end of the tree Nash noticed that it formed a curve, almost a hemisphere, since the woodsman had cut V-shaped notches in order to reduce the diameter and force the trunk to topple. Out of curiosity he took his own axe and began to cut a further series of V notches about eighteen inches further up the trunk in its now horizontal position, as though he were felling it again. Turning the wood in order to complete the circle of his notches, and finally severing the piece from the trunk, he found the resulting object resembled a large rough wooden ball. But then he was left, as before, with a semi-circular end of tree-trunk so the natural impulse was to repeat the process and carve out another wooden lump. Enjoying the process he carried on, but as he gradually moved up the trunk he found that it narrowed, so it was better to use a smaller size of axe. 'It was like eating peanuts – I just carried on . . . It was such a delicious experience, but I wasn't sure of it. It seemed too easy! Could this be art? I couldn't cope with the result of the experience. I was, in a way, ahead of myself.' Eventually the trunk yielded nine rough balls of wood. They were put on one side and covered over with other material, and for a few months Nash forgot completely about them.

Other rough works, cut with axe and chisel, immediately followed. Another trunk of ash produced a sculpture in which the round lumps appeared to be precariously balanced on each other because Nash had cut nine tenths of the way round them. *Bonk Pile 1* (1971) is made out of one piece of wood only, the four round elements (two of which have small buds of wood protruding from them) sitting in a roughly carved base. This warm, chunky piece, with its sensual rounded forms and rough faceted surfaces inviting touch, was an enormous distance away, in concept, from the highly complex constructions Nash had made up until then. It represented (with the nine balls, to which we will return shortly) a totally new approach: the approach of an artist who was discovering a language of material with which he was closely, physically involved. In its solidity, its weightiness, *Bonk Pile 1*, and the pieces in the same

idiom which followed, were the exact opposite of the airy, intellectual abstractions he had been trying to create in the *Towers*, the *Peaceful Village*, and the *Waterfall*. He was partially aware of this and yet, as his own words reveal, he did not quite trust the new experience, with the result that for the next two to three years a dichotomy appeared in his work. Absorbed in the new language of wood he was discovering, Nash decided to 'go with it' and see where it led him. But he found it hard to give up the intellectual quest he had pursued so doggedly over the previous five years and, in consequence, a number of complex, constructed works still appear in photographs of the interior of the chapel taken between 1971 and 1974, some – like *Cellar, Room and Spire* (1973) – being on a very large scale.

Bonks on a Rostrum and *Two Bonks in a Box*, both from 1971, show two further approaches Nash took at this time towards the presentation of a sculpture. Before describing them it would be as well to explain the word 'bonk' which is given to a number of pieces dating from this time. Nash uses the word to mean a solid, rounded chunk of material, not simply the wood he is using, but also natural rock, like the lumps or outcrops around Blaenau. The origin of the word, for him, came from his neighbour Ted Harris, at the original Fuches Wen cottages. Harris used to stroll along the flat terrace cut into the hillside outside the cottages saying: 'I'm going out on the bonk to have a think.' Nash loved the expression, but always assumed his neighbour meant the rounded rocky end of the path to be the 'bonk' and from then on referred to all such lumps by that term, using it naturally for these first very chunky sculptures. What he had not realised was that his neighbour was using the actual Welsh word 'bonc' for the quarry terrace where he walked, rather than the rock at the end of it. There is a certain irony in Nash's misunderstanding of the word, given that two of the most famous boncs, the Bonc Coedan and Bonc Shaft, form part of the Oakeley quarry which towers over the chapel-cum-studio where his own 'bonks' were conceived. But the word has other resonances, of course, which appealed to him. It is onomatopoeic, mimicking the sound of the axe hitting the wood , and then – when he was working outside – the echo of that same sound bouncing back from the other side of the valley. For Nash, the whole rocky lumpiness of the outcrops that appear all over the Ffestiniog valley expressed this solid, satisfying feel of the lumps of wood he was now cutting and carving. Sometimes tussocks of grass or humps of moss would assume similar forms, while down at the bottom near Maentwrog, hidden deep in the cleft of the chestnut-wood, the vast Cynfal boulder, the ultimate bonk, rested beside the stream. With growing recognition he saw that these forms had been with him throughout his life in Wales, even from childhood, and that in working with them now he was discovering that connection with origins that

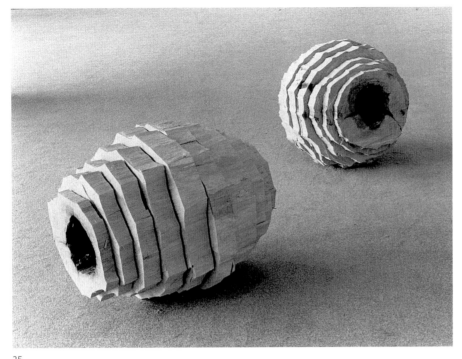

25

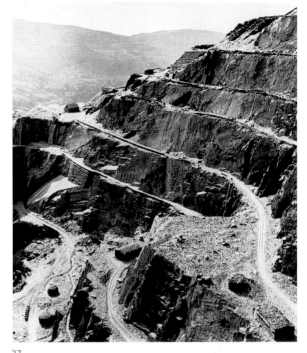

27

28

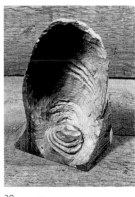

29

26

25 *Two Rough Balls*, 1984,
oak, each 71 × 91.5 × 76 cm
(28 × 36½ × 30 in)

26 Rhosydd Slate Quarry,
9 Adit, looking south

27 Bonc Terraces, Penrhyn
Quarry, North Wales

28 *Inner Space*, 1972, oak,
36 × 24 × 20 cm
(14½ × 9½ × 8 in)

29 *Sound in an Inner Recess*,
1972, oak, 17.5 × 11.5 × 9 cm
(7 × 4½ × 3½ in)

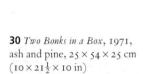

30 *Two Bonks in a Box*, 1971, ash and pine, 25 × 54 × 25 cm (10 × 21½ × 10 in)

he had recognised in Brancusi and in Giacometti, but had been unable to touch in his own work so far.

In *Bonks on a Rostrum* (1971) Nash constructed a formal wooden stand out of sections of pine which are effectively carpentered together. On the stand rests a separate presentation rostrum in three layers, and on the rostrum, almost as though they are being presented to potential purchasers in a shop window, are three separate rough 'bonks' of wood, the largest on the lower of the three levels, the smallest on the top. The whole piece is nearly six feet high, so the effect of the small round elements being formally presented to the viewer is very marked. The separation of the rostrum into three levels harks back to the several 'planes of distance' works that Nash had made at Kingston some four years earlier, while the formal, lectern-like structure of the whole piece is similar to Giacometti's *Four Figurines on a Stand* of 1950 which Nash had seen in the Tate Gallery's Giacometti exhibition of 1965.

With *Two Bonks in a Box* (1971) Nash appears to be attempting a totally contrasting method of presenting his carved pieces since, rather than being openly displayed, the two 'bonks' are closed in, shut away inside a box frame, like prisoners in a cramped cell. The use of a frame, or box, to enclose other objects is a theme he explored in a series of experimental works made in 1972 which are described separately below. *Two Bonks in a Box* also proved to be the seed which led to a major

work some sixteen years later when he was preparing a number of new sculptures for the *Viewpoint* exhibition held in Brussels in 1987: in *Plinth and Tomb* he made two enormous 'bonks' of solid oak, one of which is resting, almost concealed, inside a wooden box. The other is openly displayed on the top of a matching box, the two separate double-elements of the sculpture being placed in matching spaces within the gallery, for which they were specially made. This beautifully balanced piece seems to sum up the two methods of 'presenting' a work with which Nash was experimenting earlier, while also incorporating the element of a charred surface which he was to bring to a number of his sculptures in the 1980s.

The last work of this group, made over the winter of 1971/2, is *Sphere and Pyramid on Three Steps*, a small, very formal work, in which two 'bonks', or spherical elements, together with two small pyramid shapes, are displayed on a stepped base in the form of a ziggurat, rather like the 'step pyramid' of Saqqara. Images of the ancient Egyptian monuments had been very prevalent in the Press at this period in connection with the forthcoming Tutankhamen exhibition at the British Museum, which was much publicised. But Nash must also, in this piece, have been echoing the formal, geometric studies of spheres, cones and cylinders that he had practised in his drawing lessons at school, as well as reworking, once more, his theme of the three planes of distance.

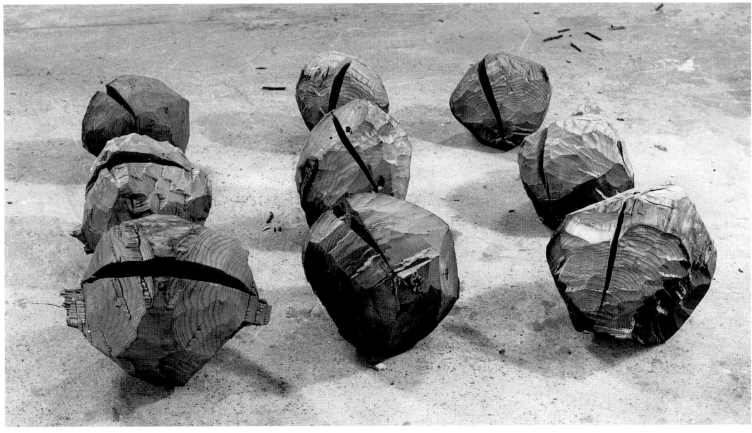

31

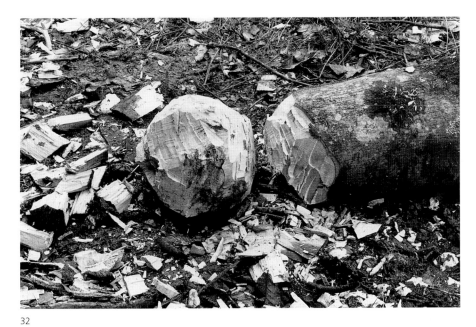

32

33

31 *Nine Cracked Balls*, 1970/1,
ash, 150 × 150 cm
(60 × 60 in), largest diameter
40 cm (16 in)

32 *Nine Cracked Balls*
in progress

33 Reed and grass tussocks,
Vale of Ffestiniog

In all these early works, which form a distinct group within his *œuvre*, we see Nash moving more and more towards simplicity of form while engaging ever more closely with his material. Whereas he had earlier used pieces of wood to construct his works – the material itself being concealed beneath a painted surface – he was now working with and in the material, carving, cutting, chiselling and chopping his increasingly elemental forms. He made a large number of very basic carved shapes which were small enough to be held in the hand, varying the naturally spherical form that his chiselling produced by drawing it out into flanges or wings which, in turn, led him to christen them *Cosmic Geese* (1971). And it was precisely at this time that he noted, once more, the pile of carved 'bonks' which he had cut from the ash tree and then put aside, several months before.

To his surprise they had altered. Across the middle of each round wooden lump a wide crack had opened, so that the whole group looked like a series of grinning mouths sharing a joke with him. In physical terms what had happened was that the moisture in the green wood of the ash lumps had dried out, causing the grain of the wood to contract and open. In visual terms the effect was extraordinary, since the deep cracks, opening into darkness, gave the elements an effect of fullness and of life. It was as though they were calling out to him, and Nash's instinct was to say 'yes', and accept them. Laying them out on the floor of the chapel in three rows of

three, he found himself looking at a sculpture which combined simplicity of form and material with something of the rigour of minimalism, while still having a distinct vitality of its own. *Nine Cracked Balls* (1970/1) was to become a new starting-point in Nash's work, not only for the considerations already mentioned, but because it incorporated two new factors that were to become central concerns in his sculpture: the elements of *time* and of *change*, the second of these being dependent on the first. Had he laid out the nine balls as a work at the moment when he first completed them they would have appeared just as simple forms. By leaving them over a period of time, thus allowing the wood to dry out and the cracks to open, he reduced the level of his own intervention in the final shapes. The cracks, which are so prominent, have been produced by the movement and action of the material, not by the hand of the artist. This process, he realised, overturned the concept of the 'finished' sculpture with a surface which should remain intact, unchanged, from the moment the sculptor's tool left it. The piece could determine its own final form and surface which would not be pre-determined by the sculptor; the artist would become less dominant and the material would be allowed to speak with its own voice.

These principles would come to inform David Nash's work from now on, including sculptures of a very different kind that he would make over periods of many years. For the time being, he continued to experiment

34 Step pyramid of Saqqara, Egypt

35 *Cosmic Geese*, 1971, ash, birch and beech,
3 elements: $6 \times 16 \times 6$ cm
($2\frac{1}{2} \times 6 \times 2\frac{1}{2}$ in);
$7 \times 12.5 \times 7.5$ cm
($2\frac{1}{2} \times 5 \times 3$ in);
$7.5 \times 20 \times 9$ cm ($3 \times 8 \times 3\frac{1}{2}$ in)

36 *Plinth and Tomb*, 1987, oak and pine, each
$76 \times 169.5 \times 104$ cm
($30\frac{1}{2} \times 68 \times 41\frac{1}{2}$ in)

37 *Sphere and Pyramid on Three Steps*, 1971/2, pitchpine,
$16 \times 13 \times 13$ cm
($6\frac{1}{2} \times 5\frac{1}{2} \times 5\frac{1}{2}$ in)

34

35

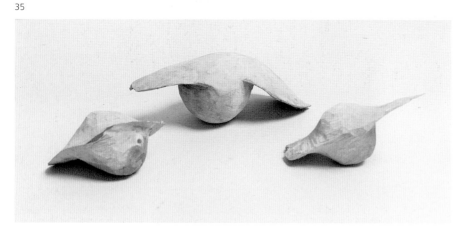

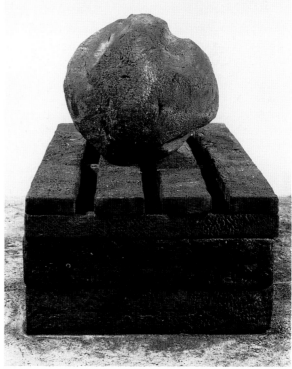

36

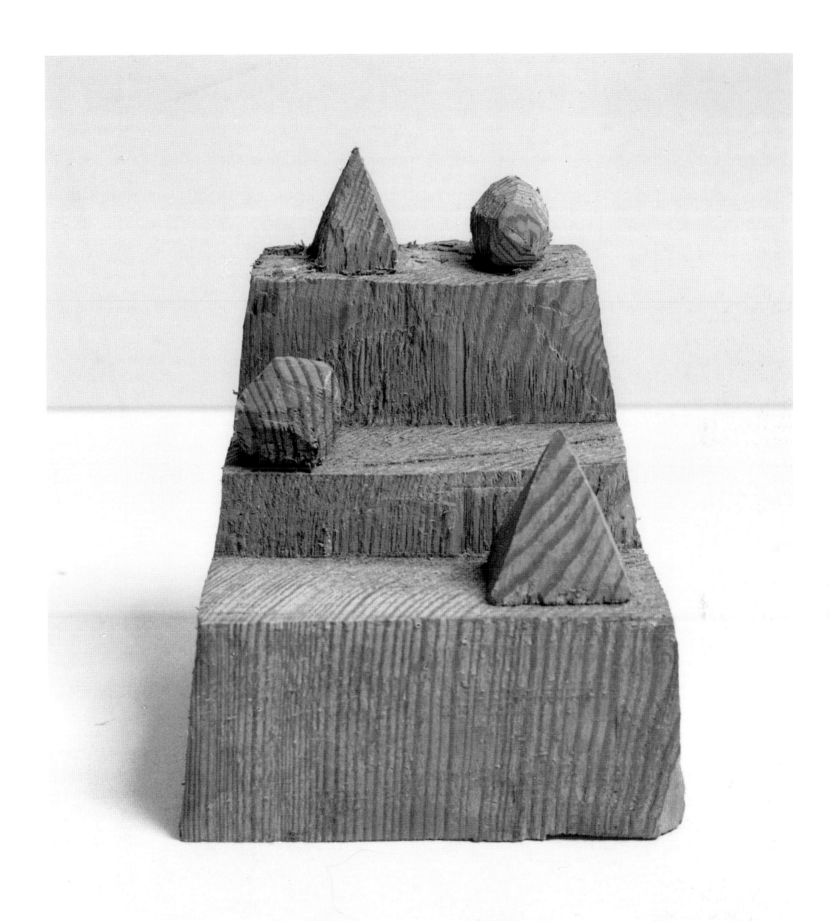

37

with other types of sculpture, particularly the constructed pieces, at the same time as he explored the new language of material which had brought itself to his notice in such a dramatic way. In the period following the *Nine Cracked Balls* he made a number of other pieces that combined the principles of time and change, through the processes of drying-out and cracking, with satisfyingly simple forms, exemplified in *Three Clams on a Rack* (Plate 2) and *Stack of Pods*, both of 1974, and *Long Pod Split* of 1975. *Pods in a Trough* (1975) does not involve the change element but is a different exploration of the pod shape, combined with presentation of these elements in a strong, solid container.

Using the processes of carving and chiselling to make rounded forms led Nash to consider what would be the best technique to use for square or cube shapes. His first experiment was to carve a tiny house out of a protruding piece of a large root, so that the little building appeared to be nestling into a rough hillside. The effect was too literal so he knocked the roof off the house. The resulting cube led him to feel that while carving was the natural method to use for a sphere, construction would be more suitable for a cube. This, however, meant using industrially worked wood, in the form of planks. He therefore used some boards from the floor of the chapel to build the first of his cubes, leaving a slight gap at the mitred corners which created a black line along all twelve edges of the cube, like dark lines drawn with a pencil.

To solve the problem of the smooth machined surfaces of these formal works he was influenced by memories of the *Cubi* sculptures of David Smith. Smith had dealt with the surface of his steel by polishing it with sweeping movements of a disc sander, sometimes reaching the effect that the 'gesture' marks appear bigger than the surfaces on which they are made. Nash also remembered a beautiful lozenge-shaped sculpture by William Tucker, made of fibreglass, violated by a clumsy footprint, a crude affront to the 'perfect' surface. Surface itself can become too precious, making the whole sculpture vulnerable, so Nash determined to roughen the surfaces of his cubes with his axe.

But the question remained – how to display the cubes? Unlike the rounded forms they did not look right on the floor: clearly they would have to be lifted up. An attempt to create a plinth failed – once again the sculptures looked artificial and 'precious'. So Nash tried placing them on an ordinary old table, intending to roughen up its surface. But that did not work because the table seemed too small. He remembered Claes Oldenburg discussing the difficulty of getting domestic objects to 'read' properly as sculptures. He realised that the table would have to be enlarged, and that he would have to make the table in the same way that he had made the cubes: 'It was a very important development for me, making a plateau to put objects on, as a functional, recognisable object'.

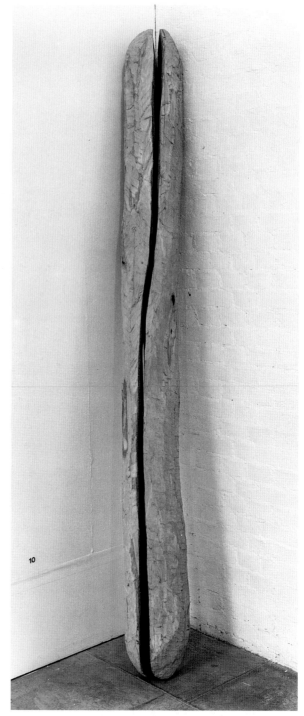

10

38

Table with Cubes (1971; Plate 1), more than five feet wide, is now in the collection of the National Museum of Wales, in Cardiff. Its massive form is accentuated by the rough, scarred surfaces of the heavy boards from which it is made, while the formal cubes resting on it are like solid echoes of the spaces seen beneath it and between its cross-bars and legs. At one level it can be read as a rather minimal sculpture, yet the table form carries with it, unmistakably and deliberately, all those connotations of domesticity, family and friendship – even religious faith – which spring to mind as soon as this humble object is

38 *Long Pod Split*, 1975, beech, 165 × 22.5 × 22.5 cm (66 × 9 × 9 in)

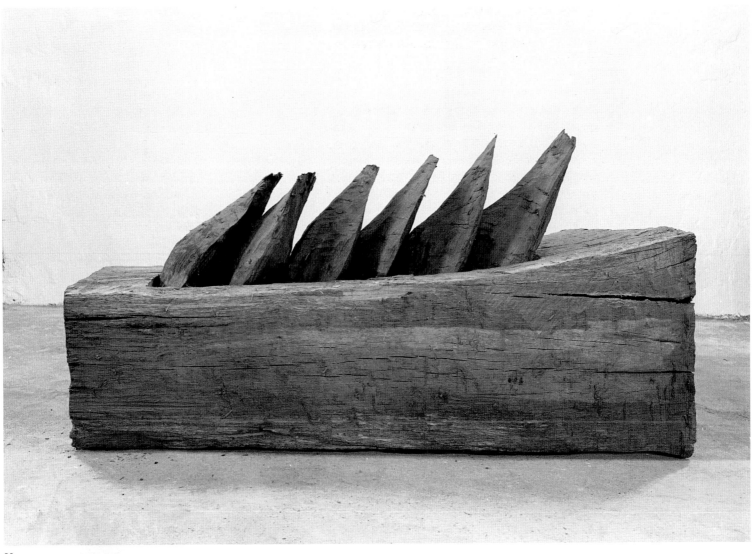

39

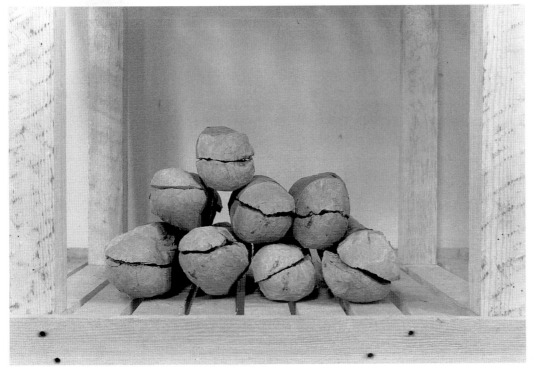

40

39 *Pods in a Trough*, 1975,
walnut and oak,
65 × 125 × 50 cm
(26 × 50 × 20 in)

40 *Stack of Pods*, 1974, beech,
40 × 65 × 60 cm
(16 × 26 × 24 in)

mentioned. In the small leaflet[7] he produced to accompany his first exhibition in 1973, in which he showed illustrations of all the works displayed, Nash has put the words THE MASSIVE CENTRE against his drawing of *Table with Cubes*.

There was also a more local, personal reason for Nash's interest in tables at this time. He had become friendly with the writer Richard Hughes who lived at Mor Edryn, an isolated house on the edge of the saltmarsh at the opening of the Glaslyn estuary. Hughes, who loved being surrounded by his large family of children and grandchildren, was well-known for his ability to get on with young people. He took an interest in this young sculptor who was so clearly trying to break out of the confines of an English middle-class background – something he recognised all too well from his own experience. He began inviting David to join him and his family at meals around the enormous sycamore table at Mor Edryn – the same piece he had described as 'a really noble kitchen table' when he bought it at Harlech in 1919.[8] Nash was impressed by this table and the sense of warmth and fellowship generated around it.

Thereafter tables recur in his work, and the table form is used as a kind of armature for very different kinds of sculpture – for example in *Corner Table* (1977) or *Branch Table* of the same year, where in each case he is exploring separate themes. But his next version came about as a result of one of those happily surreal chances Nash greatly enjoys and from which he draws inspiration. He had been doing some carpentry work at a local hotel when a quantity of wood was delivered. It turned out that through some mistake the planks had all been cut

to the wrong scale – far too large – and were therefore unusable for the job in hand. Nash moved them up to the chapel to build an enormous work, *Big Table*, almost nine feet long by seven-and-a-half across, to which he invited a number of friends for a meal. Sitting at this huge table created an 'Alice in Wonderland' effect, leading the adults to start behaving like six-year-old children!

In the Table (1973) is an attempt to explore two different themes within the same piece. The 'table' is actually a series of racks, allowing Nash to display objects not only on the upper surface but within the lower spaces. It relates closely to some of the tower structures with which he was still experimenting in the chapel, notably *Cellar, Room and Spire* (1973), and to *Stacked Table* (1974) into which he packed a group of his cracking pods with a number of stick bundles and other small pieces. These more complex tables (which he soon abandoned) had been in part inspired by a photograph in the *Evening Standard* at the time of the Tutankhamen exhibition, showing the interior of the ransacked tomb with tables piled high with objects, which were also stuffed into the spaces beneath the surface.

7. *Briefly Cooked Apples*, York 1973

8. Quoted in *Richard Hughes: Novelist* by Richard Poole, Poetry of Wales Press 1987, and by Richard Perceval Graves in *Richard Hughes*, Andre Deutsch 1994

41

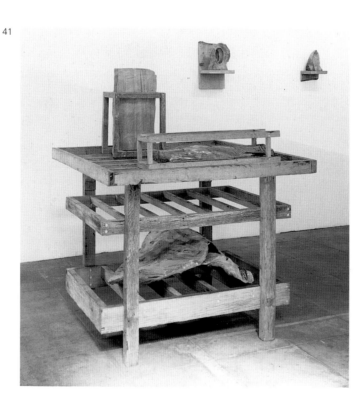

41 *In the Table*, 1973, oak, beech, pine and yew, 136 × 110.5 × 113 cm (53½ × 43½ × 44½ in)

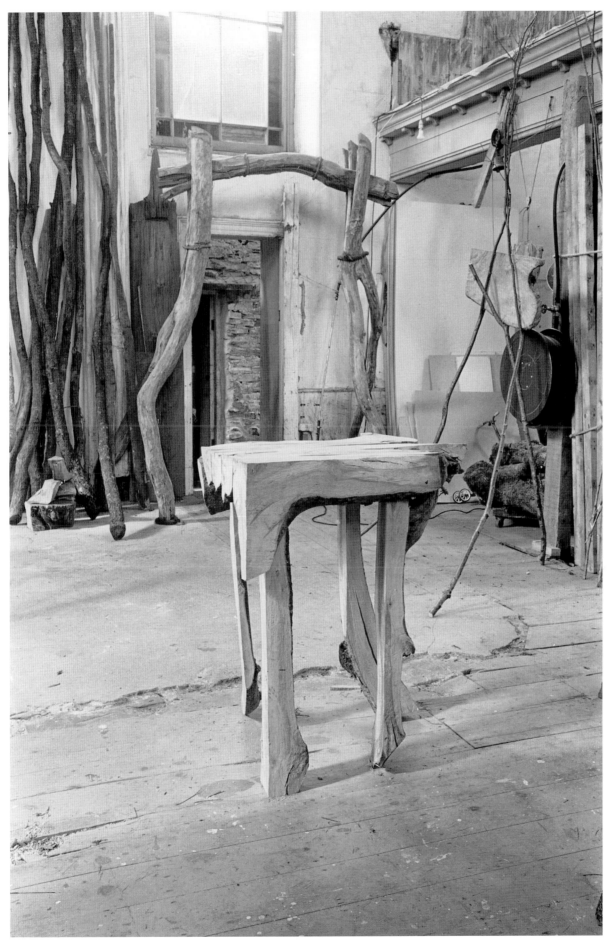

42

6

TOWARDS A LOOSER STRUCTURE

By the beginning of the 1970s Nash had become aware that a dichotomy was developing in his art. There were the constructed works, particularly the tower-like sculptures rooted still in the intellectual concerns that had preoccupied him at art college and in his first years in Wales; and there was the pull of the natural material, the form resulting from a basic physical process.

Eventually the pull of the natural material was to win out in his work, but at this stage he was wondering whether it would be possible to construct sculptures that would have the same rough, organic feel he had found so rewarding in his solid, carved pieces. The answer seemed to be to try and approach his constructions with more natural lengths of wood, taken from branches rather than boards and pre-cut joists, finding ways of fastening these together using the nature of the unseasoned wood instead of carpentry. He tried splitting open the branch ends, wedging them into each other, using rope. But first he needed to know what kinds of branch were best suited to such constructions. His familiarity with the

characteristics of natural woods had greatly increased as a result of opportunities he had been given to work out of doors, on a piece of land covered with debris from recently felled trees. This place was Cae'n-y-Coed (literally 'the place in the wood'), about four acres of rough woodland which belonged to his father, at the bottom of the Ffestiniog valley.

A beautiful place with a selection of beech, oak and ash trees many of which were already mature, the land also contained a number of birches which had been specially planted to lead the hardwoods. Birch, known to foresters as 'the mother of oak', is planted with oaks to encourage them to grow upwards towards the light, drawing up a straight trunk. In 1971 a local woodman persuaded Charles Nash that the time had come for the trees to be thinned. Sadly, in the event, all the mature trees were cut down and their trunks removed (whether by mistake or by design is not certain) and Charles Nash was shocked to find his lovely woodland devastated. A quantity of varied branches had been left lying around

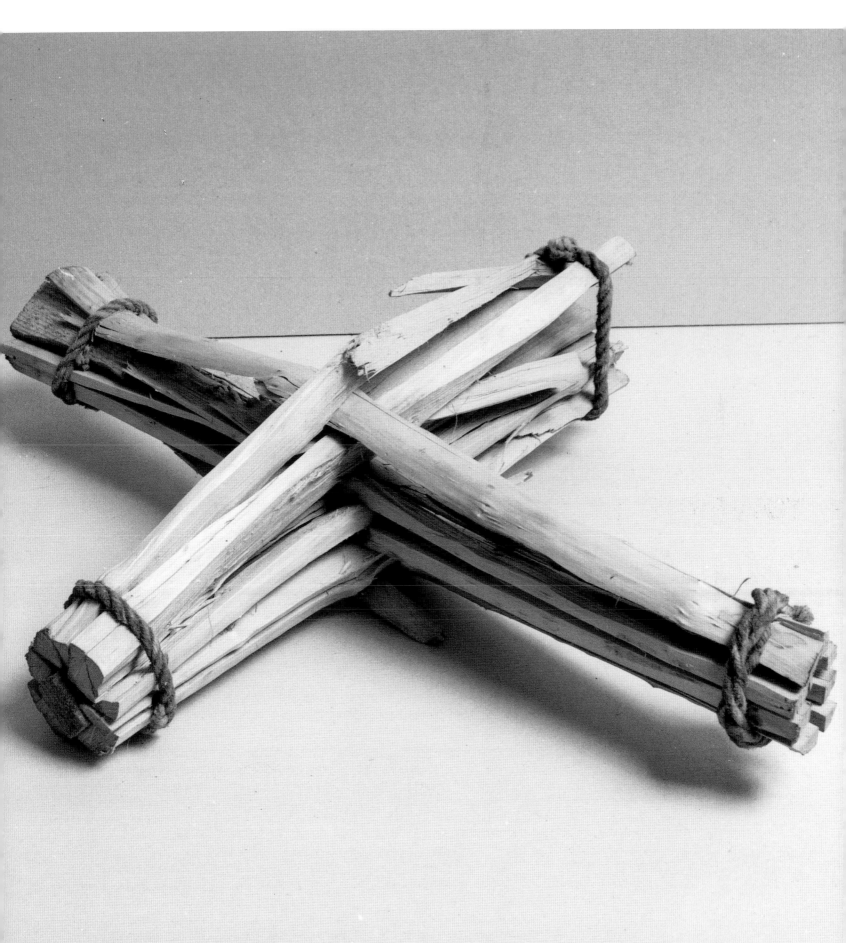

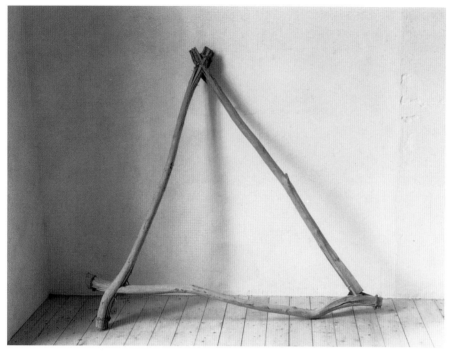

44

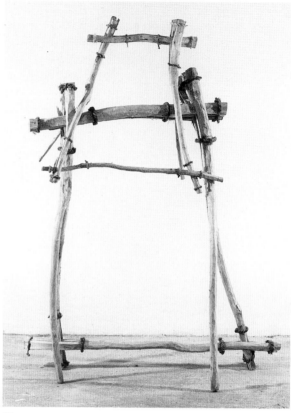

45

43 (overleaf) *Split Willow Cross*, 1971, willow and rope, 16 × 62.5 × 49 cm (6½ × 25 × 19½ in)

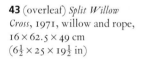

44 *Triangle*, 1971, willow, 147 × 157.5 × 23 cm (58 × 62 × 9 in)

45 *Split and Held Across*, 1971, willow and rope, 236 × 178 × 63.5 cm (94½ × 71 × 25½ in)

and David was allowed to remove as many of these as he wanted for his own work, as well as helping to clean up the mess and start replanting. This work, together with his earlier spell of labour for the Commercial Forestry Group, gave him more experience of the individual nature of specific trees and the qualities that would, or would not, make them suitable for sculpture. The process of re-planting linked him back to those generations of foresters who had planted the original oaks in this place in the eighteenth century, as preparation for what they expec-ted would be the requirements of the shipbuilding industry of the late twentieth century. Nash also found himself noticing the ways in which local farmers trimmed and fletched the hedges which grew along the stone walls, training, bending and weaving branches to form impenetrable, yet tidy barriers against the perpetually straying sheep. Gradually his own sense of identification, not simply with the land, but with the management and care of it, grew stronger as he came to recognise the re-silience of the local hill farmers and the steady survival of basic husbandry techniques across many generations.

The first looser, more organic construction that Nash made was *Split Willow Cross* (1971). It is composed of two short willow branches, the longer being just over two feet, split open for most of their length, spliced together to form the cross shape, and secured by small rings of rope that hold the ends together. It is a pleasing piece which, like so many of the works in this idiom which he was to produce in the following years, is a little more complex than it appears at first sight. It would have been

perfectly simple to split the branches from end to end, place them on top of each other alternately, and then bind the four bunches of ends, to gain almost the same effect. But by leaving one end of each willow intact, with the split coming to within an inch or two of the solid end, Nash gave the work far more tension. In *Triangle* (1971) the three willow elements have been left largely intact. Only the ends of each piece are split for a few inches and wedged into each other to hold the solid end of the next side, then secured tightly with twine. The work has a diameter of nearly five feet so the space created within the three sides is substantial. Yet it remains light, delicate-ly poised, held in balance by the tension of the bound extremities. It is interesting to note that the first two pieces Nash made in this way are simple geometric forms.

In *Split and Held Across* of the same year, Nash has succeeded in creating a much more ambitious work which is also one of his first self-supporting structures. Though totally abstract in its form it suggests the figure in its stance. The sculpture consists of two separate ele-ments, constructed in similar fashion, one approximately half the size of the other, with the smaller resting on the larger. Nash has formed each element from two long forked branches, placed with the fork downwards to create legs. One leg of each fork is split at the bottom to hold the split ends of a single horizontal branch, which forms the lower crossbar. Neat rings of rope secure these joins and ensure the splits do not extend any further. The top of each fork similarly secures another crossbar. Once again the daring simplicity of the piece, which approaches

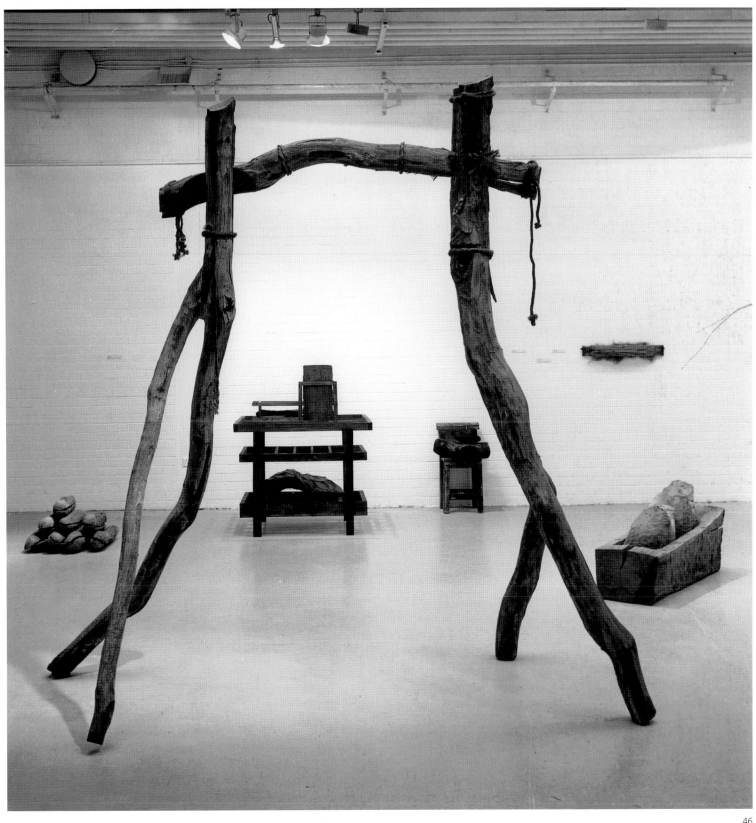

46 *Roped Arch*, 1972,
oak and rope,
270 × 255 × 107.5 cm
(108 × 102 × 43 in)

a demonstration of Pythagorean theory in three dimensions, conceals the subtlety of the construction. The utterly casual way in which the smaller element rests on the larger strengthens this illusion. The sculpture may also be read as a gentle parody of the 'Mother and Child' theme so beloved by Henry Moore.

The most substantial of the group of sculptures made in 1971/2 is *Roped Arch*, nine feet high, which has been much illustrated and exhibited and which Nash has retained for his own collection at Capel Rhiw. This was one of the first really large works that he made out of doors at Cae'n-y-Coed. A simpler version of *Split and Held Across*, it consists of two massive forked branches supporting a horizontal crossbeam which, like the tops of the uprights, has split ends, the joins, once more, being neatly secured by tight rings of rope. There is an anthropomorphic quality about its stance, the left-hand pair of 'legs' lazily crossed, while the right-hand ones appear to be making more of an effort to support the crossbeam. This odd, slightly quirky, life-like quality imbues a great many of the sculptures Nash made during the 1970s. Here, at virtually its first appearance, this touch of humour works superbly in a sculpture which manages to appear simultaneously monumental, yet informal.

Before moving on to examine a related group of roped works, the *Tripods*, a few words should be said about David Nash's use of rope. While he naturally made use of cords and ropes to tie up bundles of branches, he was prompted to use rope rings to secure his sculptures by his friend, the writer, Richard Hughes. Hughes and his wife Frances were regular visitors to the chapel. Seeing lengths of rope lying around the studio, Hughes, an experienced sailor, decided to show Nash how he could make use of them. He taught David how to make a circular quoit out of a short length of rope, by unravelling its strands and then re-plaiting them to make an even ring with no protruding lump or knot. Nash, realising that he could make such ties of rope as small or as large as he liked, began to use them extensively on his arch and tripod pieces at this period. In addition to the tidy finish they give his sculptures (see *Roped Arch*, 1972), they also provide strength and flexibility in self-supporting structures, acting like tendons or muscles, while the uprights and cross-pieces are the bones. One sees this in the numerous tripod pieces: in *Roped Bundle Tripod 1* (1972) three large oak branches, each with a marked curve like a knee, come naturally together at the top, where they are bound, together with a dozen separate lengths of smaller branch, with three separate circles of rope. They form a shape like a traditional faggot or bundle, giving an effect of great strength.

In *Roped Tripod* (1975), a more delicate piece, the tops of the three branches are held by two lengths of finer cord that have been bound round as many as ten times before having the ends plaited. These two sculptures again present a contrast, the masculinity of the oak against the more feminine curves of the birch, the dark

47 *Roped Bundle Tripod*, 1972, oak and rope, 255 × 180 × 180 cm (102 × 72 × 72 in)

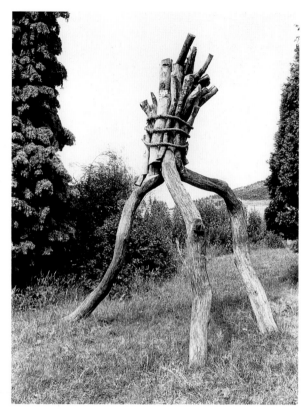

47

lengths of rope on the latter piece looking almost like silk scarves or accessories on a fashion model. In *Chestnut (Pegged) Tripod* of the following year, however, Nash has abandoned rope and has deliberately accented the rough finish of his three split lengths of chestnut by the use of heavy wooden dowel pegs of the kind one would expect to find in a primitive farm cart. In making these works Nash got great satisfaction from the fact that the structure, and the way it supports itself, are entirely obvious and visible to the viewer. He also learned another lesson: that a piece like *Roped Bundle Tripod*, originally made out of doors at Cae'n-y-Coed, can take on a scale of its own and appear to grow markedly in size when brought into an indoor space. This sculpture had been intended for his first exhibition, *Briefly Cooked Apples* at York in 1973, but proved too large for the gallery. When the show moved to Bangor, however, it was included and looked extremely powerful.

Three Dandy Scuttlers (1976) can be considered alongside the *Tripods*, although two of its three elements stand on four feet rather than three. It consists of three separate elements, each of which contains two forked branches, placed upside down, held together by solid squared-off wooden blocks. The blocks hold the forked branches together while, at the same time, the 'feet' of the forked branches hold the blocks up. The effect of three running, or rather scuttling figures, is emphasised by the title of the work. This, probably the most anthropomorphic work Nash has produced, and *Running Table* of 1978, have been among the most widely repro-

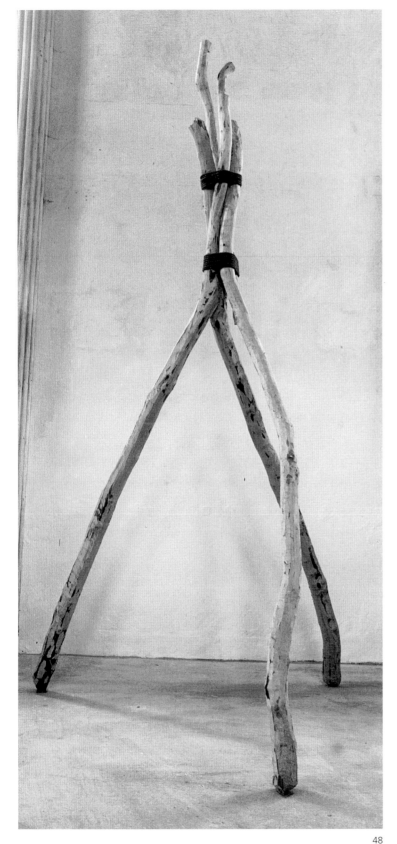

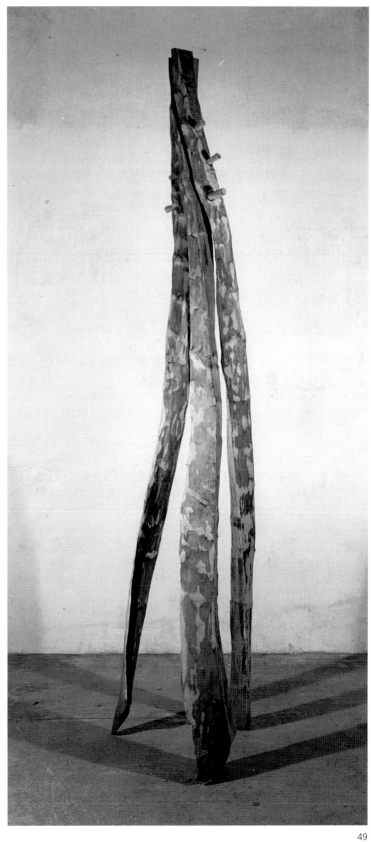

48

49

48 *Roped Tripod*, 1975,
birch and rope,
390 × 200 × 225 cm
(156 × 80 × 90 in)

49 *Chestnut (Pegged) Tripod*,
1976, chestnut,
470 × 180 × 90 cm
(188 × 72 × 36 in)

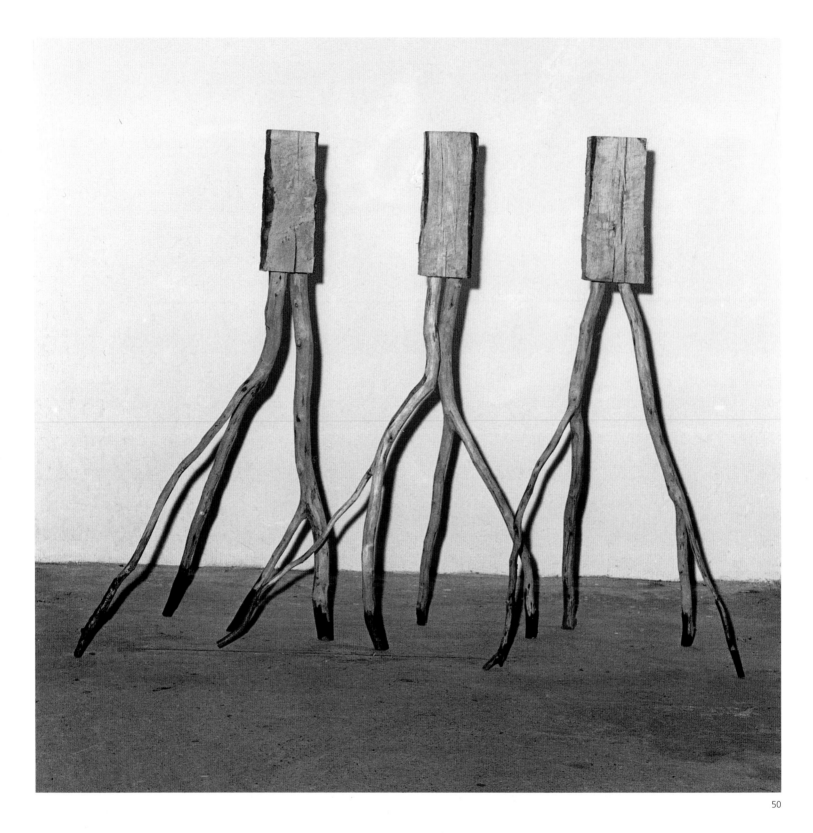

50 *Three Dandy Scuttlers (The Chorus Line)*, 1976, oak and beech, 157 × 240 × 75 cm (63 × 96 × 30 in)

duced of his sculptures, leading to Nash becoming identified, in the eyes of some critics, exclusively with this type of work.

Within the concept of the tripod is a group of works which were produced in sequence - a series of sculptures in which Nash seems to be drawing in the air with very fine branches. In fact these works were inspired by a book containing photographs of Edwardian gentlemen

in plus-fours and deerstalker hats, posed on Scottish moorland, contorting themselves into strange sculptural poses, as they settled with their rifles into the heather to await the arrival of a stag. In 1977 Nash produced a series of pieces with their titles taken from the captions to these photographs: *Over the Brow*, *A Taint in the Wind*, *An Awkward Stalk*, *Off the Knee* and *Point Blank*. In the first work, in addition to fine hazel branches, Nash used a

48 TOWARDS A LOOSER STRUCTURE

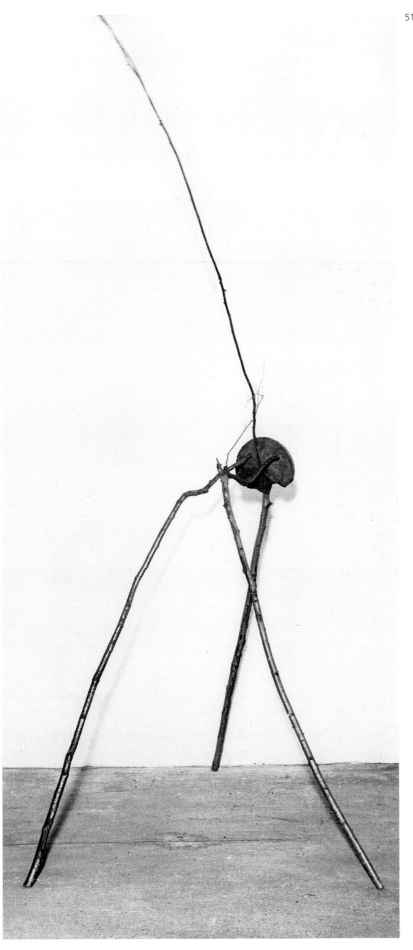

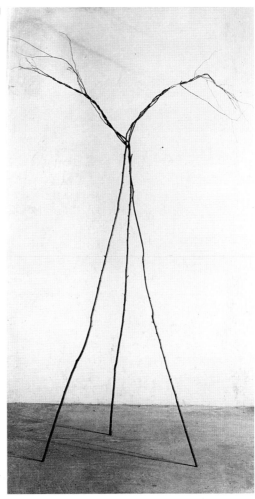

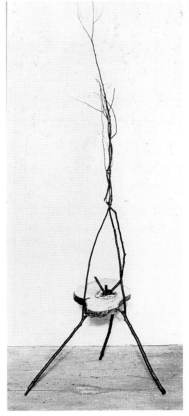

53

51 *Over the Brow*, 1977, hazel and slate, 300 × 250 × 125 cm (120 × 100 × 50 in)

52 *A Taint in the Wind*, 1977, hazel, 270 × 120 × 120 cm (108 × 48 × 48 in)

53 *An Awkward Stalk*, 1977, oak and hazel, 220 × 75 × 75 cm (110 × 30 × 30 in)

piece of slate to hold the branches together, which also, through its weight, ensured that the piece stood firmly and independently. The origin of these works should not distract one from Nash's main concern: for the fine lines of his hazels to capture, enclose and 'hold' space in the manner that David Smith and Anthony Caro had been doing with steel bars and girders.

Illustrations 54, 55 and 57, 58 show a few examples of the small experimental works Nash was making during 1972. In cleaning up the remains of the felled trees at Cae'n-y-Coed, when he moved many branches to the chapel, he also found himself collecting bundles of sticks. Enjoying the shape and feel of these bundles he began thinking of different ways of holding them together, as small sculptures. *Lead-wrapped Sticks* shows one attempt, but he found it more interesting to revert to the box-like structure he had used the previous year to enclose the two 'bonks': *Red Box Bundle* is a good example of this. *Spoon and Sticks Bundle 2* is one of several experiments in which ordinary domestic utensils (also found at Cae'n-y-Coed) were incorporated into bundles of sticks which were then tightly bound with different types and colours of string. At this time Nash was trying, very deliberately, to reverse his experience at Chelsea, of controlling and dominating his materials, and was instead trying – in his words – 'to respond to what came at me'. The several *Bound Rope* pieces he made are really minimalist works in that he is using the material to comment on itself, enjoying the contrast of red or black string bound round a golden length of natural rope.

These pieces have never been exhibited, with the exception of *Loosely Held Grain* (1975), a gentle and beautifully considered piece which was used as the cover illustration for the leaflet to accompany his exhibition at Arnolfini Gallery, Bristol, in 1976. Willow branches, cut into almost equal lengths of about sixteen inches, have their ends finely split, almost like bunches of reeds. The curved centres of the lengths seem to invite the hand to pick them up, making the title of the work very evocative, since the pieces are evidently not being held in the photograph but are simply resting on the ground. Nash's use of quirky language in the titles of his works, particularly his fondness for humorous or slightly surreal double-meanings, became more marked at this time. In *Loosely Held Grain* a looser approach to sculpture, and an acceptance of found forms and materials, is becoming a dominant concern in Nash's work. Interestingly, the gentle curves of these willow branches also have a specifically local reference. They were inspired by the sagging roof of an old barn that Nash often passed on the road between Blaenau and Betws-y-Coed. He enjoyed the paradox that the elegant curve of its roof was made of a number of elements, all of which were square, the split ends of his willow resembling the fragmented ends of the straining joists and rafters of the building. This observation also inspired his *Extended Cube* (1986). His most abstract shapes are often influenced by forms in the Merioneth landscape.

54 *Red Box Bundle*, 1972, birch twigs in stained beech box frame, 12.5 × 50 × 15 cm (5 × 20 × 6 in)

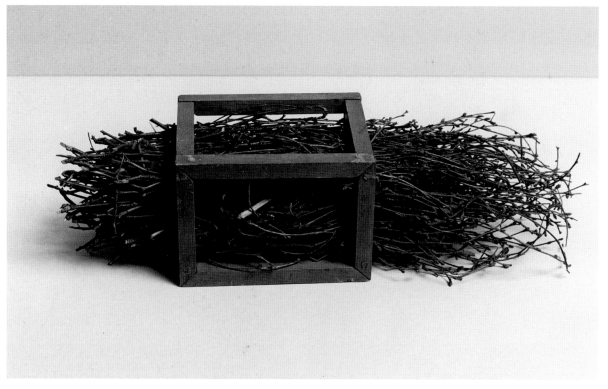

54

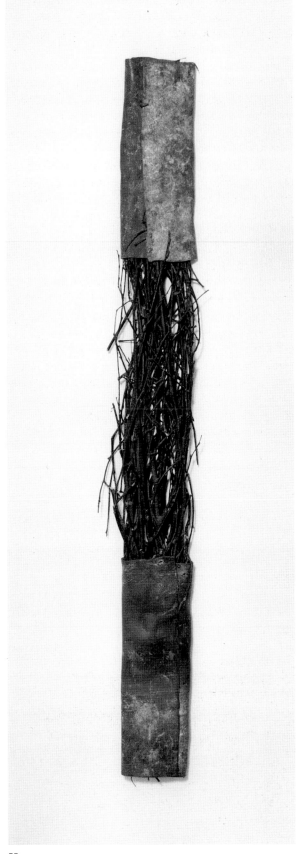

55

56

57

58

55 *Lead-wrapped Sticks*, 1972,
birch twigs and lead,
5 × 75 × 7.5 cm (2 × 30 × 3 in)

56 *Loosely Held Grain*, 1975,
willow, 40 × 90 × 50 cm
(16 × 36 × 20 in)

57 *Spoon and Sticks Bundle 2*,
1972, pierced ladle, sticks and
string, 7 × 35 × 9 cm
(3 × 14 × 3½ in)

58 *Bound Rope 3*, 1972, rope,
wool, cotton and plastic
string, 9 × 9 × 31 cm
(3½ × 3½ × 12½ in)

7

BETWEEN FIGURE AND FORM

59

Following on from the pieces made with fine branches of
hazel Nash made a series of sculptures in which he com-
bined the 'drawing in air' effect with a geometric form:
Ash Branch Cube (1979) is a good example. He has taken
sections of branch of similar length and diameter and
squared two sides, leaving long forking shoots coming
off them. These have then been joined to make a simple
open cube which, naturally, encases its own formal space.
However, the long branched shoots opening out from the
formal shape create their own wider area of space around
the sculpture. The effect of the white, cut lengths
contrasting with the natural branches creates an illusion,
making it difficult at first for the viewer to 'read' the work.
Nash makes use of this device – the contrast between a
natural form and a constructed one – in a number of
sculptures some of which, like *Branch Table* (1977) and
Ash Stick Chair (1979) are deliberately ambiguous: in the
former a waving branch rises from one leg of a table as
though indicating its origin as a tree, while in the latter
the mass of forking twigs branching out from the con-

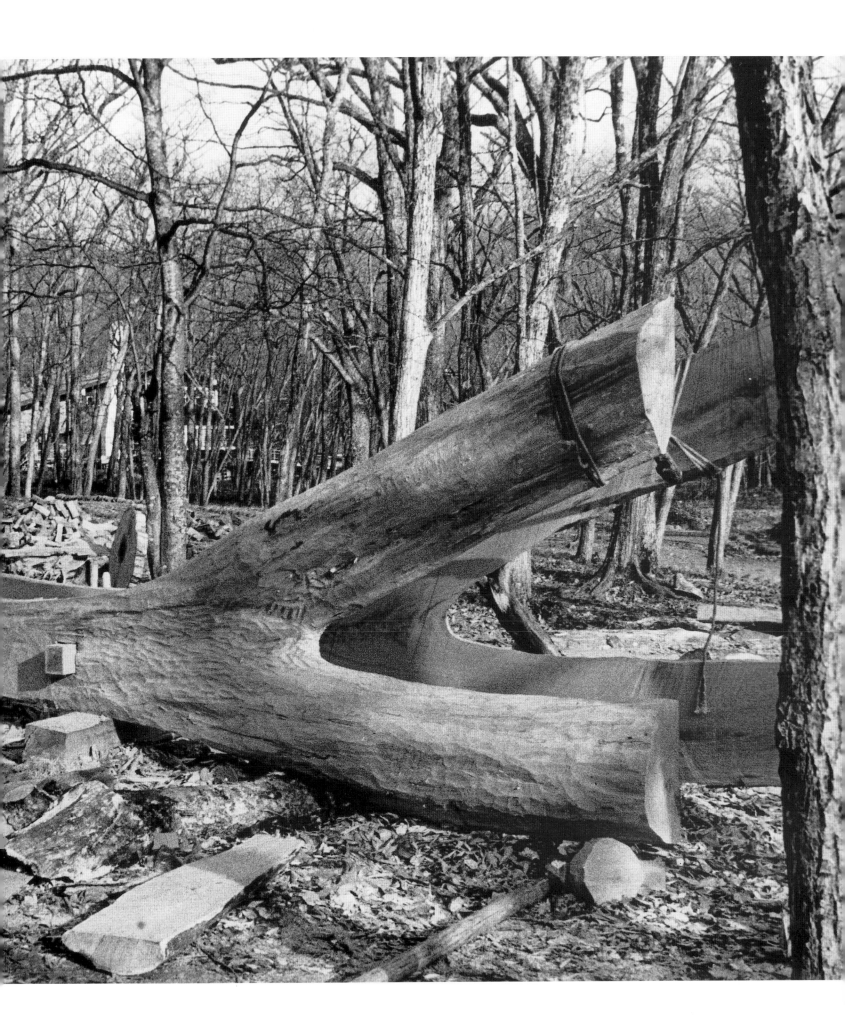

structed elements actually support the chair shape. It is a chair which cannot be sat on, in fact, and in its construction it uses the practice of pegging sections of wood into others, in this case to make the stretchers and back-rests of the chair, which Nash developed in a series of *Ladder* sculptures.

The idea of framing was something he found most satisfying, since it enabled him to make a direct visual pun between the natural shape of the branch and the formality of the constructed frame. In *Branch Frame* (1977) he is making a different kind of visual pun, since the top, formal part of the work is a real frame, enclosing a drawing of the tree from which the piece appears to be made.

The intellectual satisfaction he gained from the construction of these frame pieces led Nash to start making them on a large scale. The size of the branches used for these sculptures meant that he had to make them in the open air. *Flying Frame* (1980) which is over seven feet high, was originally made at Cae'n-y-Coed, while *Standing Frame* (1984), slightly taller again, was made at Upper Nikko in Japan. Both these pieces were, however, made specifically for indoor display, in museum spaces where their size would be more dramatic. Over the following fifteen years Nash would return to the frame shape from time to time with works such as *Small Standing Frame* (1985), a minimal piece, *Square and Branch* (1986), in which the ragged branch sections contrast with the solid square centre (made by cutting out a section of trunk from a large oak tree), and most recently with *Cut Corners Frames 1 and 2* (1995). In these he has returned to the device of accentuating the edges of his sculpture, making them look as though they were drawn with charcoal, as they reveal dark space within. It is a similar technique to that used in his *Table with Cubes* (1971). Behind all these works, still, lies that concern with geometry and formal relationships stemming from the grounding in this subject that he was given at school.

A complex work made at this time which also incorporates the frame motif was *Elephant Passing the Window* (1977). The origin of the piece came from drawings Nash had made of elephants at the London Zoo, combined with the child's drawing game in which one person has to guess what an object is from a fragmentary detail of it drawn by another. In this sculpture a piece of slate represents the brow of the elephant (it was simply a waste piece Nash had picked up, in which he 'saw' the animal), and its positioning between baulks of old timber gives the impression that it is just passing behind a window-frame. One long protruding branch, which could read as the elephant's trunk, serves to support the piece, while the structural elements of the frame are all extended beyond the framed image.

One of the most anthropomorphic sculptures made in this period was the *Running Table* (1971) of which several versions exist. Basically it is an extremely simple

59 (overleaf) Work-site,
Kotoku, Japan, 1984

60

60 *Branch Frame*, 1977,
hawthorn and drawing,
90 × 45 × 4 cm
(36 × 18 × 1½ in)

61 *Ash Branch Cube*, 1979,
ash, 249 × 152 × 96.5 cm
(98 × 60 × 38 in)

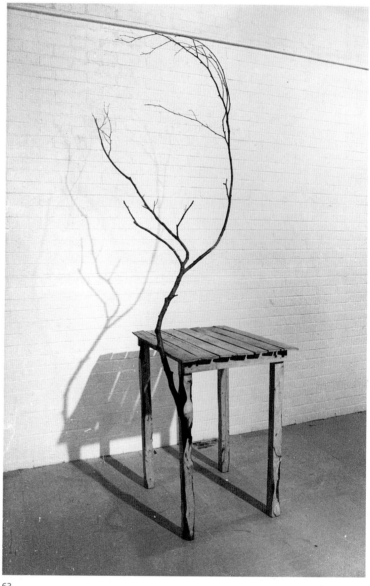

62

63

62 *Ash Stick Chair*, 1979, ash, 116 × 99 × 79 cm (45½ × 39 × 31 in)

63 *Branch Table*, 1977, beech, 227 × 100 × 77.5 cm (89½ × 39½ × 30½ in)

piece, made in the same way as the frames, even using the same number of elements. However, they are joined together in a different way: another neat geometric solution resulting in an elegant minimal sculpture. By positioning the sections in an alternate configuration, so that the four protruding branches work against each other, an effect of legs in motion appears: the sculpture seems to be speeding away like an animal in flight. The first version of the *Running Table* was made for Grizedale Forest (the first piece of sculpture to be made there). Its

liveliness has led some critics to look on it, and other works in the same vein, as simply an example of whimsy, without seeing the geometric simplicity concealed within the form. Nash enjoys teasing, sometimes deliberately blurring the boundaries between what is a formal sculpture and what is a fun object: *A Useful Pig* (1982), comfortably solid in its simplicity, is a case in point where the title, once again, stresses the animate aspect. In making these works Nash was well aware he was taking a risk, in making art with a narrative element that went

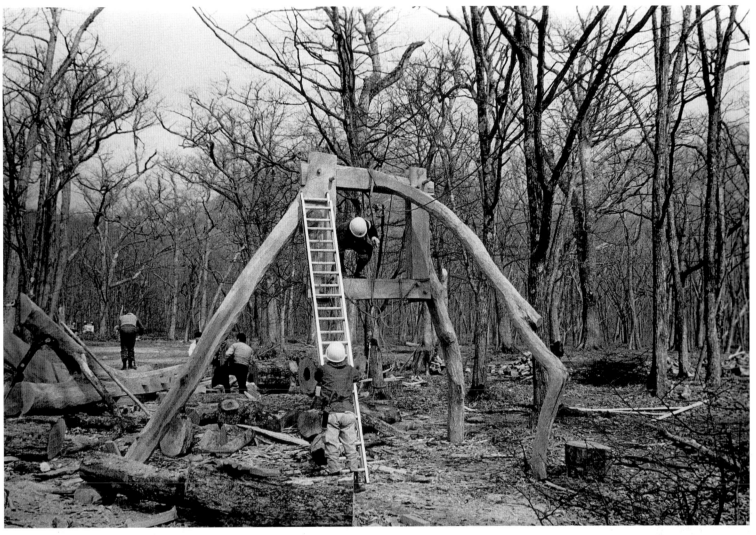

64

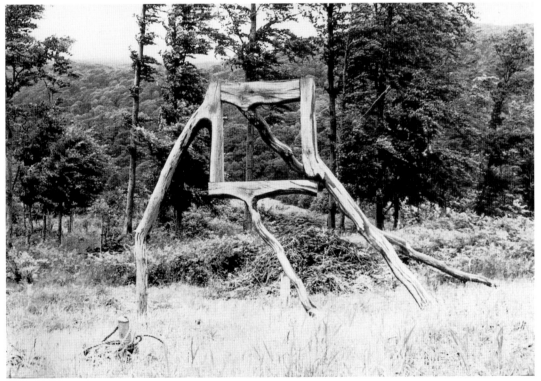

65

64 *Standing Frame* in progress, 1984, oak, 375 × 350 × 240 cm (150 × 140 × 96 in)

65 *Flying Frame*, 1980, oak and steel, 216 × 343 × 120 cm (86½ × 137 × 48 in)

BETWEEN FIGURE AND FORM **57**

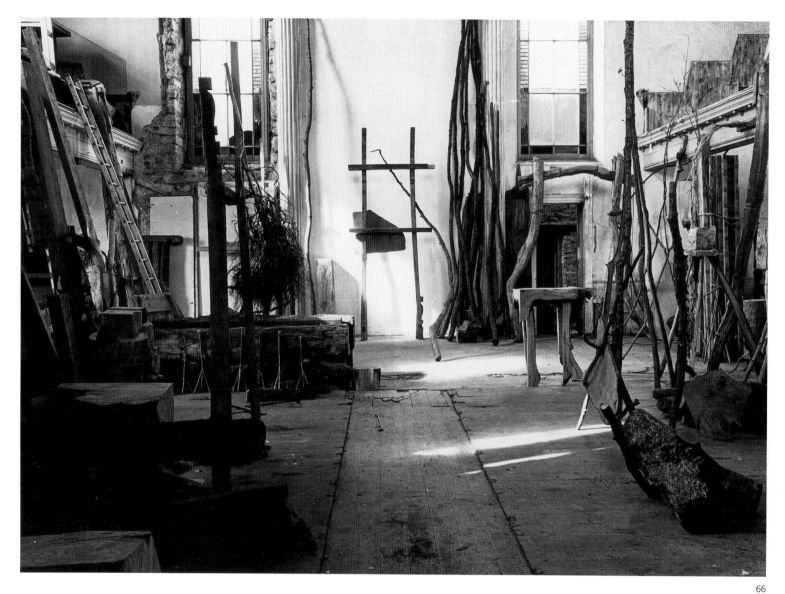

66 *Elephant Passing the Window*
at Capel Rhiw

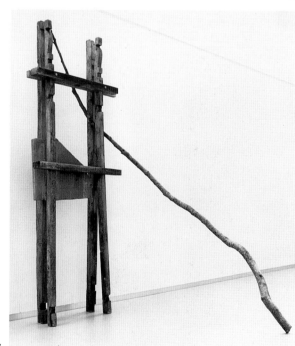

67 *Elephant Passing the
Window*, 1977, wood and
slate, 321 × 234.5 × 172.5 cm
(126½ × 94 × 69 in)

67

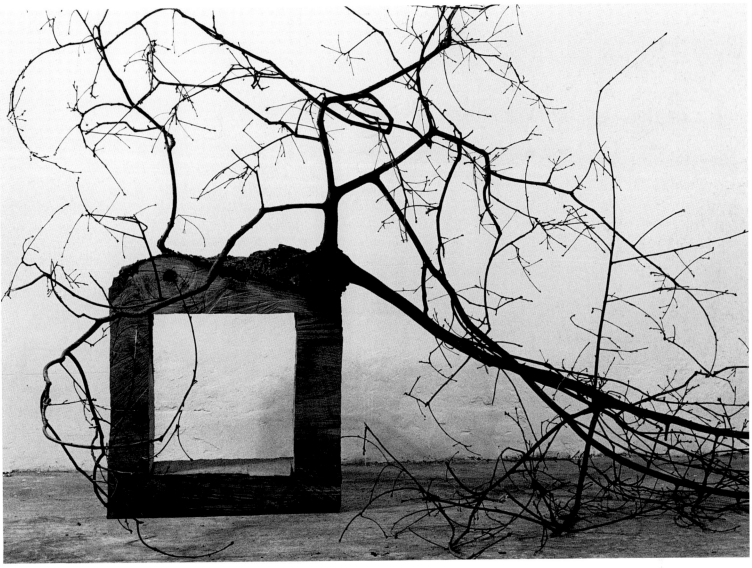

68

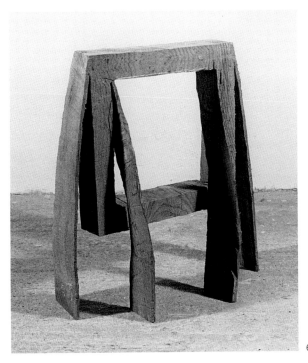

69

68 *Square and Branch*, 1986,
oak, 250 × 250 × 60 cm
(100 × 100 × 24 in)

69 *Small Standing Frame*, 1985,
elm, 60 × 56 × 28 cm
(24 × 20 × 8 in)

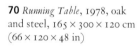

70 *Running Table*, 1978, oak and steel, 165 × 300 × 120 cm (66 × 120 × 48 in)

against the tide of fashion. From the detachment of his position in Wales he was aware of the London art world, and of the dogmatic attitudes adopted in some quarters by artists and their supporters who claimed that this or that was not acceptable in sculpture. It was typical of Nash that he set out to challenge this orthodoxy – though it must be stressed again that these works represent only one aspect of the art he has produced.

For some of the frames and anthropomorphic works Nash adopted the technique of splitting a branch or trunk open, right along its length, by careful use of wedges. Splitting a section of wood in half produced the interesting effect of duplicating a unique shape that had grown by chance. It was then converted into something symmetrical and formal. In one case, taking a forked branch and splitting it, he placed one half of the Y against the wall and laid the other half down on the floor, as a 'shadow' of the first. The duplication enabled him to create pairs of elements which were mirror images of each other and which could then be joined up again to create a paradoxical effect, as with the *Running Table*, and particularly with the series of *Ladders* he began making in 1978. *Branch Ladder* is made from a long fork

of ash, split in half, the halves held together by wooden 'rungs' made from a branch of the same tree. Several long twigs have been left on the branch sections to define a wider area of space around the ladder form. The splitting technique could also be used on much more substantial pieces of timber: in *Stack of Ladders* (1982) Nash has carefully positioned his wedges so as to open up three large sections of sweet chestnut branch. The process leaves the rough inner surfaces of the sections visible, complementing the exteriors where the bark has been removed: 'There's this wonderful moment when you open it up – and a symmetry appears. This seemingly disordered bit of wood, which could be anything, becomes extremely specific because it's duplicated.'

71

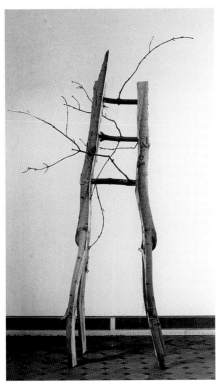

72

73

71 *A Useful Pig*, 1982, beech,
66.5 × 34 × 88.5 cm
($26\frac{1}{2} × 13\frac{1}{2} × 34\frac{1}{2}$ in)

72 *Branch Ladder*, 1978, ash,
246 × 112 × 61 cm
(97 × 44 × 24 in)

73 *Stack of Ladders*, 1982,
sweet chestnut,
3 elements: overall size
102 × 53 × 206 cm
(40 × 21 × 81 in)

THE MINIMAL TOUCH

Nash was given his first solo exhibition as part of the 1973 York Festival, and was offered a relatively small room at St Williams College, near the Minster. The show ran from 15 June to 8 July and included fifteen sculptures, plus a number of the tiny studies and experimental carvings he had made, including several of the *Cosmic Geese* (1971). Later the show moved to Bangor, North Wales, a larger space, where it proved possible to add some more substantial works including *Roped Bundle Tripod* (1972). The exhibition concentrated on the chunky, carved, sculptures he was finding more and more absorbing, though one early constructed work was included. The small leaflet he produced to accompany the exhibition included not only drawings of all the pieces in it but also a biographical note about himself, a long statement about the physical/mental state he is in while working, and a number of small quotes and aphorisms about the individual pieces, the tools he uses and the work process. The title of the show and the leaflet came from a surreal displacement: he had misread a greengrocer's sign for Bramley Cooking Apples

as 'Briefly Cooked Apples', the latter phrase perfectly expressing the philosophy of keeping his own intervention in the works to a minimum: 'The best apples are those that have been only briefly cooked, so they preserve their crispness and freshness. Similarly a sculpture should be crisp and fresh, showing the mark of the tool that has just left it.' Some of the messages read like injunctions to himself: 'do not sharpen the edge too keenly', 'the mark of the cut is the mark of the tool'. They are similar in tone to notes that the visionary artist Samuel Palmer put into his 1824 sketchbook as reminders to himself. Nash had never seen this but it seems that, like Palmer, he was working in a state of heightened sensibility at this time.

Nash had married Claire Langdown in 1972 and they were expecting their first child in the autumn of 1973, not long after that first exhibition. Very different from the awkward and diffident student who had arrived in Wales some six years earlier, the statement he now put into the York leaflet gives a clear and direct sense of an artist at peace with himself, confident in what he is doing:

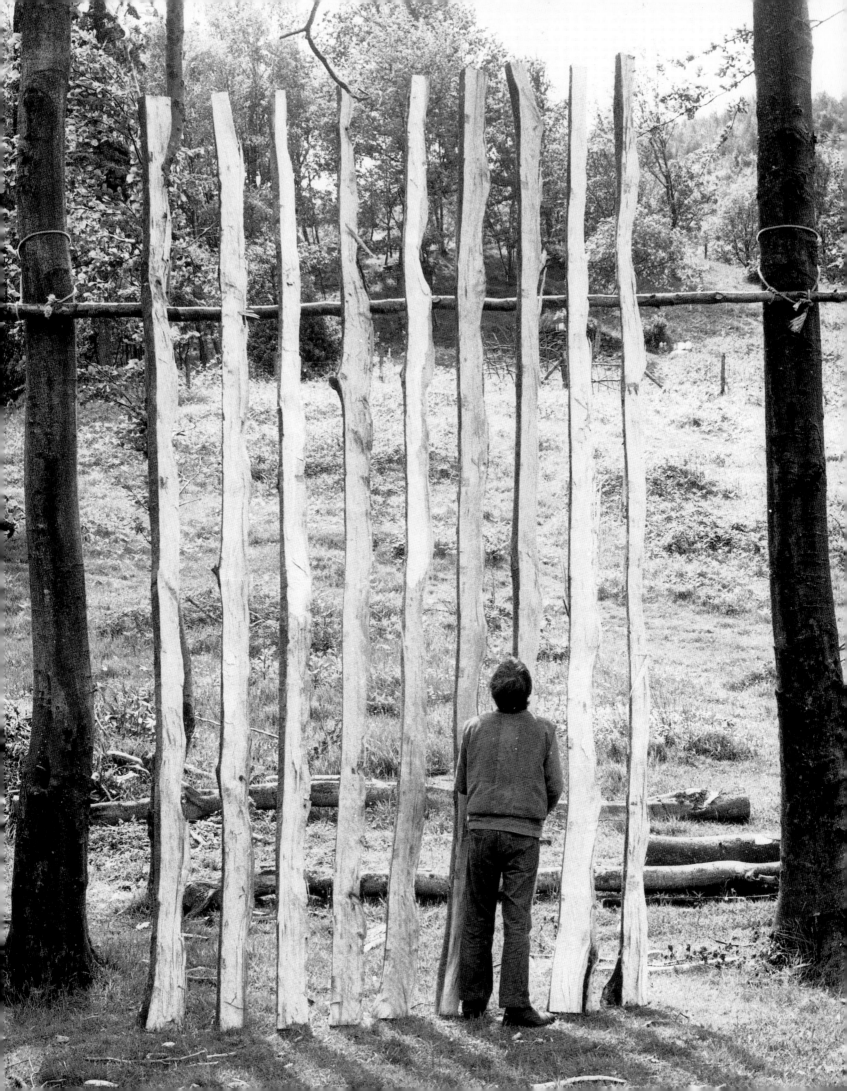

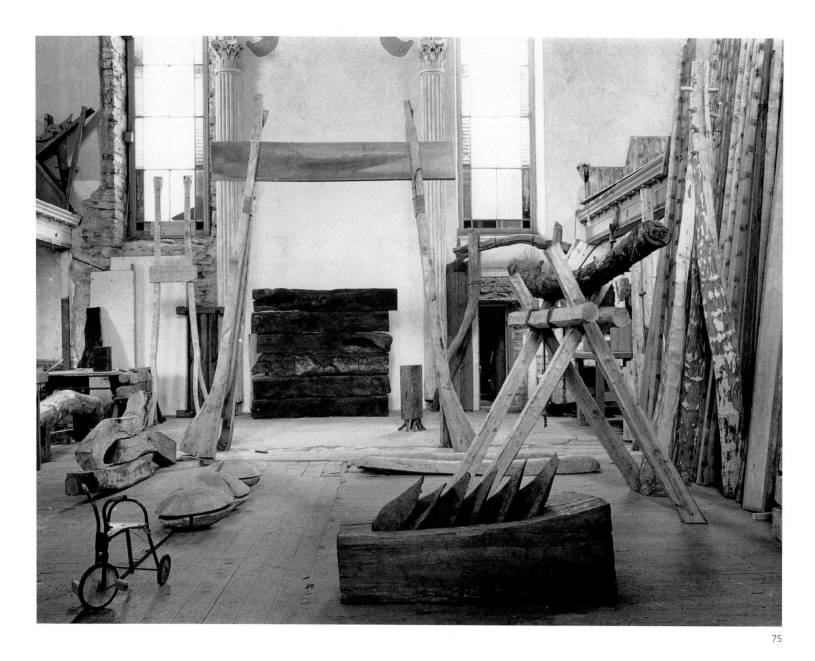

75

74 (overleaf) *Nine Split Leaners*, 1976, beech, 450 × 240 × 30 cm (180 × 96 × 12 in)

'Taking it early in the morning. The sound of the axe bangs back off the hill from across the valley. Keep the thought to the elements of the action – the blade, its edge, the length of the handle, and the height of the toss up and pull down, – work round, this side, step over that side. The white chips fly all around settling in the grass in a circle. Always keeping the wood between the blow and the ankle. Shave the angle of strike across the grain, not straight down. First cleave in and lift the grain, THEN, straight down on top of where it still holds and off it flies into the radius of white chips. The sound bangs back off the hill from across the valley. The rhythm of the effort develops into a steadiness of pace and time. Other thoughts happen in; thoughts back, thoughts forward, but the pace is of the time now.'

In the mid-1970s this interest in reducing the signs of human intervention on his sculptures led Nash to produce a number of works in a distinctly minimalist vein. Having

75 Capel Rhiw interior, 1976

found out what happened when he carved round segments out of a trunk of wood, cutting across the grain to separate his sections, he now tried working along the grain, producing bigger, longer elements similar to the heavy beams used for the construction of early houses. The process of cutting up felled trees at Cae'n-y-Coed led naturally to him squaring up the lengths by cutting off the rounded sides of each piece; it was then equally natural for him to stack these up when he got them back to the chapel. No close-up photograph survives of the largest work in this series, *Big Stack* (1976), but it is visible against the back wall in a photograph of the chapel interior also showing *Up, Flop and Jiggle* (1975) on the floor, left centre, with *Three Clams* and *Pods in a Trough* in the foreground. *Big Stack* was a solid, elemental piece (subsequently recycled into another work) which has clear echoes of the rigid, formal shapes explored by sculptors such as Donald Judd and Sol Lewitt. Nash was interested

64 THE MINIMAL TOUCH

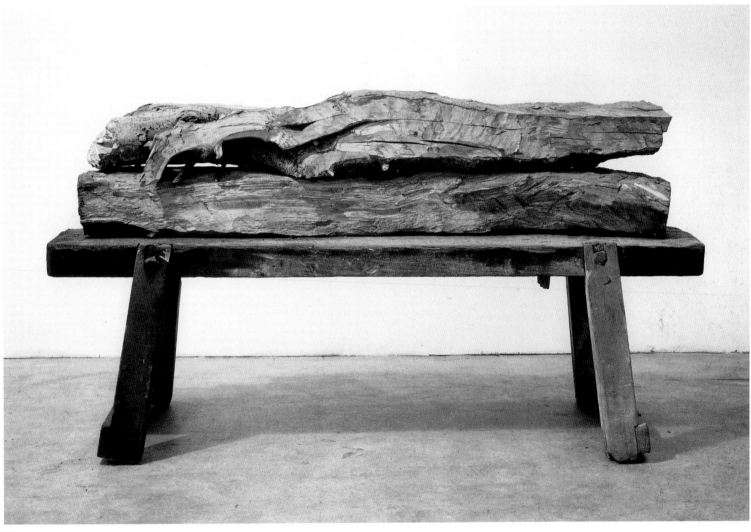

76

76 *Two Squared Lengths on a Bench*, 1975, holly and oak on pine, 77.5 × 145 × 120 cm, (30½ × 57 × 48 in)

in the work of these artists, but was out of sympathy with the highly complex technological processes used to produce their sculptures. In his experiments with these heavy baulks of timber he was attempting an economy of form through a physical process that was itself minimal, once again leaving a roughened surface on his simple blocks while slightly tapering the ends of the elements to stress the point where they finished. This is seen clearly in *Two Squared Lengths on a Bench* (1975) and *Up, Flop and Jiggle* of the same year. This last piece, which he subtitled *Three movements through the horizontal*, shows Nash following the natural form of the wood, as he had done with the vertical elements of his *Tripod* pieces, but squaring the sections at the same time. He has followed the grain of the wood, where the trunk of the original tree curved, but has placed the three elements – one rising, one falling and one in a kind of S-shape – in such a way that they are interdependent, holding each other up

in a pattern of balance that seems partly illusion. He had in fact made a fourth section for this work but decided not to use it, finding the relationship of three was sufficient. Placing the last piece against the wall to get it out of the way he realised it made a complete sculpture in its own right: *Wall Leaner* (1976) is probably the most minimal of all his works, yet retains a comfortable chunkiness, far removed from the smooth finish of a Donald Judd cube, for example.

The principle of placing certain parts of a sculpture so that they become complete only by their contiguity to something else, such as a wall or a horizontal bar, was explored in a number of other 'leaner' pieces at this time. *Nine Split Leaners* (1976) is an example. A significant piece in the series was *Four Split Lengths: Time Passing* (1976-8), in which Nash split a six-foot length of fresh beech into four pieces, leaving them out of doors to weather, so that they gradually began to change colour. At intervals of six months he brought one of the lengths indoors and then, after two years, with the process complete, he placed the four lengths vertically, resting against a simple horizontal bar with wooden pegs like a rack to hold pitchforks. The process of weathering of the four lengths, arranged in this minimal form, was quite clear. Once again the element of time has been brought into a sculpture.

The best-known work that emerged from this minimal approach was the one he made by recycling the six enormous beams of *Big Stack*, originally from a ruined barn. From these he eventually made *Ancient Table* (1983; Plate 5). The sculpture combines minimal touch by the artist with basic economy of form, resulting in a work of great strength. It links sculptural concerns to that fundamental sense of a table being 'the massive centre' of family and social life. *Ancient Table*, which also resembles an ancient Welsh cromlech or burial chamber (there are several in the vicinity), is perhaps the most Brancusi-like of Nash's sculptures. Certainly its massive timbers would fit easily into the atmosphere of the reconstituted Brancusi studio in Paris that Nash so much admires. Another parallel is with the sculpture of Carl Andre, whose *Philemon* of 1981 and *Luxor* of 1989, for example, also make use of heavy beams of wood with unpolished surfaces, giving an effect of simple, elemental strength.

In this period of working outdoors with huge timbers, moving as well as cutting them, Nash had become interested in the processes used by house-builders in Elizabethan times, who often made the structural framework of their buildings in, as it were, kit form, using green timber. These framework structures could then be moved to the village or town where the finished house was to be constructed, at which point the spaces could be filled with mud and lengths of wattle. As the timbers dried out and shrank the builders could remove the mud and wattle – possibly as long as fifteen years after the original process – replacing it with brick. As he squared up his own timbers, enjoying the sense of volume these large sections gave him, Nash thought of that early building process which had all been carried out in the forest, precisely as he himself was working now. The element of time which had affected the structural timbers would also affect his own works as the volume of wood gradually dried out, becoming lighter, leading to changes. The way in which such changes could be controlled and directed would become increasingly important in the sculptures he would produce during the 1980s.

77 *Up, Flop and Jiggle*, 1975, oak, 74 × 206 × 20.5 cm (29 × 81 × 8 in)

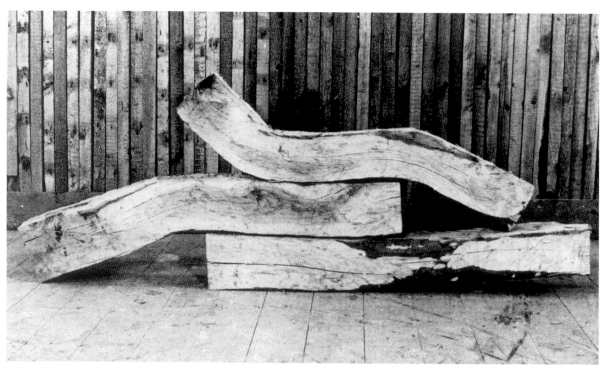

77

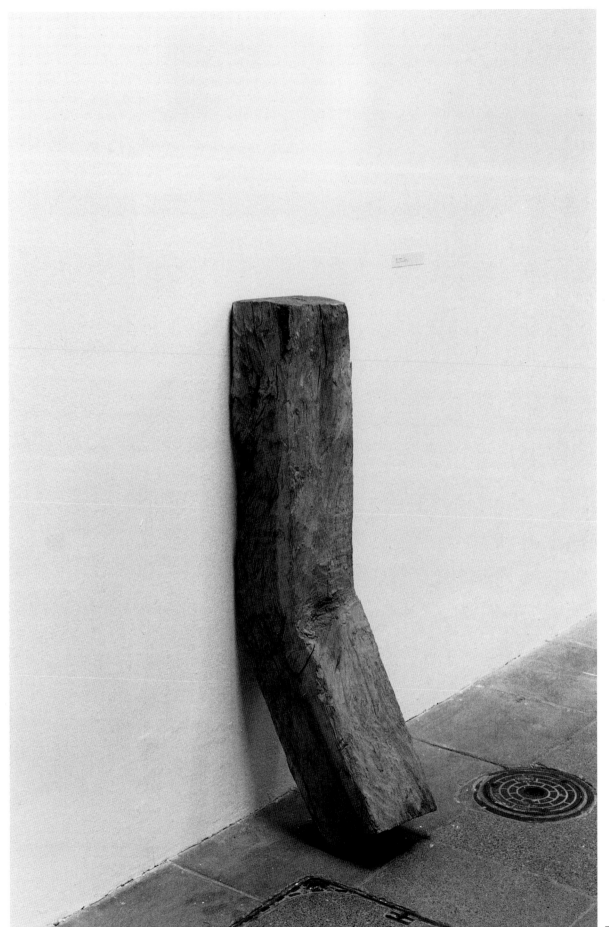

78 *Wall Leaner*, 1976, oak,
135 × 27.5 × 36 cm
(54 × 11 × 14 in)

78

LINE OF CUT

Between 1965 and 1977 David Nash worked exclusively with hand tools, mainly axes of various sizes, saws, chisels, and wedges. Living in a rural area meant he came across certain tools that are not usually found in ironmonger's shops. From time to time he would find implements used by farmers and wonder how he could make use of them in his own work, occasionally getting an idea for a sculpture from a particular tool. One example was a huge auger which he found in a local agricultural store, and which enabled him to bore two-inch diameter holes in heavy lengths of wood. By making large pegs, two inches wide and eight or more inches long, he was now able to join large pieces of wood together. It was this facility that allowed him to make the *Pegged Tripod* (1976) and the first *Cracking Box* (1979), an important piece which will be described separately. The forms he made came from the function of a particular tool. As the notes in his *Briefly Cooked Apples* leaflet indicate, he enjoyed the fact that the correct use of a tool, such as the full-length axe, or a six-foot saw, involved his whole body: 'You don't just use your arms – you can go right down to your toes to get the rhythm going. I could saw for half-an-hour to an hour at a time, and it would be like a meditation, going through big pieces of wood . . . and this fluid, almost circular, spiralling, curving gesture of movement would be going into keeping the saw cut straight. And the actual wood I was cutting through had been formed in a "gesture of process" . . . this growth, there's nothing straight about it – and there wasn't actually anything straight about my movements, to push and pull.' But the line of cut made by the saw was straight, a perfect, clean line, and in 1977 Nash made a conceptual work that expressed the feelings quoted above. *Line of Cut* (1977), consisting of three photographs, was made for an exhibition called *On Site*, mounted by Arnolfini Gallery, Bristol. A number of artists were invited to make works for specific sites in and around the city, to be shown in documentary form at the gallery. Nash worked with three fallen trees, making a deep saw-cut into each trunk. In the first of his three images we see the stump section of a tree, in which his

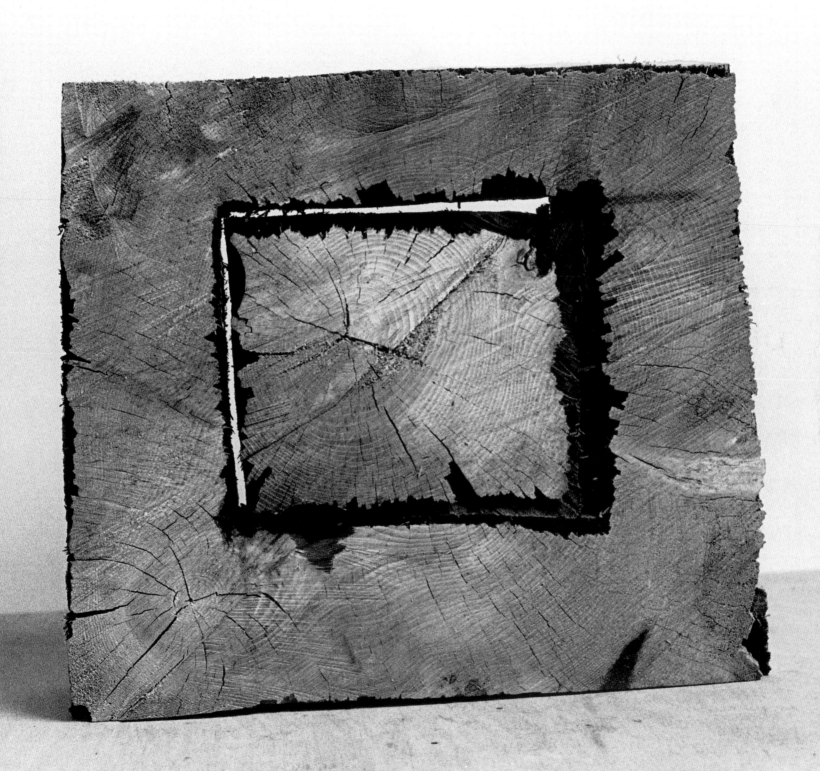

79 (overleaf) *Framed Cut Corners*, 1995, elm, 2 parts: overall size 39 × 47 × 13 cm (15½ × 18½ × 5 in)

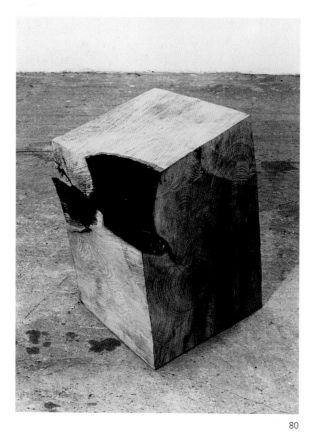

80 *Beech Block (The Uncarved Block)*, 1978, beech, 50 × 45 × 45 cm (20 × 18 × 18 in)

80

fine cut goes vertically down the centre, with the grain of the wood. In the second section he has cut across the trunk horizontally, against the grain. In the last photo the fine line runs diagonally across the grain.

Just before making this sculpture Nash had explored the idea of making a straight cut on three separate planes. It was in fact the inspiration for *Line of Cut* and should be considered with it. *Corner Block* (1977) was the first of a number of solid block sculptures made between 1977 and 1982. This was a period when he made many minimalist works, exploring the contrasts that can be created on the one hand by the tension of three separate surfaces coming to a point, as in this work, and on the other by the loosening of an apparently solid, geometric piece through the device of cutting it in carefully considered ways. *In Beech Block (The Uncarved Block)* (1978) he has used part of the trunk of a tree at a point where it forked. By leaving the bark on the inner curve of this fork, so that it shows as a black space, he has empha-sised the solidity of the roughly squared cube – but it was this very solidity that he was about to undermine in the following sculptures. *Corner Block* reveals the process of its own making: it is clearly a quarter section of a large trunk (in fact the crown of an oak) from which Nash has cut off three sides to create one corner where three planes meet. Two of the rough offcuts have themselves been placed flat on their respective cut surfaces so that they support the central element of the piece. The con-trast between the still-visible curves of the original trunk exterior and the geometric tension of the revealed interior gives the work its sense of balance. *In Beech Block (The Uncarved Block)*, however, he deliberately made the piece as simple as possible. By making his cube bigger than the wood can cope with, so that the fault in it is clearly visi-ble, he is stressing the origin of the piece: the material has not been totally dominated by the will of the artist.

For many years Nash resisted the temptation to use a chain-saw in his sculpture, feeling it would distance him from that direct contact between the artist and his material that had become so important, as expressed by the rough surfaces with the marks of hand-tools. But by 1977, having learned the nature of many different species of wood, he realised that the versatility of this tool could bring him advantages. He found that it could function as an amalgam of many hand-tools, as well as speeding up the process of cutting large pieces of timber.

A chain-saw is a dangerous tool even in the hands of an expert. Nash was aware of the section on safety in David Smith's book: 'He is really saying "You've got to take proper precautions" and I do what David Smith says.' A professional chain-saw (Nash has a selection of five, of different sizes and with different lengths of blade) may weigh as much as sixteen pounds. The steel chain on the longest (thirty-six inch) bar is a third of an inch thick, carrying as many as a hundred razor-sharp cutter-blades which revolve at forty-five miles an hour when the

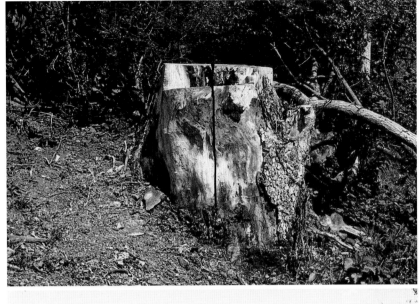

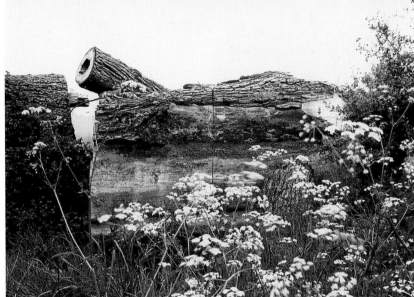

81 *Line of Cut*, 1977, 3
elements, County Avon

81

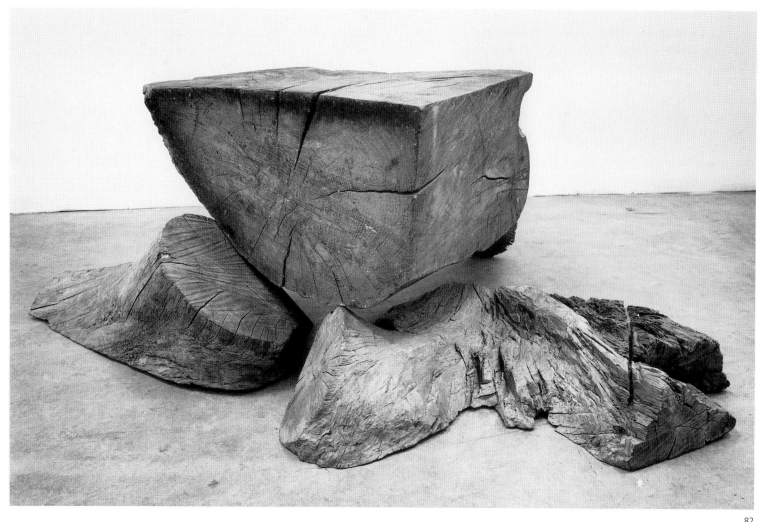

82

82 *Corner Block*, 1977, oak,
60 × 112.5 × 100 cm
(24 × 45 × 40 in)

83 *Cutting Round the Cube*,
1979, sycamore,
25 × 25 × 25 cm
(10 × 10 × 10 in)

84 *Rough Block*, 1977,
sycamore,
160 × 101.5 × 101.5 cm
(63 × 40 × 40 in)

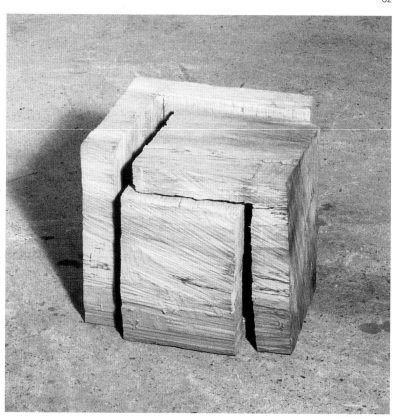

83

machine is running at full throttle. To handle this amount of force requires considerable strength and if any careless movement is made, causing the end of the blade to catch or snag, the resulting kick-back can be violent, with the risk of serious, even fatal, injury to the operator. A remarkable aspect of David Nash's work is the way he has mastered the chain-saw, turning it to uses its manufacturers never envisaged, handling it at times almost in the way a hairdresser uses electric clippers, shaving sections of surface wood away to create curved surfaces, teasing out thick corner sections so that they narrow down to soft delicate forks and angles, but also using it to shape and facet flat surfaces on which a very definite roughened finish is left – the mark of the tool, the 'truth' of the making.

The first sculpture Nash made with the chain-saw was *Rough Block* (1977), a simple, elegant piece consisting of a cube of wood resting on a formal tripod. He followed this with a number of pieces in which he exploited his newly developed skills to cut directly down into the wood, instead of having to rely on his line of cut gradually deepening to the limit imposed by the width of the wood and the size of the hand-saw. *Slot Wedge* (1979; Plate 3) illustrates this point well. Taking a section of oak-trunk and cutting one end off at a sharp angle, Nash has driven the end of the chain-saw through the block to make three separate cuts – one across the grain high up in the centre, then two downwards along the grain from the extremes of that first cut, down to the base, thus cutting an interior section totally free from the block. This section, of course, also has an angled base, so by pushing it partly out of the surrounding trunk it serves to hold the whole sculpture upright: without it the block would fall over since the work can only support itself if the interior section is partly protruding. At the same time this partial separation of the two elements makes one instantly conscious of the *volume* of wood (and therefore of space) contained within the sculpture.

These works were followed by a number of developments and variations on the same theme. *Corner Cuts* (1979) began as a circular slice from the trunk of an oak which has been cunningly opened up to reveal a block with four right-angled corners, concealed within it. *Cutting Round the Cube* (1979) is not quite as simple as it looks, since in order to leave an oblong block that can be slid out of the centre of this piece Nash has first had to make a shape that appears cubic but is actually more of a solid rectangle, longer on one axis than the other. He has then made his cuts in such a way as to remove first one L-shaped section (two sides of the original) and then another from the remaining block, leaving his perfect cube. It is interesting to consider this work within the context of the best minimalist art, in which sculptors such as Donald Judd also explore geometry in three dimensions, with beautifully balanced, highly formal shapes enclosing space and light, or – as with Nash here – implied volume

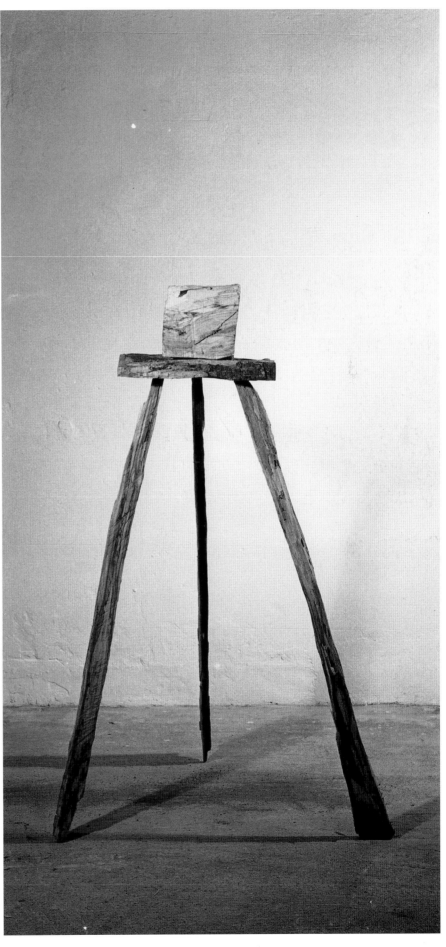

84

85 *Corner Cuts*, 1979, oak,
50 × 70 × 70 cm
(20 × 28 × 28 in)

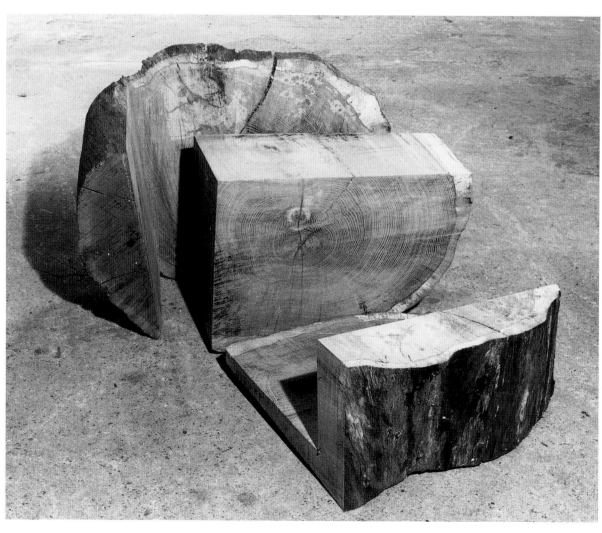

86 *Extended Length*, 1980, oak,
49 × 245 × 50 cm
(19½ × 98 × 20 in)

85

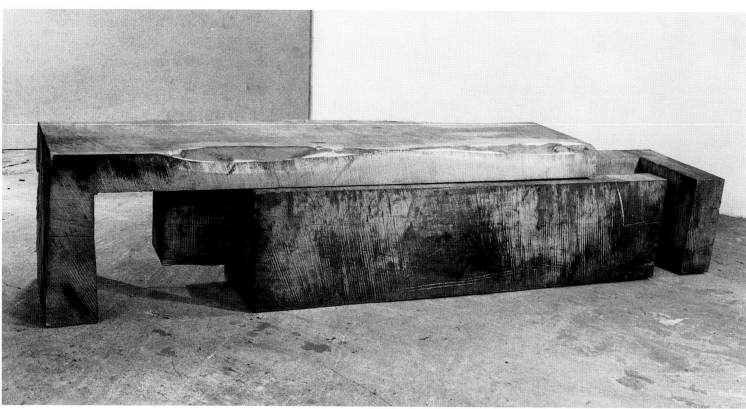

86

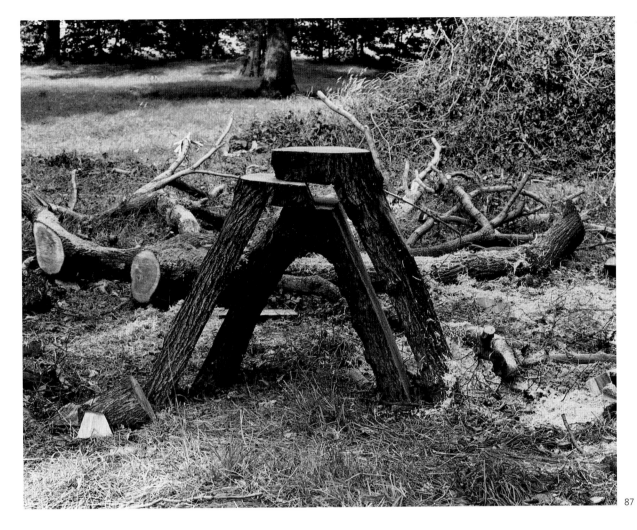

87 *Dismantled Fork*, 1981, elm,
90 × 105 × 40 cm
(36 × 42 × 16 in)

87

88

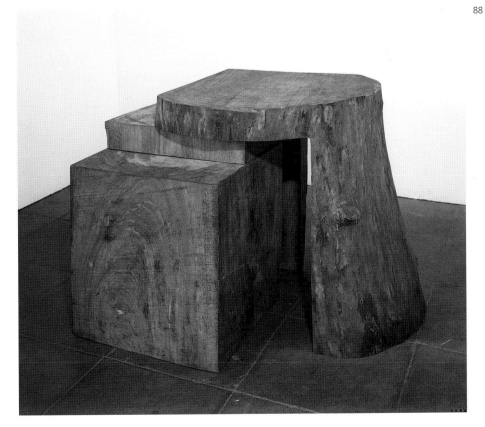

88 *Capped Block (Emperor of China)*, 1980, elm,
79 × 79 × 109 cm
(31 × 31 × 43 in)

and dark, unseen inner space. *Triple Square Block* is a more complex variation, the first of a number of related pieces in which Nash extends his original cube or block by sectioning it into smaller and smaller elements, drawing them out like a series of wooden building blocks. On this sculpture – and even more on *Cutting Round the Cube* – the rough marks left by his chain-saw are clearly visible, a feature he would exploit further in later works. *Capped Block (Emperor of China)* (1980) is perhaps the most successful of all these works and, with the *Extended Length* that he made at about the same time, is one of the largest solid block pieces he would attempt. It differs from the previous two works described, in that Nash used a milling-saw to give a very precise surface to the work. The sculpture looks elegant in spite of its weight, and although it is easy to see how the cuts have been made, the stepped and angled surfaces of the top sections, which rest on the cube, give an enigmatic and puzzling impression so that one has to look again to confirm that it is, in fact, a very elemental construction. In *Extended Length* (1980) Nash has made his cuts so as to leave a bevelled edge along the top section of the piece, part of the curve of the original tree-trunk. These softer marks give a more human touch to what might otherwise have appeared a coldly symmetrical piece – the artist's hand, once again. *Extended Cube, Aber Eden* (1986; Plate 4), with its five separate divided sections, demonstrates the skill that Nash had developed with the chain-saw, since he could now control his cuts to make thin slices into the hard-wood block, while taking great care not to push the point of his saw too far as he reached the bottom. *Dismantled Fork* (1981) combines the sectioning technique of these recent works with the more anthropomorphic forked branch Nash used so often in the earlier tripod pieces, to make a self-supporting sculpture that clearly reveals the process of its own making. For *Wooden Fish*, he has experimented with a different basic form – an extended pyramidal shape, rather than a cube. This much larger sculpture was made at Upper Nikko, on his first visit to Japan in 1982. He has deliberately left visible the beginning of a fork in the large branch used to make the 'tail' to his fish.

This series of works is one of the most successful sculptural themes that David Nash has developed. We find him picking it up again at later stages within the context of a particular project, sometimes simply making another variation, as with *Extended Length* (1986), sometimes by combining it with a different theme, as in the recent *Framed Cut Corners* (1995) in which the central block has been left within the solid frame from which it has been cut.

Reference has already been made to a work made in 1979, *Cracking Box*. In this sculpture Nash has built a wooden box out of six ring sections of oak cut across the grain, taken from the heart of a tree trunk and trimmed to more or less symmetrical square shapes, each about an inch-and-a-half thick. These he has fastened together with heavy oak pegs, dowelled into holes cut with an auger, to make his box form. The box was made in fresh wood in the knowledge that the square sections would quickly dry out, leading to shrinkage. However, the fact that the grain in one section has been placed, as it were, in opposition to that in the next, and that both are firmly held by the heavy dowel pegs, leads inevitably to great tension as the wood tries to shrink and finds itself prevented. Inevitably it cracks open under the strain, but the precise position of these cracks cannot be predicted and every box constructed in this way will crack differently. Furthermore oak dries out and cracks in a different manner from chestnut or beech, for example, each type of wood having its own characteristics. From now on we see him making careful choices of which wood to use in a particular piece, with a view to the way it will behave and alter in the future, whereas in his first works he simply had to make do with what was available.

Cracking Box illustrates one of the most original principles David Nash has brought to contemporary art: namely, that an art object should not necessarily be seen as something inviolable, to be preserved at all costs in the exact state it was in when the artist's hand left it. For Nash, using natural materials, it has become axiomatic that his pieces must be allowed to behave in a natural way and undergo whatever changes the forces of nature may bring about. Such changes may happen over a long period, but the fact that cracks may appear in a work,

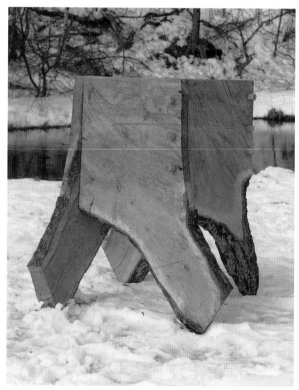

89

89 *Turning Box*, 1982, oak, 122 × 128 × 120 cm (49 × 51 × 48 in)

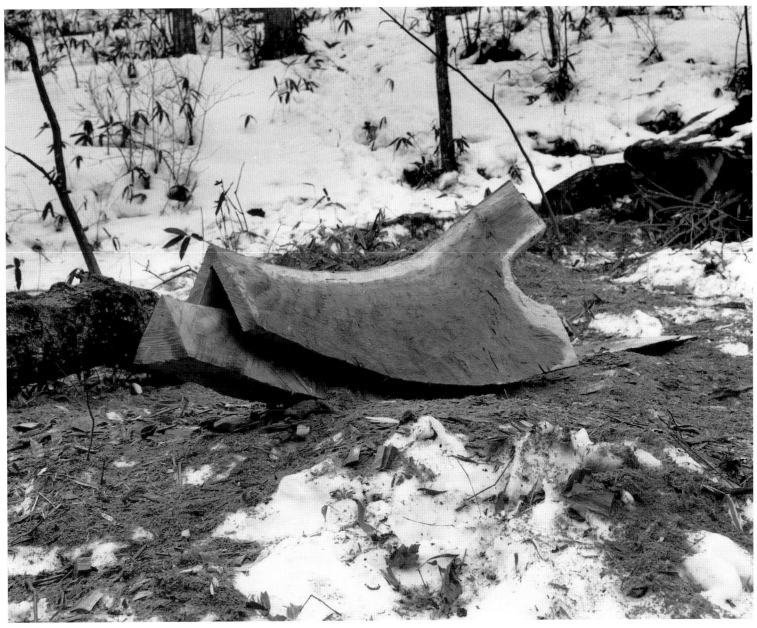

90

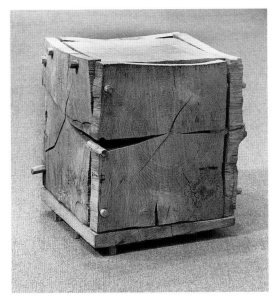

91

90 *Wooden Fish*, 1982,
Japanese oak,
83 × 228 × 88 cm
$(32\frac{1}{2} × 90 × 34\frac{1}{2}$ in$)$

91 *Cracking Box*, 1979, oak,
61 × 61 × 61 cm
$(24 × 24 × 24$ in$)$

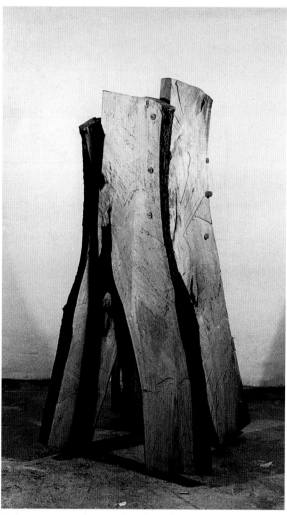

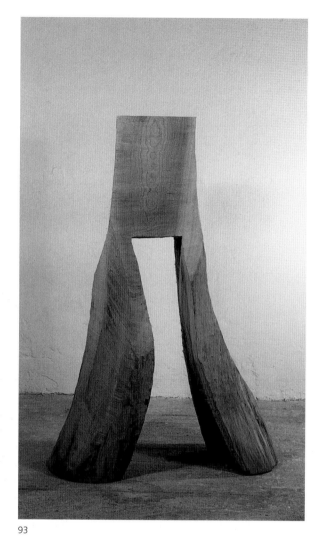

92 *Pegged Lime Box*, 1983,
lime-wood,
197.5 × 90 × 90 cm
(79 × 36 × 36 in)

93 *Cloaked Block*, 1989, elm,
137 × 92 × 36 cm
(54 × 36 × 14 in)

92

93

that it may change in colour and even in texture, does not make that piece in any way less valid as a work of art. Nash is careful to distinguish, however, between works made for indoor situations, which are expected to stabilise within a reasonable period, and others made for outdoor sites which are intended to change quite radically – *Wooden Boulders, Vegetative Rocks* (1988) for example, which will slowly gather accretions of lichen and moss until the wooden elements become indistinguishable from stone. By welcoming the elements of change and therefore *time* into his sculpture, Nash has challenged the idea that there is a moment of completion upon which works of art are to be judged. The desire to collaborate with nature as far as possible results in a subtle approach to the making of art. The fact that such an approach has attracted attention from many people who have felt out of sympathy with some trends in contemporary art, and

that this has made it more marketable, is an irony which has not escaped him. The *Cracking Box* has been followed over the years by a number of variants on the box shape, some of which use principles evolved in Nash's earlier work. *Turning Box* (1982) for example, uses forking branch shapes which bring a sense of movement to the work. In this sculpture the sections have been deliberately placed with the grain in parallel, so that they cannot crack. *Pegged Lime Box* (1983) is a much taller version, while *Rough Box* 1990, made of yew, has its sections cut in such a way they look as though they might be slid apart, like *Extended Length*. Finally, within this group of works, we should include *Cloaked Block* (1989). It combines the solidity of his block pieces with the upright, standing shape used in his tall tripods, a self-supporting sculpture which is simultaneously strong and graceful.

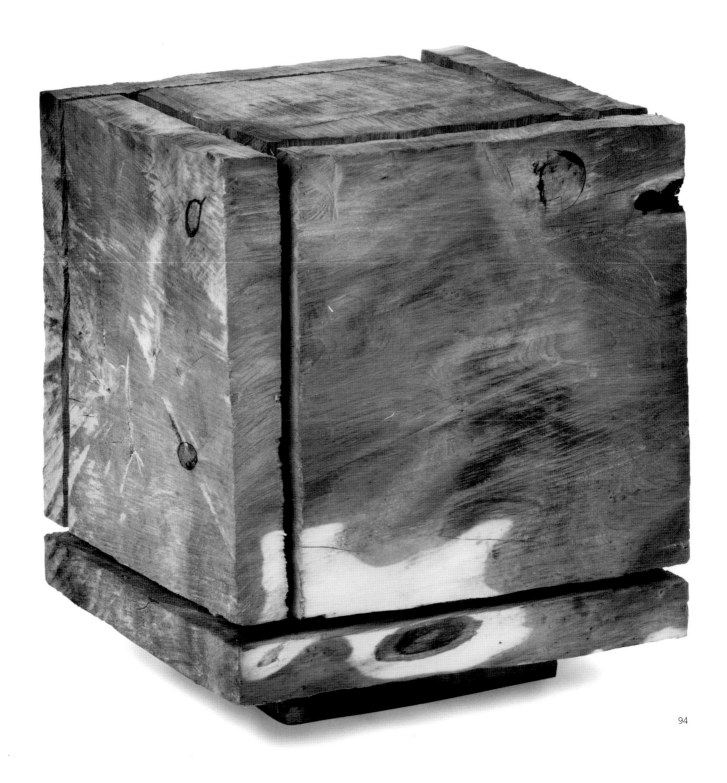

94

94 *Rough Box*, 1990, yew,
39 × 32 × 34 cm
($15\frac{1}{2}$ × 13 × $13\frac{1}{2}$ in)

COLOUR PLATES

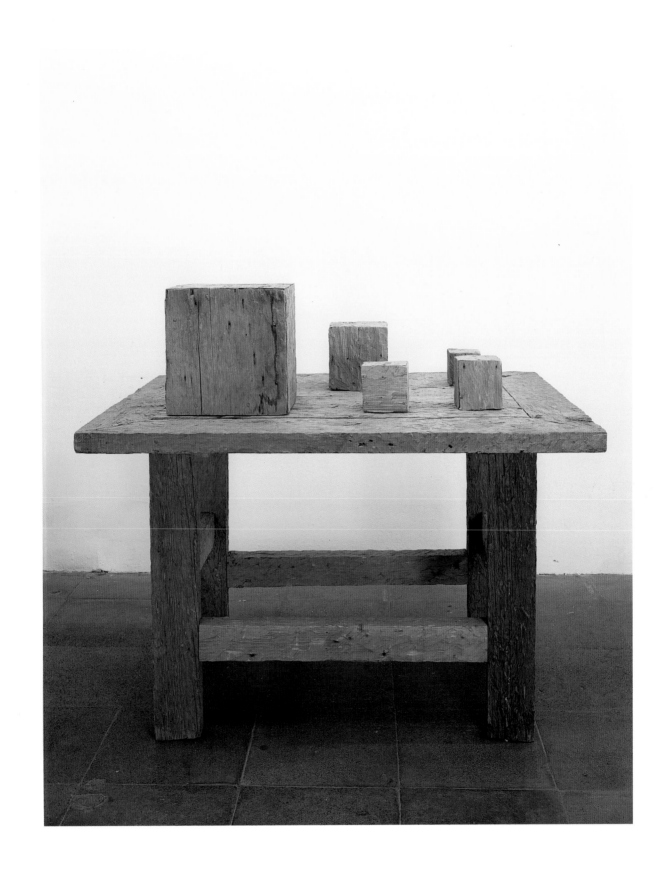

Plate 1 *Table with Cubes*, 1971,
pine, 98 × 155 × 112 cm
(38½ × 61 × 44 in)

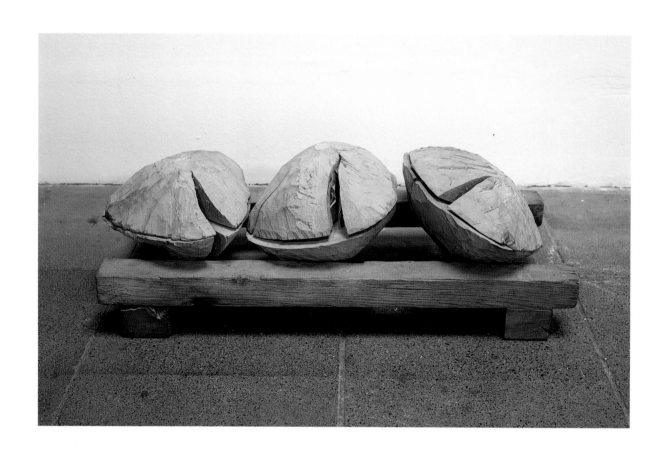

Plate 2 *Three Clams on a Rack*,
1974, beech and oak,
32.5 × 85 × 35 cm
(13 × 34 × 14 in)

→
Plate 3 *Slot Wedge*, 1979, oak,
125 × 83 × 43 cm
(50 × 33 × 17 in)

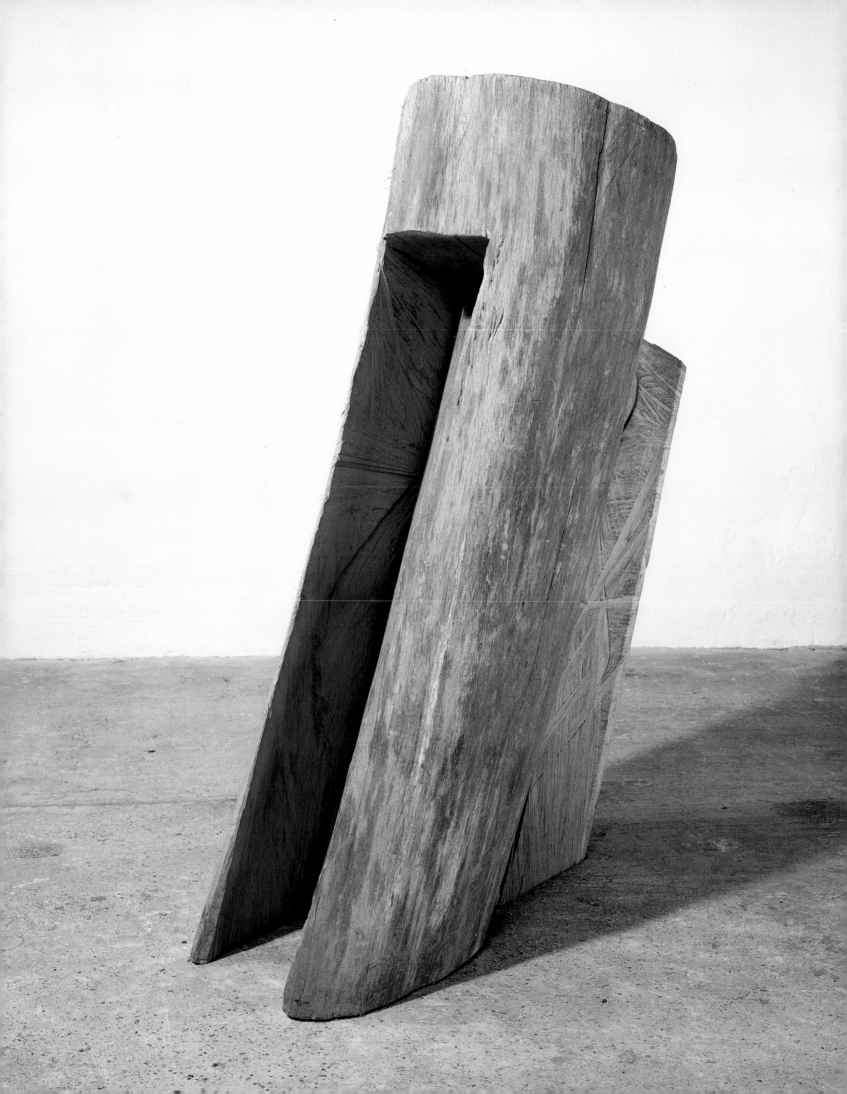

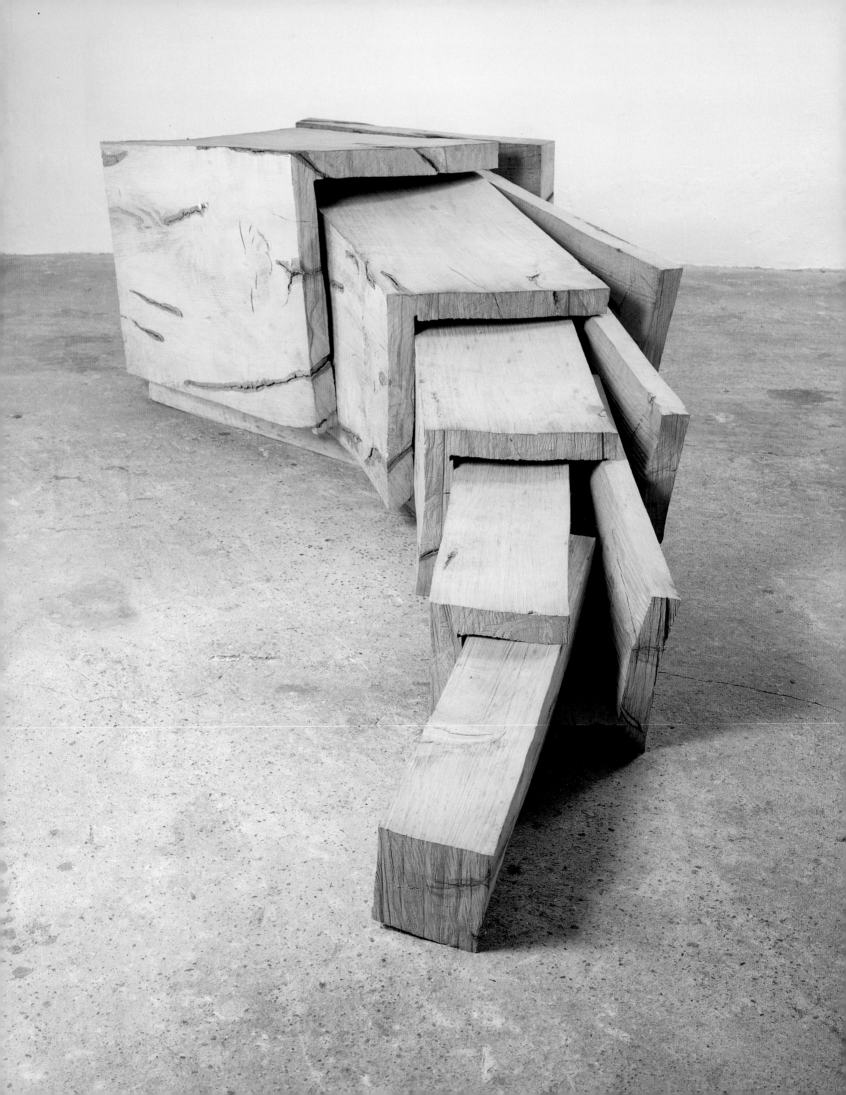

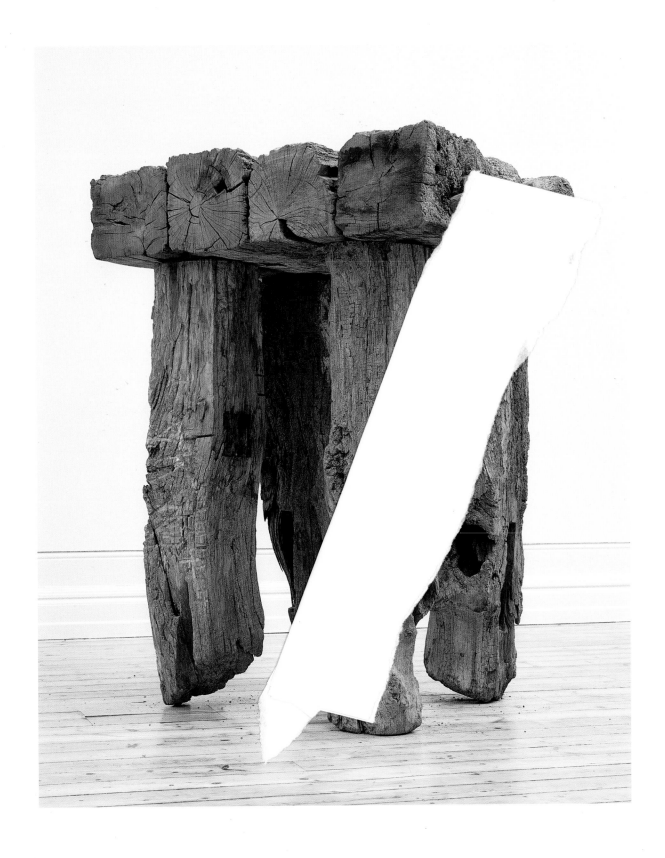

←
Plate 4 *Extended Cube, Aber
Eden*, 1986, beech,
58 × 58 × 200 cm
(23 × 23 × 79 in)

Plate 5 *Ancient Table*, 1983,
oak, 165 × 120 × 100 cm
(66 × 48 × 40 in)

85

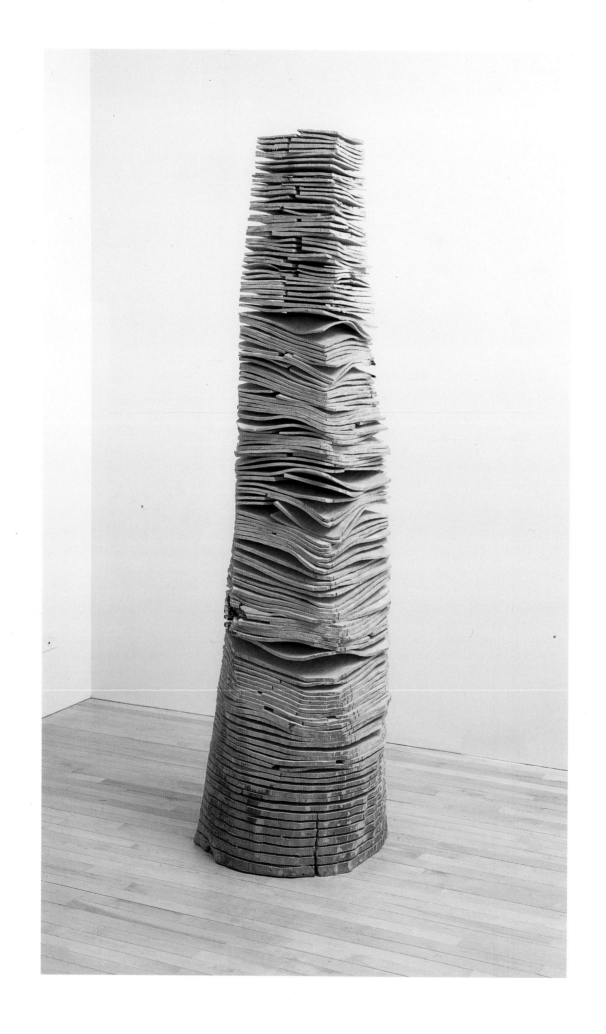

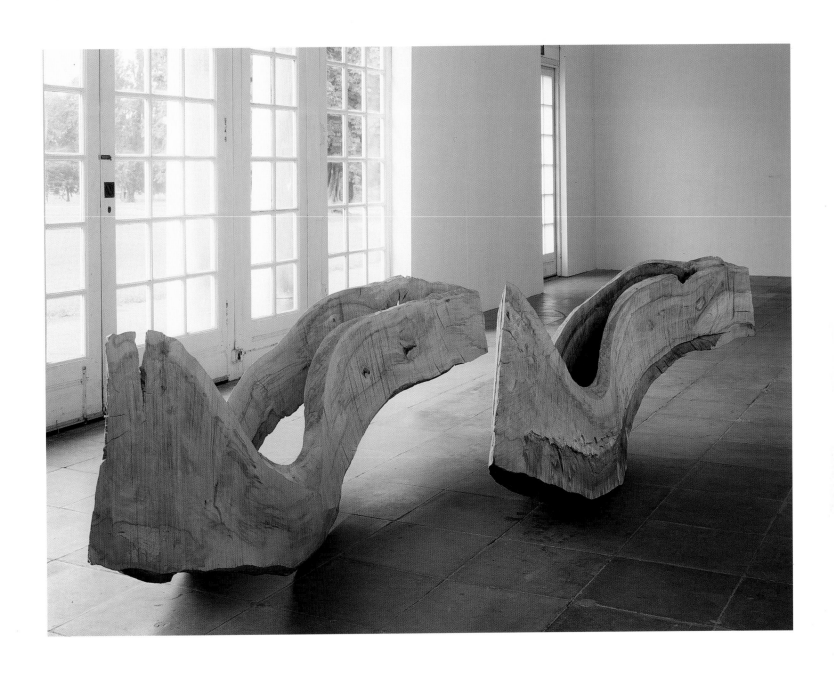

Plate 6 *Birch Crack and Warp Column*, 1989, birch, 218 × 53 × 53 cm (85 × 21 × 21 in)

Plate 7 *Serpentine Vessels*, 1989, beech, 2 elements: 99 × 318 × 35 cm (39 × 125 × 14 in) 99 × 370 × 46 cm (39 × 146 × 18 in)

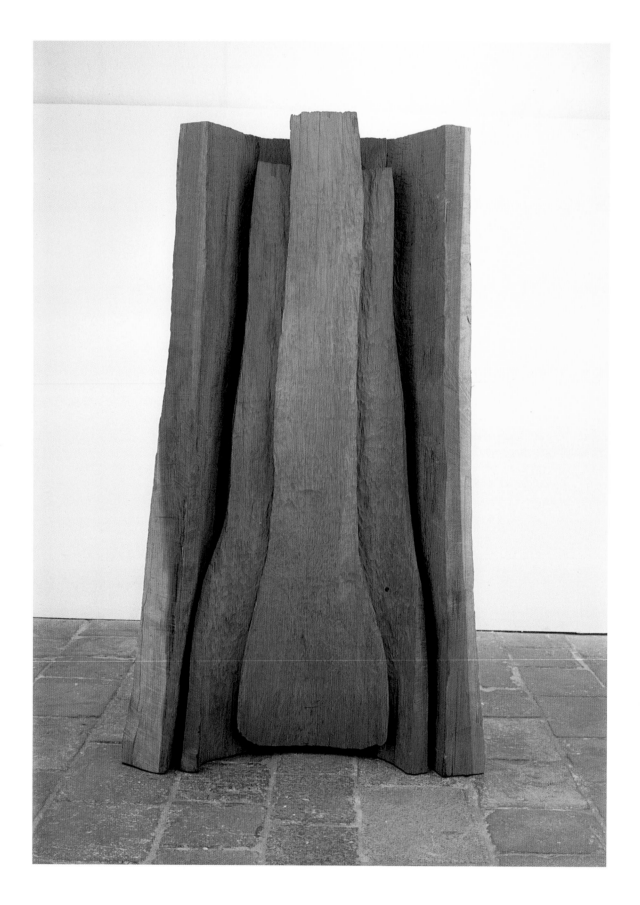

Plate 8 *Red Shrine*, 1989,
redwood, 235 × 140 × 81 cm
(94 × 56 × 32½ in)

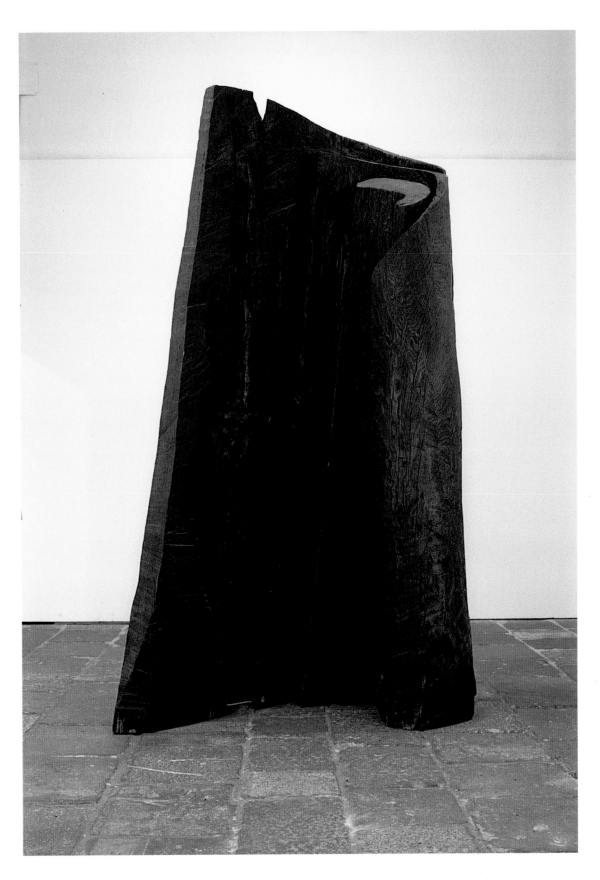

Plate 9 *Folds*, 1990,
charred redwood,
237.5 × 140 × 105 cm
(95 × 56 × 42 in)

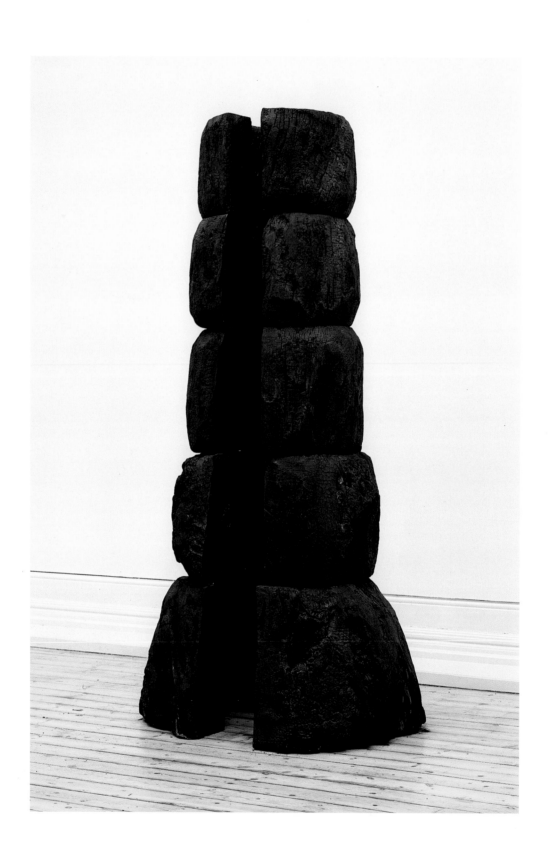

Plate 10 *Threshold Column*,
1990, charred elm,
240 × 135 × 117 cm
(98 × 53 × 46 in)

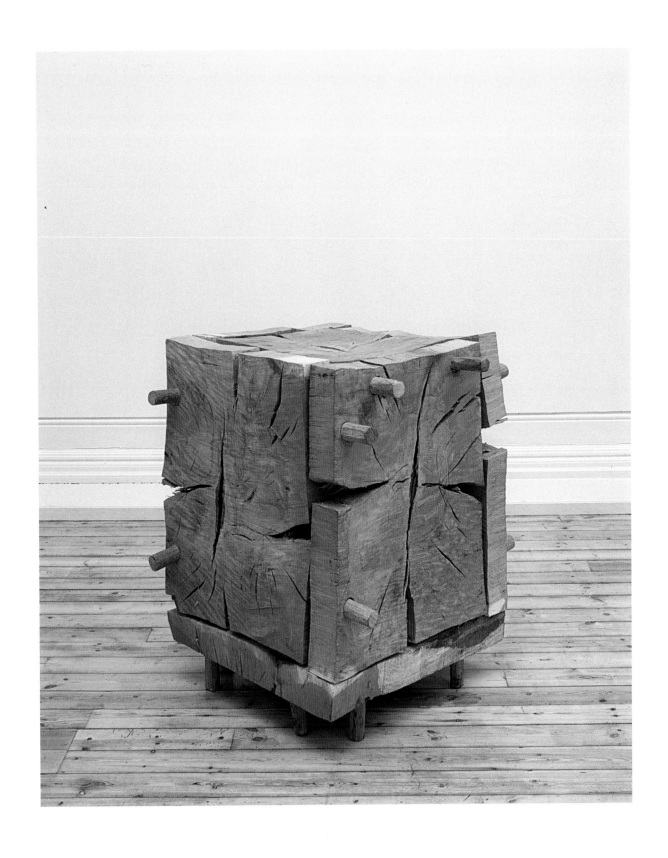

Plate 11 *Cracking Box*, 1990,
oak, 93 × 100 × 97 cm
($36\frac{1}{2}$ × $39\frac{1}{2}$ × 38 in)

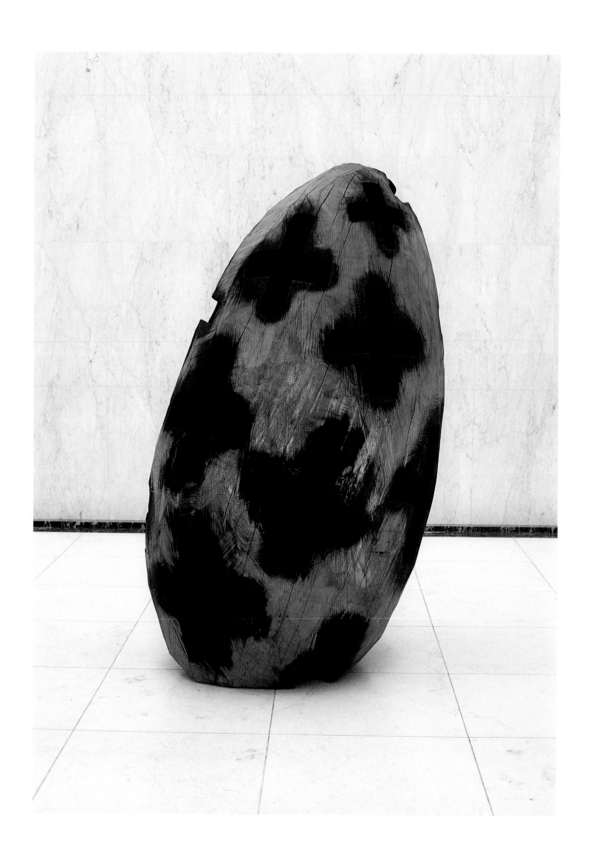

Plate 12 *Charred Cross Egg*,
1994, oak, height 178 cm
(70 in)

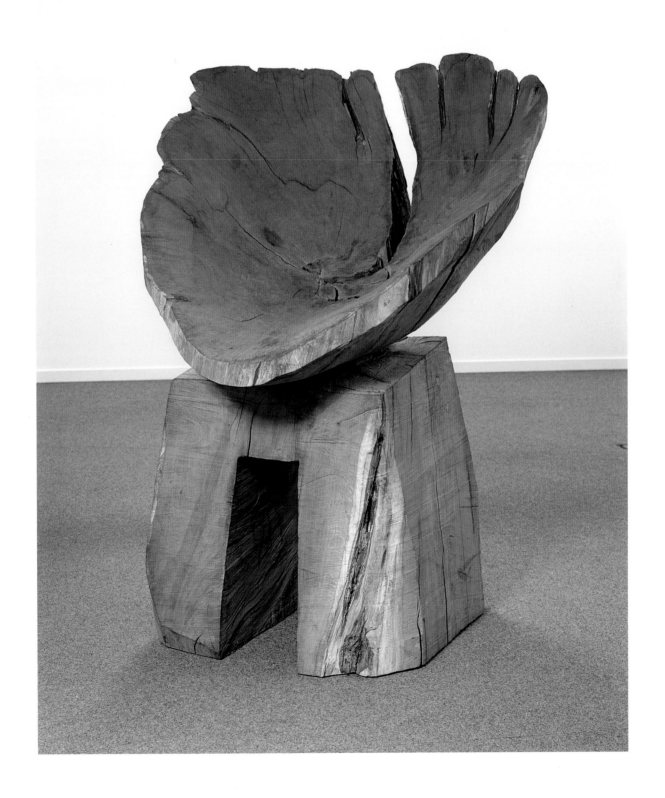

Plate 13 *Bowl*, 1994, oak,
210 × 137 × 155 cm
(84 × 55 × 62 in)

Plate 14 *Ash Dome*, 1996

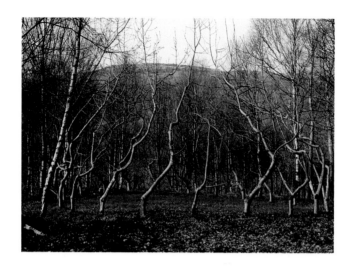

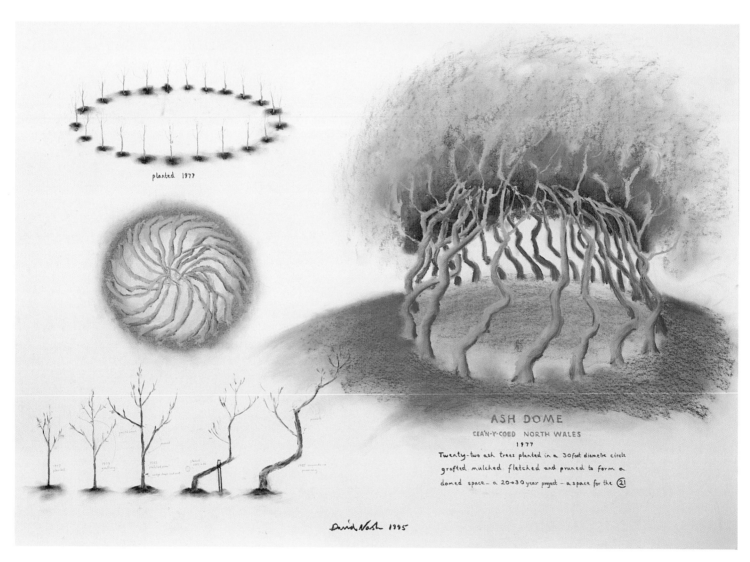

Plate 15 *Ash Dome*, 1995,
pastel and graphite drawing

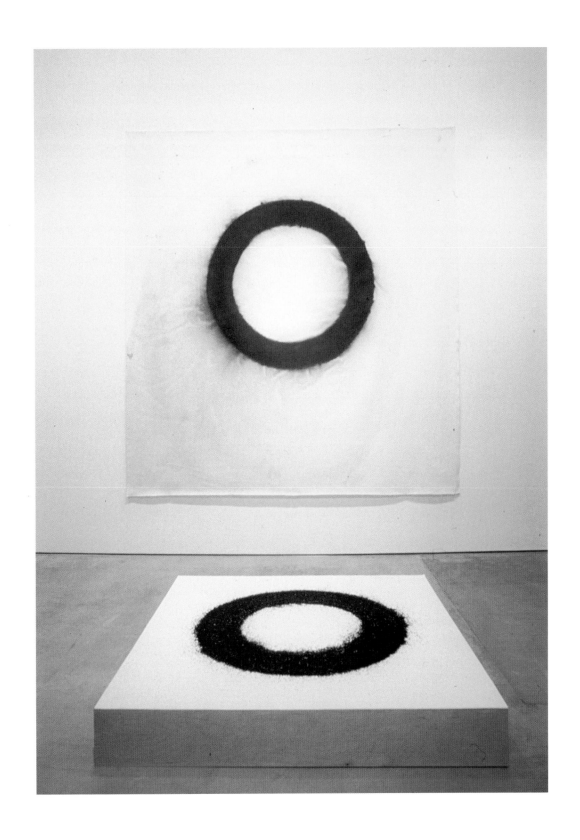

Plate 16 *Blue Ring*, 1992, blue-
bell seeds and pastel drawing:
sculpture, 20 × 105 × 105 cm
(8 × 42 × 42 in),
drawing 130 × 110 cm
(52 × 44 in)

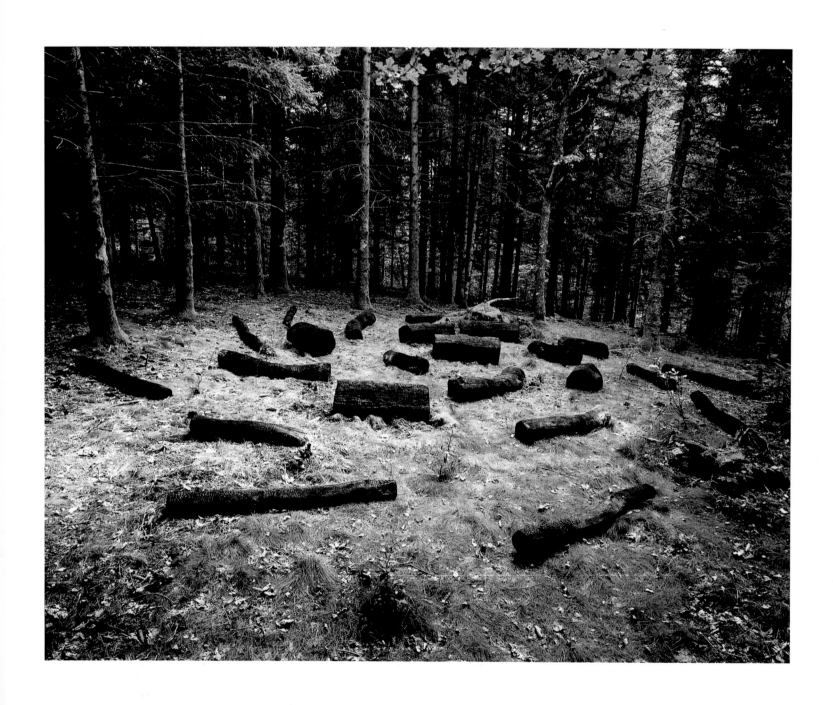

Plate 17 *Charred Wood and*
Green Moss, 1989, charred oak,
diameter 15 metres (49 feet),
and (opposite)
related drawing, 1996

10

THE ENVIRONMENTAL WORKS

THE PLANTING PIECES

During the mid-1970s a problem which preoccupied David Nash was how to create a large wooden sculpture out of doors which would not rot. In its natural state wood will eventually break down and reintegrate with the earth, while indoors this process may be arrested. He was aware that his efforts to create 'epic' works in the *Towers* could never really succeed, because of their inherent instability and the perishable nature of the material used.

The idea of creating a sculpture from growing trees did not come as a sudden flash of inspiration but grew gradually in his mind from the convergence of a number of thoughts and concerns. Part of the difficulty of attempting a work on an epic scale was the very flamboyance of the ambition: could one reverse this, then, and create a major, even permanent piece of sculpture, without advertising it in a 'noisy' manner? A low-visibility epic, in fact? He had read a story about a man in southern France who, over a period of many years, had worked alone planting trees to create a secret forest, twenty-five by ten kilometres in area, without anyone having been

aware of this. He also thought of the seventeenth- and eighteenth-century foresters who had planted trees for the shipbuilding needs of future generations. The idea of creating a work that would encompass the concept of longevity began to appeal to him. In the work he had been carrying out at Cae'n-y-Coed he had become aware that planting trees involved careful planning, particularly as regards the space they would require when mature, some thirty years and more into the future.

He had already noted examples of fletching techniques used by local farmers in the Ffestiniog valley. Now, reading the history of shipping at the local harbour of Porthmadog, he learned that trees had been trained to grow in certain configurations in order to produce strong, thick beams with a curve or bend in them, to be used for a particular truss within the construction of a vessel. But a vessel, by definition, contains space and it was from this concept, rather than from the structure, that he began to approach his subject. He thought of the Chinese potters who would focus their minds on the empty volume within

the pot they were to make, rather than on the clay within their hands, drawing the clay gradually up and around this invisible shape. Gradually, the concept of a dome of space grew in his mind: a sculpture formed from living trees that would actively engage with the natural forces of its location.

He made no detailed plans for the project, and only one preliminary drawing of it exists, since he preferred to work from the place itself. A site for such a work had already suggested itself to him: a slightly dome-shaped area of raised ground within the Cae'n-y-Coed wood, surrounded by beech trees. From there he looked straight out across the valley to the slopes of Moelwyn Bach, with the huge curved bulk of Manod Mawr, the 'art mountain' as he thought of it, rising up to his right.

At that time Cae'n-y-Coed was not fully fenced off from the surrounding pasture, and to his dismay he found his circle of young ash trees had been eaten by sheep within a short time of being planted. He had to begin again, protecting the area with a fence. But his second circle of trees was also eaten, this time by rabbits. At the third attempt he took care to surround each of the twenty-two saplings with spiral tree-guards that could be removed at a later stage when the bark was sufficiently tough to resist the rabbits. He also began a documentation of the work that continues today. The established circle, which he called *Ash Dome*, was planted in the spring of 1977.

The choice of twenty-two for the number of trees was partly deliberate, partly determined by the size of the area and by what seemed to Nash to be appropriate distances between each of the trees. Twenty-two was also a number which had, as far as he knew, no resonance or association with occult interpretation. He decided there should be no entrance or doorway into the space, since this would spoil the symmetry of the dome and also raise the question of what alignment an entrance should have.

The choice of ash was made because he had noticed it adapted well to fletching and bending in hedge-making, being capable of leaning a long way out of the vertical. It is also very resilient and vigorous, quickly healing from pruning wounds. He realised he would have to make quite drastic interventions in the growing process, probably at intervals of several years.

Certainly other stimuli for this work came from the artistic and social climate of the period. Conceptual art, in which an idea presented by an artist is more important than the art object, or physical means, by which he presents it had been extremely influential in the 1960s and 1970s. The *Ash Dome* was undoubtedly a 'concept', since it would not grow to physical reality for at least thirty years. The environmental movement was also gaining ground at this time, with slogans like 'Plant a Tree in '73', 'Plant More in '74'. But Nash also liked the fact that the work would require a full commitment from himself to

95 (overleaf) Planting *Ash Dome*, 1977, Cae'n-y-Coed

stay with it, to nurture it from its conceptual level into a physical reality. Such a commitment must of necessity be a part of the process of creating the work, but it also meant remaining permanently in Blaenau Ffestiniog. Since making this commitment, in 1977, he has found that the work has required far more physical intervention than he had originally envisaged, but he has stuck with it. Learning from this experience he has since embarked on other such projects that require little or no intervention. He had originally imagined that the interior dome space would be on the scale of a small hall, but he had failed to allow sufficiently for the fact that as trees grow bigger the space between them automatically becomes smaller, so the end result is likely to be rather more domestic in scale than he had hoped. Subsequent growing works were planned in various configurations to suit specific site conditions, but *Ash Dome* (1977) is unique and holds a special position in David Nash's life and work. In its continuing growth, its pushing upwards towards the light, and the now clearly articulated space between the trunks and rising canopy of branches, it parallels Nash's own growth as an artist, his optimism and sense of purpose, his total commitment to the place and way of life he has chosen. The *Ash Dome* is a work which is 'coming', which is about growth and the future: Nash is well aware that the progression of life must be seen as a 'going' process as well, and on the opposite side of the valley has created just such a work, the *Wooden Boulder*, which is described later.

The first, major interventions to the *Ash Dome* took place in 1979 and 1980. Photographs show how successful these processes have been. Close-up pictures show details of the man-made bends in the trees which will be familiar to horticulturalists. In shaping the dome each tree has to have enough leaf growth to sustain itself, and Nash must ensure that none of the limbs take over and usurp the trunk as the lead growth. There is also the problem that as the upper sections of the trees develop and grow closer together, closing the hemisphere of the dome, they will have less and less light available to share between them, thus inhibiting growth. Nash is dealing with this by judicious pruning and his knowledge of what the trees need, in terms of water, sufficient minerals, enough air and light. In the early stages of the growth of *Ash Dome* he planted screens of birch outside the circle which, growing much faster, have protected the young ash trees. He is now thinning out the birches and will later remove a few of the old beeches which have, up to now, served the purpose of 'pushing' the growing ash trees towards the centre. Eventually, when the dome is fully formed, Nash will clear the space around it so that it will be seen to be standing in an open glade.

In an exhibition at the AIR Gallery, London, in 1978 Nash showed a series of drawings and photographs of the *Ash Dome*, documenting its present and projected progress. The work attracted a lot of interest and has

96

96 *Ash Dome*, 1995

remained the sculpture with which he is most closely associated. It was inevitable that he should be invited to create similar works, using living trees, at other venues. He had already done so, in fact, during his residency at Grizedale Forest in Cumbria during the early months of 1978, but not without unexpected difficulties. A *Willow Ladder* that he planted, using trees that he grafted together, was eaten by deer at the first attempt. When he tried again it failed because he could not make enough visits to Grizedale after the residency to give it the attention it required. The experience taught him that he should not undertake a planting project unless a contract for regular maintenance was part of the commission. Also, at Grizedale, he attempted a *Sweeping Larch Enclosure* which failed because he had not anticipated the effect of wind being funnelled through the site, thus 'burning' the trees which later died. A planting piece attempted at the Yorkshire Sculpture Park in 1981 suffered a similar fate. Increasingly, he realised the need to take into account climatic as well as site conditions in planning such works.

He had a happier experience at the Rijksmuseum Kröller-Müller at Otterlo in the Netherlands, where his *Divided Oaks* and *Turning Pines* have flourished since he planted them in 1985, helped by the fact that Nash visits the park each year to tend them. More recent commissions include *Above the Waters of Leith* (1988) for the Scottish National Gallery of Modern Art in Edinburgh, in which groups of trees leaning out from a hillside will mark the line of a path. A 1994 piece called *Boulders and Birches* in Minneapolis, USA, combines birch trees, which will grow, charred lumps of oak, which will gradually decay, and glacial boulders – which will not change at all. Meanwhile, he has continued to experiment with other types of planted work at Cae'n-y-Coed, close to the *Ash Dome*. One of the most successful has been *Leaning out of Square*, planted in 1978. In this work, sixteen larch trees have been planted in a formal grid, but each tree leans at an angle of forty-five degrees. As they are leaning away from each other the original square layout seems to have been completely eliminated. The work makes a deliberate comment on the rather brutal geometry of Forestry Commission plantations in which one is all too aware of rigid, regimented lines of trees. Interestingly Nash made this work at the same time as he was

97

98

99

100

101

constructing his first *Cracking Box* (1979) in the studio. The two apparently different sculptures actually embody the same principle: the trees lean so as to force the geometric grid apart, while the sides of the *Cracking Box* strain to break out of the geometry that has been imposed on them. The material, in fact, has had a chance to answer back.

Several smaller, quieter works have been planted at Cae'n-y-Coed. In *Bramble Ring*, on which he worked from 1983 to 1987, Nash used one of the commonest wild shrubs to be found in the Welsh countryside to weave a circle, almost like a crown of thorns. *Blue Ring*, however, which existed from 1983 to 1988, was more of a conceptual work since it could only be seen for the very short season when bluebells are in flower, being recorded in the form of drawings and circles of bluebell seeds. Bluebells are a natural phenomenon in any area of woodland in which trees have been cut down and then allowed to regenerate, but they only flower for a week or ten days each year and then metamorphose to seed. Nash dug up and moved thousands of bluebell bulbs from parts of the wood and replanted them on an open slope, concentrating the transplanted ones into a broad 100-foot diameter

97 *Ash Dome:* mulching, 1979

98 *Ash Dome:* grafting, 1980

99 and 101 *Ash Dome:* fletching, 1983

100 *Ash Dome,* 1987

102 *Divided Oaks*, 1990, charcoal drawing, 91.5 × 203 cm (36 × 80 in)

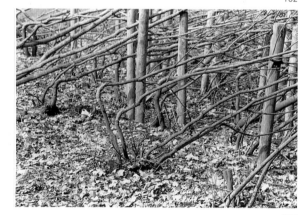

103 *Divided Oaks* (detail), 1985, oak, ¼-acre

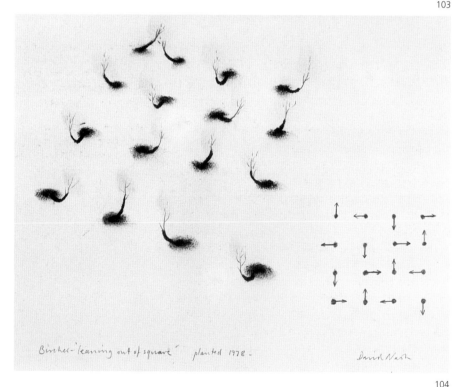

104 *Leaning out of Square*, 1992, charcoal drawing, 46 × 58.5 cm (18 × 23 in)

ring. He deliberately left all the existing bulbs where they were, so that the ring, when it appeared, would not have a sharply defined edge but would simply show up as a deeper concentration of blue. The fact that this soft, almost ethereal blue shape would only appear for a short time each year and then vanish, to return the following year, brought the element of time into the work as well, which has been noted in other Nash sculptures. Having once made his concentration of bluebells Nash made no attempt to sharpen up or redefine the ring. The result has been (as he intended) that the bulbs have now spread, the ring-shape has diffused, and has become absorbed into the rest of the hillside with its temporary veil of blue. It *was* there, existing now only in documentation. This was the first work for many years in which Nash had deliberately made use of strong colour, having worked almost exclusively with the natural tones of whatever wood he was using from the time he first began his carved sculptures. But the interest in colour which he had felt so strongly from the time of his first art-school pieces, and in his paintings, had remained and he found blue a particularly haunting colour. The fact that *Blue Ring* could only be seen from a distance, and that the visual impression of a mass of bluebells is ethereal and shimmering, tended to emphasise the experience of distance that one associates with the colour blue.

The last 'planted piece' to be discussed here is *Sod Swap* (1983), a work which has an interesting history. It will be remembered that at the first exhibition mounted at the Serpentine Gallery in Hyde Park in 1970, of work by graduate students, Nash had encountered opposition when he tried to dig holes in the turf so that the red 'legs' of his brightly painted *Tower* could rise directly out of the green grass. Thirteen years later he was invited to exhibit at the Serpentine Gallery again, this time as a participant in a group show of British sculpture. He proposed three large indoor sculptures, but was surprised to be told that he was to be considered exclusively as an 'outdoor' sculptor. Furthermore, he was to be allocated a site outside the gallery which turned out to be precisely the same piece of land on which he had erected his *Tower* in 1970, with its legs supported by flagstones.

Nash felt rather ambivalent about much outdoor sculpture, feeling that large works made of steel or other man-made materials can often appear aggressive when placed in parkland or rural settings. So, the task he set himself was to create a temporary 'planted' sculpture. The only solution seemed to be to make use of the plot of ground itself – which once more brought up the issue of the 'royal' turf. The Director of the Gallery, the same person as in 1970, vehemently opposed the proposal Nash put forward – which was that he should once more dig it up. However the management of the park had changed: it now came under the authority of the Department of the Environment, rather than the Crown Estates, and they turned out to be very sympathetic to the idea

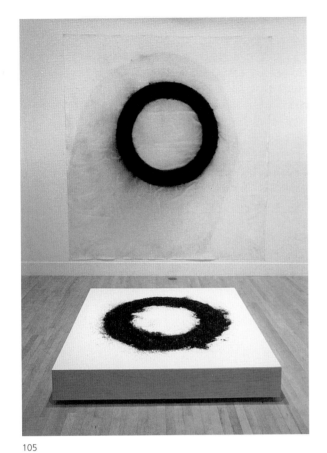

105

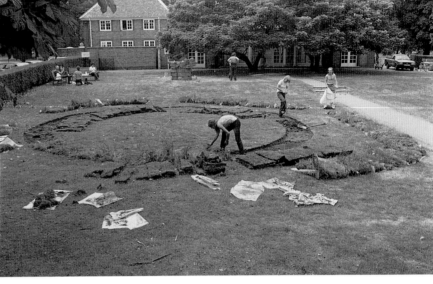

106

that Nash put forward.

With a team of helpers Nash cut a carefully measured circle of turf out of the lawn in front of the gallery. The sections of neatly mowed squares of Hyde Park grass were loaded onto a lorry where they were kept moist and covered with tarpaulin while being transported to North Wales. There Nash had previously cut a circle of precisely the same diameter out of the lower, flat section, of his plot at Cae'n-y-Coed. The pieces of neat London turf were placed into the open earth circle, making a smooth green ring. The rough sections of Welsh turf, complete with docks, thistles, sorrel and wild flowers, were placed into the bare earth ring awaiting them in London, and were then watered. Within hours they had settled in, the wild plants had begun to perk up, and the Serpentine found itself with a ring of rough Welsh grasses marked out on the smooth lawn. *Sod Swap* attracted a great deal of interest, though the Arts Council organisers of the ex- hibition were concerned that the title of the piece might cause adverse comment. They were also worried about the problem of swapping the circles back again. But there were none of the 'waste of taxpayers money' comments that accompany so many shows of contemporary art in Britain: the work was hugely popular, and the environ- mental organisation Common Ground agreed to take it over when the exhibition closed. They first commissioned a botanist to carry out a precise survey of both parts of the work, in London and in Wales. He established that

the ring of Hyde Park turf now in Wales contained only five species of plant. By contrast the Welsh turf in Hyde Park contained twenty-six separate species, all of which were clearly identified with their precise botanical titles and classifications.

Common Ground made an agreement with the Greater London Council to move the circle of Welsh turf up to Kenwood House in Hampstead, where it was estab- lished on a well-manicured lawn within the old kitchen garden area. The grass inside and outside the circle was kept carefully mown but the Welsh turf was left alone so that the circle remained clearly defined with its mass of Welsh weeds. Meanwhile, up in Wales, Nash regularly takes a mower to cut the neat grass of his circle of London turf, leaving the rough grass and weeds to grow both inside and outside it. Thirteen years later – and more than a quarter of a century since Nash's first altercation over the Hyde Park turf – that London circle is still clearly visi- ble. Sadly the Welsh circle – which, incidentally, had been renamed 'Turf Exchange' to cope with Kenwood sensibili- ties – has been destroyed. When the newly created English Heritage organisation took over the management of Kenwood House in 1992 they unceremoniously dug it up and threw it away.

105 *Blue Ring*, 1992, bluebell seeds and pastel drawing: sculpture 20 × 105 × 105 cm (8 × 42 × 42 in), drawing 130 × 110 cm (52 × 44 in)

106 *Sod Swap*, 1983, sods and turfs, Serpentine Gallery, Kensington Gardens, London

THE WOODEN BOULDER

The origin of this work is in the period in the mid-1970s when Nash was making the series of delicate sculptures using long, plaited hazel branches. He felt a need to get back to solid volume again. Around that time (1978) he learned that the occupants of the cottage at Bronturnor were worried about a large overhanging oak tree, and wanted this felled for safety reasons. Nash agreed to cut it down for them. The tree became his first 'wood quarry', from which he was able to excavate a number of sculptures. He realised that he now had the chance to make a really large, solid, 'bonk' piece, which he had been anxious to do for a long time. His first instinct was to use his axe to create rough, hewn surfaces like those he had made on the original *Nine Cracked Balls* (1970), but he found the marks too ineffectual in relation to the diameter of the tree. So using the chain-saw he gradually faceted it like an enormous wooden diamond, until he was left with a near-spherical form, still attached to the rest of the trunk. To cut it free would, he saw, create a potentially dangerous situation since the lump of oak, weighing at least half a ton, could plunge down the slope and straight through the wall of the cottage.

At this stage Nash's intention was to try to move the block to the bottom of the wood where it could be loaded onto a vehicle and moved to his studio. He envisaged keeping it there until it cracked open, as the bonks and clams had done. To move it down the rough path would be difficult, and after completing a short distance by tying ropes around it and lowering it a bit at a time his thoughts turned to the stream. He had wanted, in any case, to photograph the rough sphere close to the point it came from in order to exhibit documentation about its origin together with the block itself, in a gallery situation. But he now realised that the stream, with its succession of waterfalls and pools, would make an even better context for photographs emphasising the movement inherent in a spherical form. The possibility, then, of exhibiting a very still object together with photographs of it in movement, seemed more and more interesting.

Nash positioned a photographer, Sue Wells, beside a pool into which the rough sphere would plunge after coming down the waterfall. Manoeuvering it to the top of the fall Nash and his helpers let the sphere go. But instead of the enormous splash they had expected all they heard was a dull thump. The block had become wedged between rocks half-way down the fall, with water pour-

107

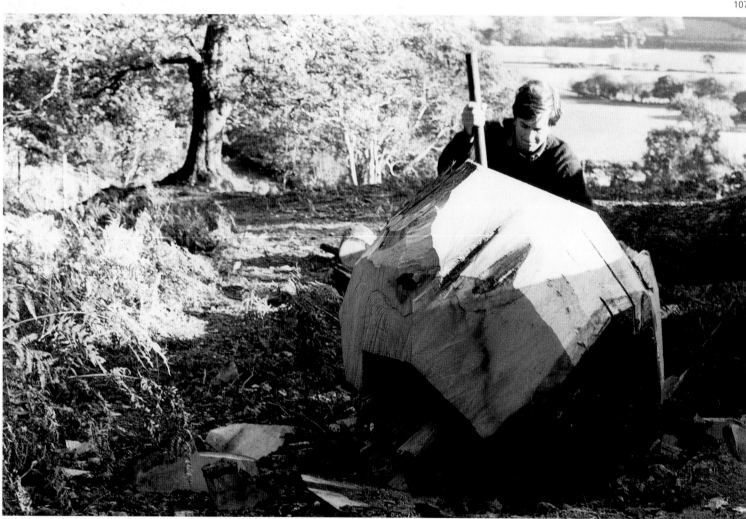

107 Rolling *Wooden Boulder*, 1978

ing over, under and round it. And at that moment, seeing it there, Nash realised that this was the right place for it: he saw it as a paradigm for the inside/outside nature of his own work, and with the movement of the water around this object felt that he, as an artist, was entering into the spirit of the stream and of the place.

The golden colour of the freshly cut wooden block turned dark from the chemical action of the water on the tannin, making it almost indistinguishable from the boulders around it. It had, in fact, established its own identity as the *Wooden Boulder* and was starting to take on a life, even a personality. In March 1979 he found *Wooden Boulder* had moved, presumably washed down by a recent heavy winter spate, and was now resting quietly in the pool below. The piece was unlikely to shift from its present resting-place by natural forces alone, so Nash decided to help it on its way. He managed to harness it with a weighted net (an almost Biblical event, one feels), moved it to the top of the next waterfall, and let it go again. The boulder, now quite indistinguishable from a stone one, lay for eight years in that pool, a natural place for it to stay, leaves wedging behind it in autumn, with a cap of snow and ice on it in winter, with the stream tumbling round it in spring, and resting quietly, half out of the water, in the summer months. Nash returned in all seasons to take photographs and to draw it, building a corpus of documentation around it and becoming slowly aware that this work, like the *Ash Dome*, was becoming a metaphor for the process of life itself, in the sense that it would eventually be 'going', from the stream, from the place, and from his life. The boulder became a kind of stepping-stone into the time-reality of the stream, always there while the stream rose and subsided and the seasons altered around it – like a ball in a ball-game which, in itself, does not change while the game is in progress. It is everything around it which changes, in an embodiment of the Heraclitus principle. Within the context of contemporary art, too, the *Wooden Boulder* seemed to have its significance. It stood in opposition to the dictum of the school of welded sculpture, that had grown out of Anthony Caro's teaching at St Martin's in the 1970s, which held that the integrity of the art object should be such that it did not matter where it was placed. Here, though, was a major sculpture which represented the antithesis of that view, since it was totally of, and in, its place and, although moveable, could not have the same significance in any other situation.

Over the years the boulder has moved several times. After resting for a couple of years in a quiet pool, a violent storm washed it more than a hundred yards downstream to a very tranquil position, under some oak branches, lying on a bed of gravel. In succeeding years the stones and gravel accumulated in front of it to such an extent that any further move seemed unlikely – until a tremendous cloudburst in the autumn of 1994 sent it on down, carrying a gate and part of a fence with it, until

108

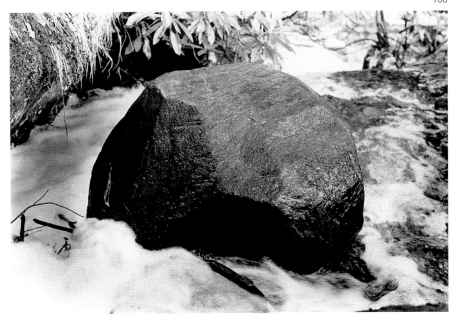

109

it lodged under the road bridge just before the stream runs into the river Dwyryd. Having been salvaged from there, it is now resting just below the bridge.

Further up the valley, barely half a mile from Bronturnor, lies the enormous Cynfal boulder which impressed Nash so much as a child. That is a permanent, unchanging sculptural presence. Opposite, exactly across from the junction of the stream and the river, up on the slope above the Maentwrog road, stands the *Ash Dome*, a work for future generations. As the *Ash Dome* is coming, so the *Wooden Boulder* is going, and these two complementary sculptures, conceptual as well as physical, symbolise not just the life of the artist who has created them but deeper subjects, touching many people who may never have taken any interest in contemporary art.

On his first project in Japan Nash was working for

108 *Wooden Boulder*, 1978, oak, 97.5 × 97.5 × 97.5 cm (39 × 39 × 39 in)

109 *Wooden Boulder*, 1988

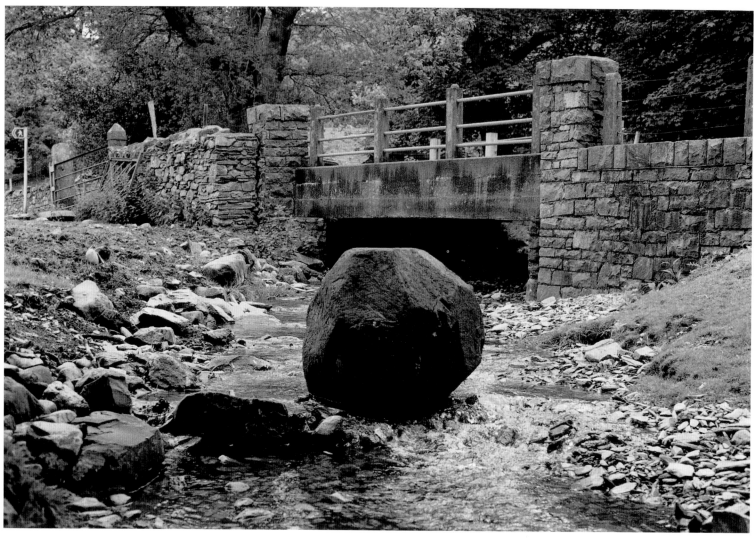

110 *Wooden Boulder*, 1996

three weeks in temperatures well below freezing. There he made a work which came about initially from necessity, but ended up as a kind of counterpart to the *Wooden Boulder* in Wales. The intense cold at the work-site was such that it was necessary to get a fire going, and to maintain it throughout working hours so that Nash, and his co-workers, would not freeze to death. Nash proposed using a surplus section of trunk from the huge mizunara (water-oak) tree that he had been using as his 'wood quarry', initially hollowing it out with an auger so that a fire of branches and sticks could be made inside it. This carefully controlled fire burned for a number of days, hollowing out the huge oak log to an even tunnel shape with a dense black, charred interior. It created a social space for the project as well, being used for cooking and heating, even to scorch other sculptures. At the end of the project Nash levered it to the bank of the river, beside which the project had been established, and rolled it in. Lying on the shallow stones of the river-bed, the log became a *River Tunnel* (1982), the quiet water streaming through it like an echo, from the far side of the world, of the stream tumbling round the *Wooden Boulder* in the

Vale of Ffestiniog: volume in the one piece, space in the other.

One other substantial piece that Nash has made in which he uses a massive volume of wood, with minimal carving or other intervention by himself, is *Wooden Boulder, Vegetative Rocks*, a private commission made in 1988. In this case a very large ash tree was found to be suffering from disease, so that it had to be felled. Nash worked on the stump and base of the tree, after the crown and branches had been removed, to make three very elemental wooden rocks, roughly carved into dome shapes, which appear to be gradually settling into the earth. This is the intention: the forms, which are visible but not obtrusive, will gradually acquire a patina of lichen and mosses, becoming more and more a natural part of the ground they are resting on, and eventually be absorbed back into it.

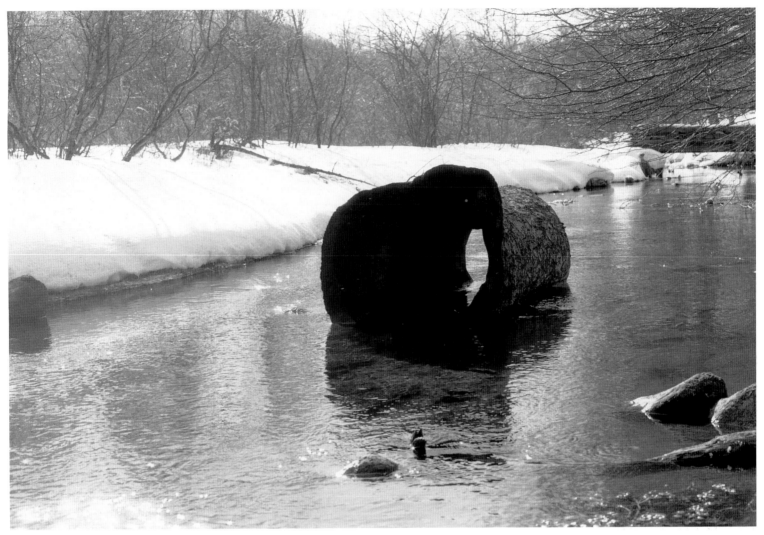

111

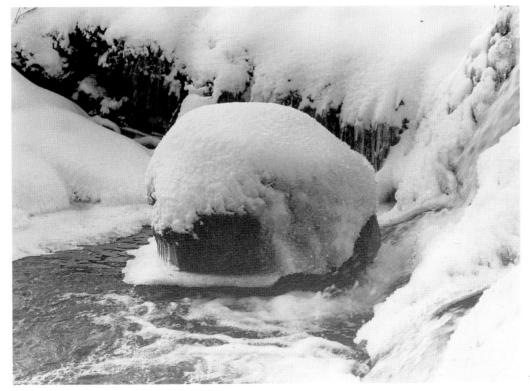

111 *River Tunnel*, 1982,
Japanese oak,
90 × 100 × 180 cm
(36 × 40 × 72 in), Kotoku,
Japan

112 *Wooden Boulder*, 1981

112

EARTH, AIR, FIRE AND WATER

In Wales as a child, and even more after he had taken up permanent residence in Blaenau after 1967, David Nash had often been aware of the presence of fire in the surrounding hills. It is the practice of the hill-farmers to set light to large stretches of dead bracken in March to make the fresh growth accessible to their sheep. On still, clear days the effect can be very strange, with widening plumes of blue-grey smoke rising from apparently bare rocky slopes, giving the impression that it has been released from some infernal blaze deep inside the mountain. Nash found himself drawn, always, to stare up at these places watching the tiny flickers of orange at the base of the rising column. The fires became the focal point in the landscape, and their smoke was revealing the drifting movements of air, which are normally invisible.

A chance question at a talk he was giving at an art college in Dublin sparked off in his own mind the idea of using fire in his works. 'Mr Nash, you've made wooden tables, wooden ladders and other domestic wooden artefacts. Have you ever thought of making a wooden hearth?' Laughter from the students, but the image stayed with him. Later on, when being persuaded to buy a wood-stove for his home, the potential absurdity of its name also struck him. At the time he was working the Bronturnor oak, his first 'wood quarry'. He found himself, one day, considering a short, forked section of trunk, wondering how he could open it out. He realised that by pushing the end of the blade into the front of the block and making two vertical cuts, about twelve inches apart, and then two horizontal ones, joining the other two, top and bottom, he had made an incised square. This enclosed a cube of wood that was still held in place at the back, within the block. By driving the point of the saw down from above, he was able to cut through that section so that the block could be removed, leaving a cube space like the interior of a stove. Setting a fire inside this space, he found that the smoke was naturally drawn up the narrow slit he had cut from the top, which functioned as a perfect flue. Furthermore the solid wood of the block itself, which was still full of moisture, did not burn away but simply formed a thick charred surface inside, the flames gradually widening the flue with repeated use.

The piece combined a practical function with an aesthetic one. In the way it linked interior with exterior space, through the visible movement of the smoke, it echoed a very basic principle of sculpture – the practice of making holes in solid blocks of wood or stone. *Wood Stove* (1979) was soon followed by others, and Nash has since made a practice of making one wherever he is working, in whatever material seems most appropriate to the place. At first he intended to bring the stove into a gallery space to exhibit, together with a photo of it burning, but the object felt too inert. Photographs of each

stove have become, in surrogate form, an experience of a moment in that place.

He saw, also, that stoves and fireplaces, or at least the traces of them, have always been one of the most basic indications of the presence of man, not simply to archaeologists but to anyone walking in remote areas such as the Welsh hills. Fire must imply the gathering of combustible material, and that process itself links man to the place where he is setting the fire and, perhaps, establishing a camp. The sense of the presence of human beings in such places is very strong.

Peat Stove (1980) was made simply by using a spade to dig the necessary space out of a bank on the moor near Blaenau, with the smoke emerging through the heather further back. Since the ground in this place is normally completely sodden, there was no danger of it setting light to the moor. *Sticks and Clay Stove* (1981) was made at a work-site in the Biesbos, Holland, using the natural materials of the place: fallen willow sticks bound together with the wet clay from the ground. On another occasion, at Bronturnor in Wales, Nash built a stove out of stones from the bed of a stream, placing it next to one of the waterfalls. This created a juxtaposition between the rising flames and the tumbling water.

Snow Stove (1982), a huge piece nearly ten feet high, was made at Kotoku when Nash was working in sub-zero temperatures on his first project in Japan. The fire first created a layer of ice within the interior space, preventing the mass of snow from melting, so that the stove was then able to burn continuously for several days. *Bamboo Stove*, was made two years later, also in Japan. Nash was visiting a monastery near his work-site, when he was surprised to hear loud explosions coming from a maintenance area. Investigating, he found that the gardeners were burning bamboo. The air within the hermetically sealed spaces of bamboo canes expands, and they eventually blow up with loud reports. Nash built a stove in which he wired all the sections of bamboo together, in the hope that the stove would not blow itself to pieces.

One should not over-emphasise the importance of these stove sculptures within the total corpus of work that Nash has produced. They are important to him in terms of coming to terms with the varied conditions of the places in which he works. They can be 'read' as conceptual, even as performance works, as well as physical entities. They have also drawn Nash into close observation of the functioning of fire as a force, and its use as an agent in forming and affecting sculptures of a very different kind. Nash has found that fire itself, the formation and intensity of flames, varies considerably from place to place, though he has not attempted to analyse this in detail. In Japan he finds that fire burns with a particular ferocity, with little flickers leaping demoniacally off the main flame, while on a recent project in Barcelona he found that the actual flames assumed new forms and moved in the air in a manner he had never encountered before.

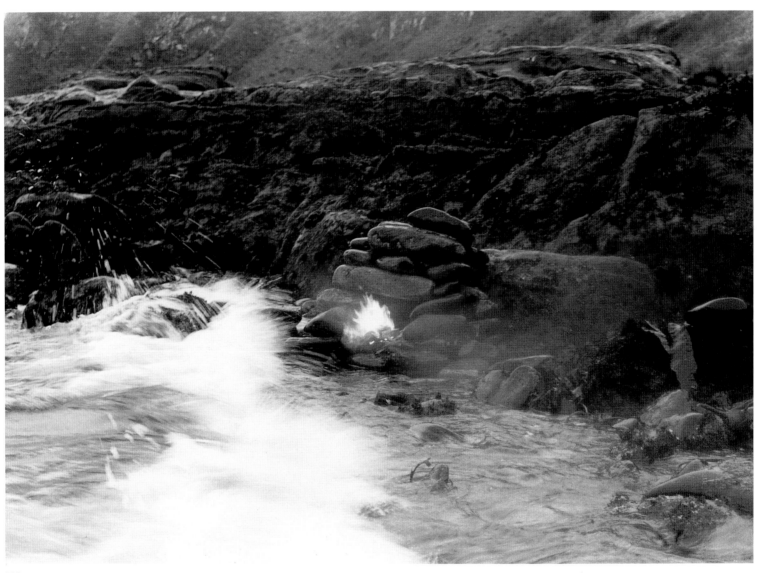

113

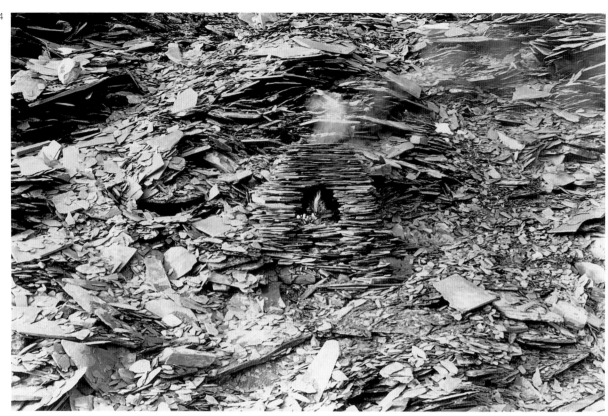

114

114 *Slate Stove*, 1980

115 *Sticks and Clay Stove*, 1981, willow sticks and wet clay, *c.* 125 × 90 × 90 cm (50 × 36 × 36 in), Biesbos, Holland

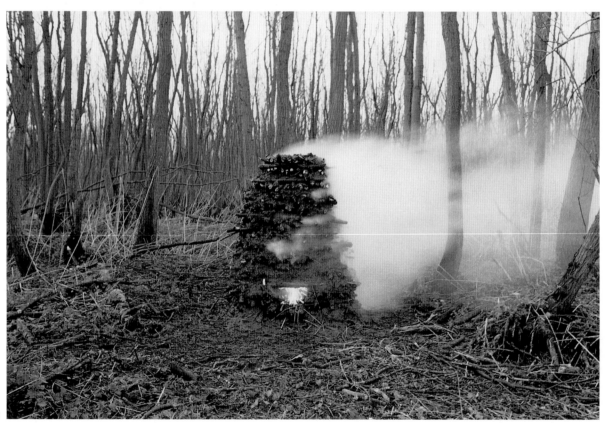

115

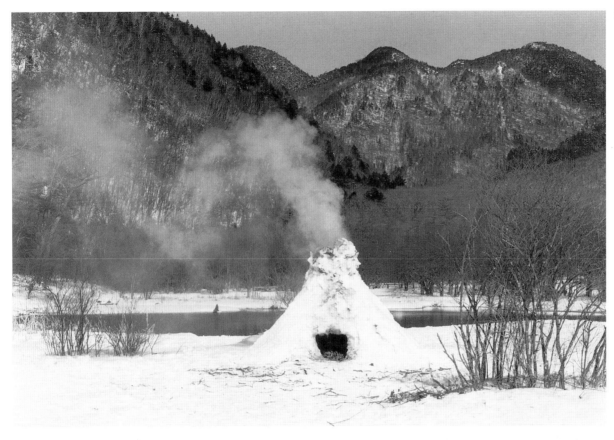

116 *Snow Stove*, 1982, 300 × 375 × 375 cm (120 × 150 × 150 in), Japan

117 *Bamboo Stove*, 1984, 100 × 90 × 90 cm (40 × 36 × 36 in), Japan

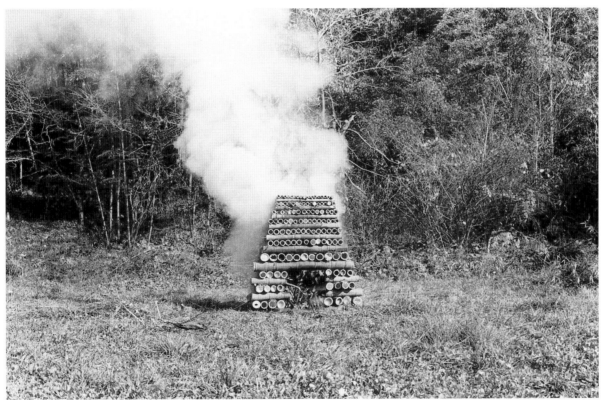

THE ENVIRONMENTAL WORKS **113**

11

THE CHARRED WORKS: VEGETABLE TO MINERAL

In addition to making his stoves Nash had also started to make deliberate use of fire in the shaping and finishing of sculptures, and in variations on preferred themes, through the process of charring wood. While he had first done this as a casual experiment in 1971, he did not then think of the process as something he could regularly apply to sculptural forms. He was to realise, later, that charring could be used as an effective agency for shaping blocks of wood, and for adding a different dimension to the surface of a work.

In 1983 he was working in the United States, in St Louis, making use of discarded tree-trunks. Nash planned to carve a trunk of American sycamore (common maple) into an irregular column and began making a number of cuts at intervals round it. His intention had been to split around each cut but he found the wood did not split in a satisfactory way. Having to seek another approach he saw an opportunity to bring the element of fire into the work. With the trunk lying horizontal he made a small fire to burn into each cut and, as the fires gradually took hold,

he started to revolve the trunk so that the charring process could go right round, biting deep into each opening. As he progressed he realised that he was learning to control the burning process and to shape the wood. The fire widened the cuts into V shapes which, in turn, accentuated the rhythmic form of the piece, very reminiscent of Brancusi's column. Nash had always felt that that work gave an impression of breathing in and out as it rose into infinity. The eventual result of this first experiment was *Charred Column 1* (1983), of which a number of versions have since been made. More than eleven feet tall, it is an imposing piece.

In carrying out the charring process Nash was aware, from the start, that in impressing the element of fire onto the wood he was not only emphasising the qualities of warmth and of light which are present in the growth of the material, but was actually altering the surface of the wood from a vegetable to a mineral substance. He had always found that whenever he looked at a wood sculpture he would be conscious, first, of the presence of

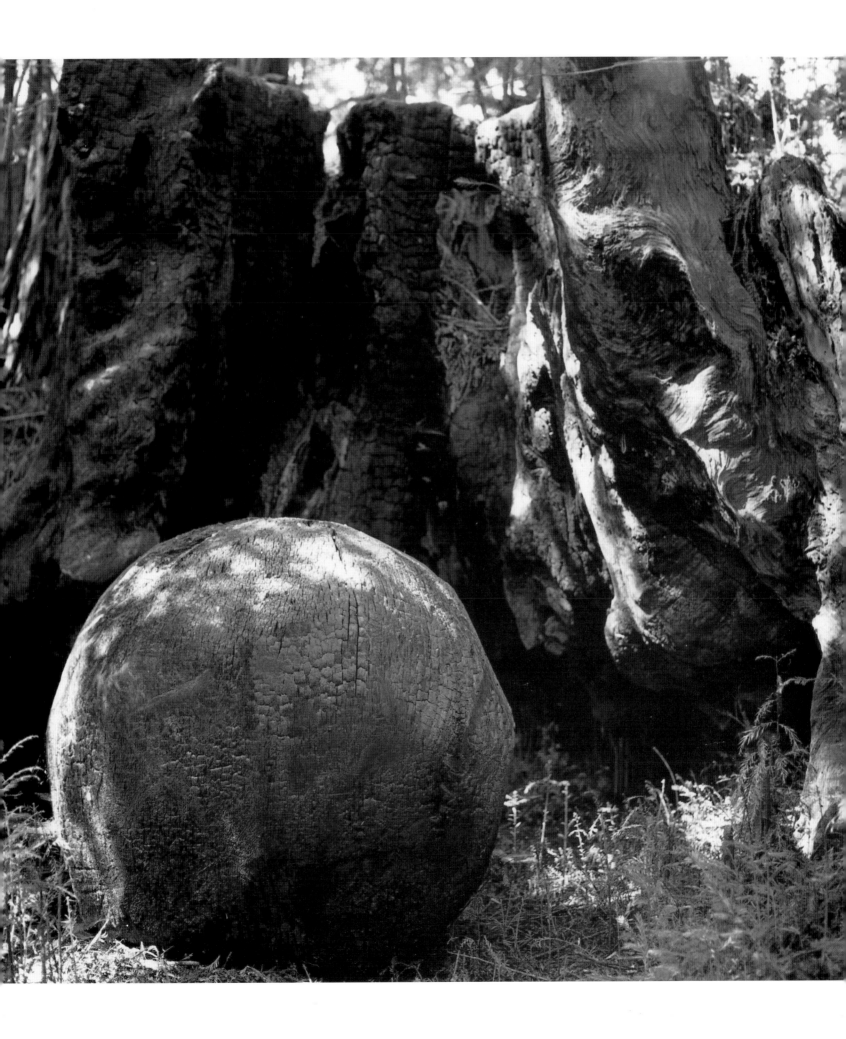

118 (overleaf) Detail of *Three Charred Forms*, 1989, charred redwood, *c.* 137.5 × 137.5 × 137.5 cm (55 × 55 × 55 in)

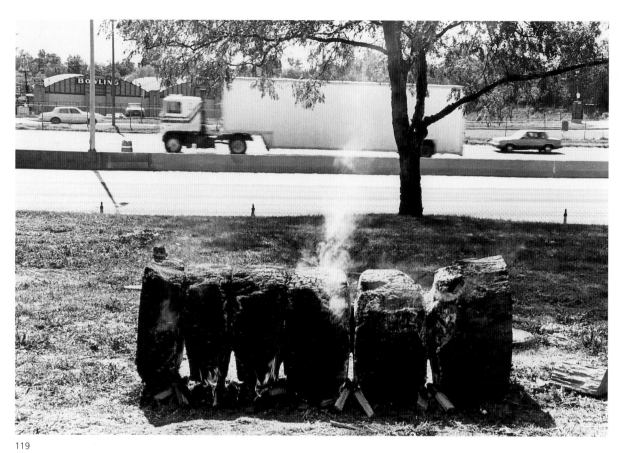

119

119 *Charred Column* in progress

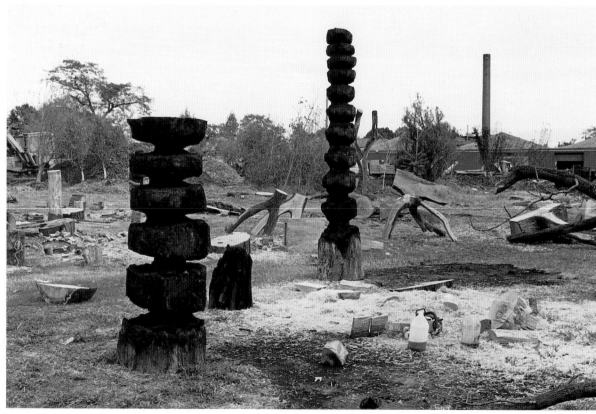

120

120 Work-site, Forest Park, St Louis, showing *Two Charred Columns*, 1983, maple, right: *c.* 335 × 40.5 × 40.5 cm (132 × 16 × 16 in), left: 183 × 46 × 46 cm (72 × 18 × 18 in)

→
121 *Charred Column 1*, 1983, maple, 335 × 40.5 × 40.5 cm (134 × 16½ × 16½ in)

wood, the material, before he really saw the form. But in transforming the surface of the piece into a black, carbonised finish he found a change took place: the intense black had the effect of distancing him from the piece so that he now saw the form before experiencing the material. He also felt conscious of the element of time which the charring process had brought into the work. Only later did he discover a comment by the philosopher Rudolf Steiner to the effect that the experience of carbon causes a duality in one's perception, so that one has simultaneous feelings of repulsion yet a keen interest to penetrate to its centre – an insight with which Nash felt an instant affinity.

The work that provides the most obvious comparison with *Charred Column* is a much later one, *Threshold Column* (1990; Plate 10), which, again, exists in several versions. In this case Nash has cut a series of segments from the trunk of a tree and has charred them after first hollowing them out, creating a tall sculpture which has a column of intense black space within it. This piece was in part inspired by a working visit to Australia where, while travelling in Tasmania, he saw a number of burned-out tree-stumps, but he was also aware of a lithograph by Odilon Redon in which the gaze of the viewer is drawn inexorably to the dark space inside a hollow tree. Another substantial charred work that he made in Britain was *Black Dome*, a commission for the Forest of Dean Sculpture Trail in 1986. Twenty-five feet across and more than a yard high in the centre, the circle of wood that makes up this sculpture is formed from nine hundred separate charred posts of larchwood, dug into the ground. The inspiration for this piece was the old charcoal-burners who used to work in this and other forests in England: Nash had seen traces of them during his 1978 residency in the Grizedale Forest. Here, the oval outlines of the original charcoal domes made by the burners in the last century were still faintly visible, marked out by particular combinations of plants, tolerant to the residue of carbon in the soil. Ideally, Nash would have liked to have made a dome out of real charcoal, but the material is too friable and fragile. His charred wood version echoes its inspiration while still fulfilling the demands of the commission, that the sculptures should be sensitive to the forest environment, while remaining easily accessible to the public. In terms of public acceptance this has been among David Nash's most successful works since, to his surprise, people have not only flocked to see it but have enjoyed walking over it. From being a piece intended for a quiet secluded spot, in which it would gradually reintegrate back into the soil, it has become a reference point on the sculpture trail and has required some restoration to counteract the attention it has been given. Nash has since made similar charred domes in other venues.

Small Coil and *Shooting Star*, both of 1987, show Nash trying out the charring process on two very different forms. It was when he began applying the technique to

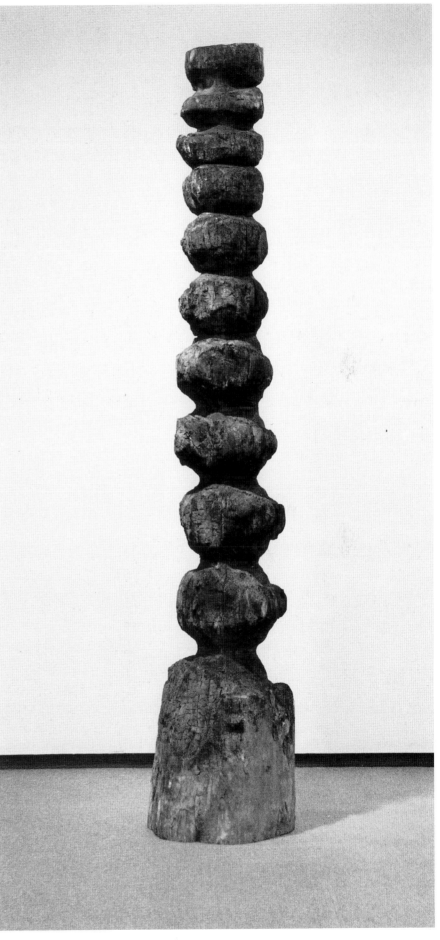

121

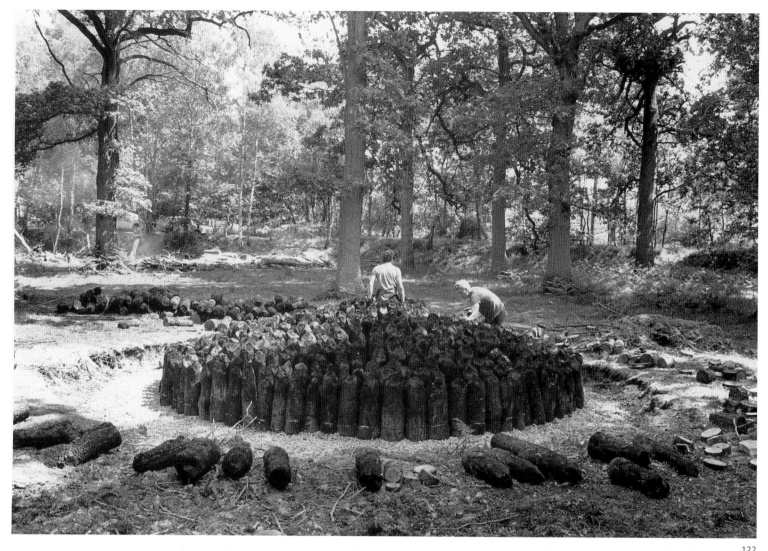

122 Installing *Black Dome*, 1986, Forest of Dean

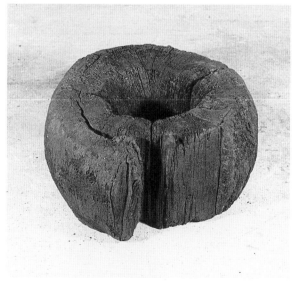

123 *Small Coil*, 1987, charred oak, 30.5 × 73.5 × 73.5 cm (12 × 24 × 24 in)

124 *Shooting Star*, 1987, elm, 75 × 75 × 45 cm (30 × 30 × 18 in)

123

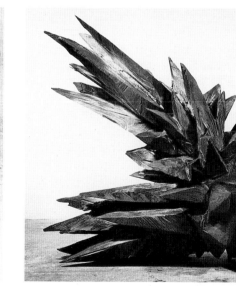

124

various of his *Vessel* pieces, made in the mid- and late 1980s, that he saw the process could produce other varied effects. The word 'vessel' can be used either in the generic sense of being a container, or the more specific meaning of a boat – also a kind of container. Nash's vessels play on the ambiguity of the meaning and in the *Vessel and Volume* sculptures make a visual pun, since the extracted centre of the vessel becomes a separate vessel shape as well. In the beech version he has charred all surfaces of both elements of the sculpture, but in the elm version he has alternated the charred and plain surfaces to add another level of illusion: the hollow vessel appears full while the solid one looks hollow at first glance. He elaborated the variation between charred and uncharred surfaces even more in *Hiroshima Vessels* (1987). This major commission for the Hiroshima City Art Museum uses the partially charred shapes of several vessels to cast white 'shadows' onto those next to them, an understated but telling reference to the blinding light and artificial, permanent shadows caused by the 1945 atomic bomb.

In the following year Nash made *Four Charred Menhirs*, originally in two pairs, brought together as one work, the larger sections of which are over eight feet high. A few years later, while engaged in charring two tall pieces, chance played a part: at the top of each element was a large knot in the wood which became detached as the fire burned, leaving a hole. The resulting two figures then appeared to be much more animate, and Nash christened them *King and Queen*. They are the two central elements shown here. At precisely the opposite pole, in terms of sculptural form, is his three-part work of 1989 entitled *Three Charred Forms*, a black version of a formal, geometric theme, *Nature to Nature*, which is analysed separately. Also from 1989 is *Comet Ball*, one of several versions of a piece inspired by the return of Halley's Comet to European skies, a piece in which Nash has used the base of an elm trunk to carve a solid wooden ball (the 'body' of the comet) out of which, still from the same block, he has carved a long, delicate tail. The base of the piece is partially charred to suggest the effect caused by the friction of heat on space capsules on re-entry to the earth's atmosphere. Next, within this group, is *Black Through Green*, a set of charred steps made in 1993 as a commission for the Laumeier Sculpture Park in St Louis, Missouri. In this case he noticed that on a rough path down a slope in the park the existing railway sleepers, used as steps, were rotting away and needed to be replaced. By making a series of replacement steps out of trunks of oak, which he then charred, but making them far longer than the originals so that they would extend out on both sides of the original path, Nash was able once again to work towards the kind of juxtaposition of strong colours that he had sought in his early constructed pieces, particularly *Chelsea Tower 3* at the Serpentine Gallery in 1970. He had noticed that a carpet of poison

ivy, a bright green plant in summer, spread all down the hillside on either side of the path. He realised that visitors to the park would gradually erode a polished path down the centre of his steps, just as they had worn the surfaces of his larchwood posts in the *Black Dome,* but the ends of the steps, protected by the poison ivy, would be emerging from and disappearing into the brilliant green on both sides – *Black Through Green*, precisely the effect he had been seeking for so long.

The group of charred sculptures discussed here have been, in a sense, artificially grouped together to illustrate Nash's use of the charring process. In addition to the effects already mentioned, which often give a haunting and evocative atmosphere to the pieces (they even retain the smell of charring for a long time), Nash is also interested in the effect and impact of *black as a colour*. In spite of many years working exclusively with natural wood, almost in monochrome as it were, he has never lost his fascination with the problem of how to use and present colour in space. In her highly poetic essay for the catalogue of Nash's 1994 touring exhibition in USA, *Voyages and Vessels*, the English writer Marina Warner points out that 'recently David Nash has been edging into colour', the Laumeier work being an example. But the signs have been there for several years now: in 1989, on a project at Ile de Vassivière in France, he made a major piece called *Charred Wood and Green Moss*. Using an open clearing within a thick, green deciduous forest, Nash laid out twenty-three large sections of tree trunks, of differing lengths and thickness, all of which he had previously charred, to make an uneven but spiralling pattern of massive black forms within the soft green of the moss that covers the space. The simple, apparently random distribution of the logs, creates a very minimalist work.[9] Bit by bit the blackened logs will become absorbed into the moss. With the cycles of moisture and warmth, green mosses and soft grey lichens will begin to cover the log surfaces. The colours, which make such a dramatic contrast at present, will gradually merge into each other.

Red and Black, made in Poland in 1991, is also concerned very directly with colour relationships, though it is a more complex work. While working on a project in the east of the country, close to the border of Byelorussia, Nash was making use of local oak and birch when he noted concentrations of alders growing in an area of uneven, heavily pitted ground. Alder wood turns a deep red when cut, so he realised he could make a work using three colours: black of the charred oak, white of birch and red of the alder. The work also had another resonance for those who knew where it came from: the area had been a battlefield during the First World War and the alder wood, blood-red, had come directly from the craters and shell-holes of this grim place. The work had brought its origin into the gallery in an unexpectedly symbolic manner.

Nash has made a number of other pieces which might

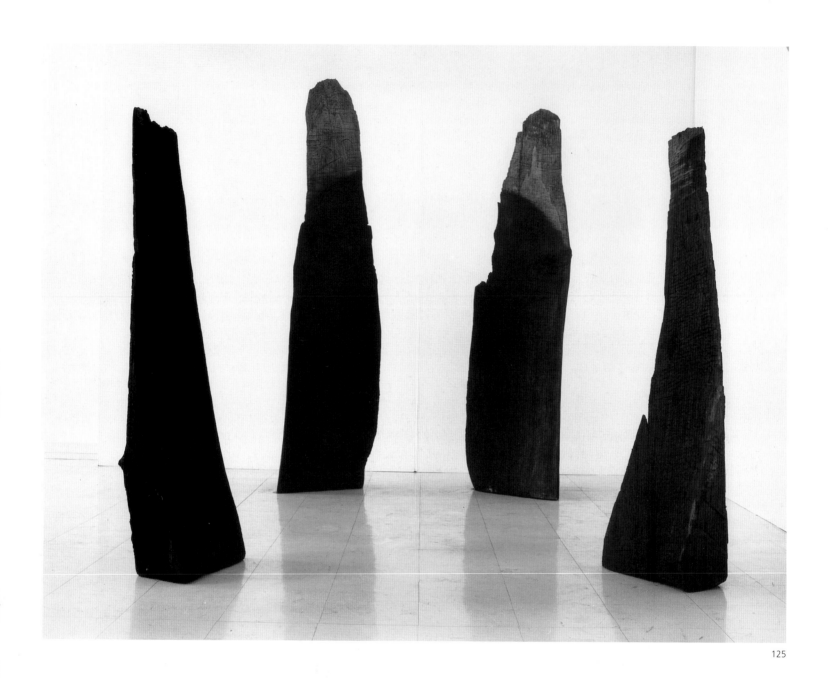

125 *Four Charred Menhirs*,
1988, oak, 4 elements: largest
elements *c.* 254 × 46 × 35.5 cm
(100 × 18 × 14 in)

120 THE CHARRED WORKS

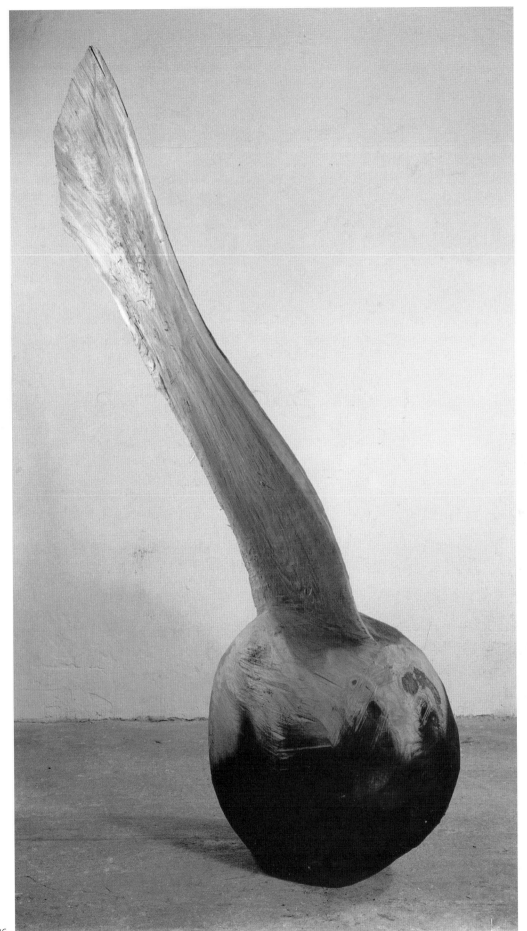

126 *Comet Ball*, 1989, elm,
205 × 60 × 60 cm
(82 × 24 × 24 in)

126

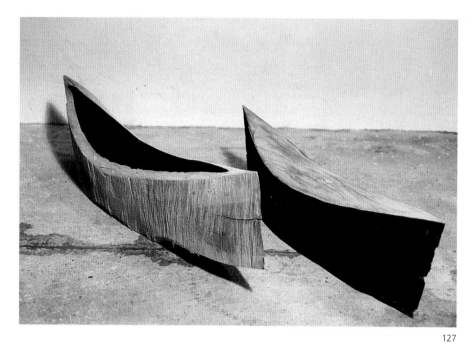

127

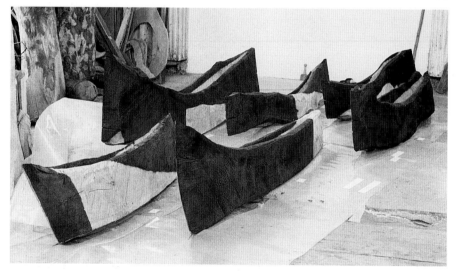

128

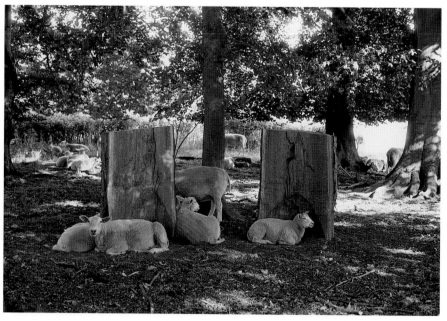

129

most appropriately be described under the general heading of 'installation works', although they do not involve charring or the use of colour. Two examples, *Wooden Waterway* and *Sheep Spaces*, are outdoor works, involving use of the actual landscape in which they are placed. They are not simply forms made out-of-doors which could be moved inside and shown in a gallery – unless in the form of documentation.

Wooden Waterway was made during Nash's residency at the Grizedale park in early 1978. Nash was surprised to find that in spite of continual rain the sodden ground dried out as the trees came into leaf. He realised that the water was all being sucked directly up into the trees. Reflecting on the image of water flowing within the wood, he decided to echo this natural process by making use of two fallen trees, diverting the water from a nearby stream to flow down channels cut in their length. Placing the upraised end of one section over the start of the next allowed him to carry the flow of water on an extended aerial journey, through a sequence of trunks and branches. He never intended this to be a permanent work, but when he returned to Grizedale later he found that visitors to the park had interacted with it. People had spontaneously gone to a lot of trouble to repair and maintain what had started out as a temporary work, replacing rotten sections, adjusting bits that had shifted during bad weather, making sure the flow of water could continue. The piece he originally thought might have existed for six weeks has so far lasted sixteen years.

Sheep Spaces, made in Denmark in 1993, derives from a series of drawings that Nash made on the moors above Llan Ffestiniog in 1980. At this period he was doing a great deal of drawing and had made himself a special portable easel, a light frame that he could hang round his neck with sheets of drawing-paper inside. It was a way of carrying large sheets of paper which also gave a firm surface on which he could draw while out on the hills. He had noticed that the local sheep, when seeking shelter from the wind, would find hollows and corners under banks or behind field walls, in the lee of huge boulders, in which to rest. Repeated visits to such places by the sheep would leave marks where they had lain, defining the space which would thus reveal itself, complementing the solid form of the rock beside it. Delighted to find the natural habits of the animals defining sculptural space in this way, Nash went in search of such places, making drawings (often multiple ones on the same sheet of paper), 'collecting' them also in photographs. Occasionally he has found the same phenomenon in other countries, most recently in Spain, where sheep define spaces beneath the roots and trunks of gnarled olive trees, staining them red with dye from the marks on their backs. In his Danish work, Nash has made eight large blocks from pieces of fallen tree-trunks, placing them in an area often used by sheep. The animals are wearing away the ground in front of each block, leaving charac-

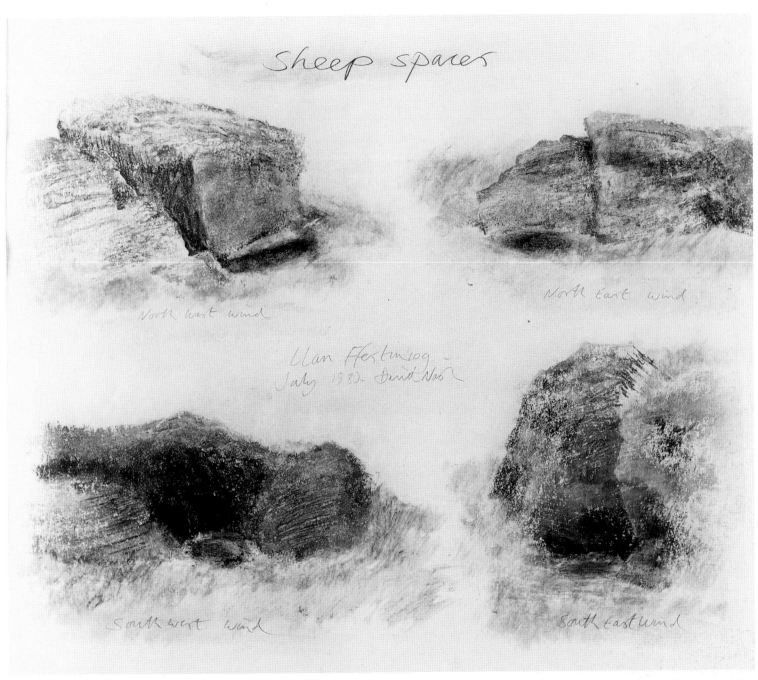

sheep spaces

North West wind

North East wind

Llan Ffestiniog –
July 1980. David Nash

South West wind

South East Wind

130

teristic marks where they rest against them. The piece functions in a similar way to the large bronze *Sheep Piece* which Henry Moore placed in one of the fields near his studio at Much Hadham, the difference in approach being that while Moore was concentrating on form, creating a sculpture whose curved shapes echo those of the sheep that cluster beside it, Nash is interested in the *space* beside the object (less important in itself) which only becomes a reality when the sheep defines it. The difference is essentially conceptual.

9. Interestingly, in 1992, the American minimalist sculptor, Carl Andre, made *25 Cedar Scatter* in which his baulks of timber are laid out in a configuration very similar to Nash's sculpture, but in an indoor space.

127 *Vessel and Volume (Small)*, 1988, partly charred elm, 2 elements: 35 × 25 × 140 cm (14 × 10 × 52 in) and 35 × 17 × 110 cm (14 × 6½ × 44 in)

128 *Hiroshima Vessels*, 1987, partly charred oak, 6 elements: overall size 60 × 500 × 200 cm (23½ × 197 × 79 in)

129 *Sheep Spaces*, 1993, oak and sheep installation, 25 metres (82 feet)

130 *Sheep Spaces*, 1980, pastel and natural materials, 65 × 77 cm (25½ × 30 in)

'12

ANOTHER PART OF THE WOOD

Within a few years of his first exhibition, shown at York and Bangor in 1973, David Nash was beginning to be noticed in the wider sphere of the art world. The gallery co-ordinator of Arnolfini in Bristol, Clive Adams, visited him in Wales in 1974 and agreed to mount an exhibition, *Loosely Held Grain*, in October 1976. Nash himself designed the publication that accompanied this show, and it has since been his practice, where possible, to take an active role in the design and editing of publications concerned with his work. Two years later, to accompany his first London exhibition mounted by Moira Kelly at AIR Gallery, Nash produced another booklet, *Fletched over Ash* (1989), similar in format. In addition to photographs of sculptures this publication contained documentation about the *Ash Dome* project and, as the exhibition toured, from London to Chester, and on to Cardiff, it became evident that this work, in particular, was attracting much attention. He was now appearing regularly in group exhibitions, having been invited by William Tucker to show work in *Condition of Sculpture* at the Hayward Gallery in

1975, and by the Arts Council to participate in *Summer Show III* at the Serpentine Gallery the following year. An excellent interview with Nash by Alan McPherson was published in *Artscribe* in June 1978, while *Art and Artists* published the first extended essay on his work, 'The Woodman' by Hugh Adams, in its issue for April 1979. Adams drew attention to the differences between Nash and others who were then loosely grouped together under the label of Land Artists, pointing out that 'not only does his work continue to exist as far as possible in future time (the conventional sculptor's way) but . . . it continues to develop through time, and grow . . . Nash, more than any other Land Artist, has made a commitment to place'. Later the same year the art critic of *The Observer*, William Feaver, commented positively on the works Nash had made in Grizedale Forest.[10] Finally, of great importance to any artist who is trying to live from his work, the first shows of Nash's work at commercial galleries outside Britain were held at the Elise Meyer Gallery in New York, and at Galleria Cavallino, Venice, in 1980.

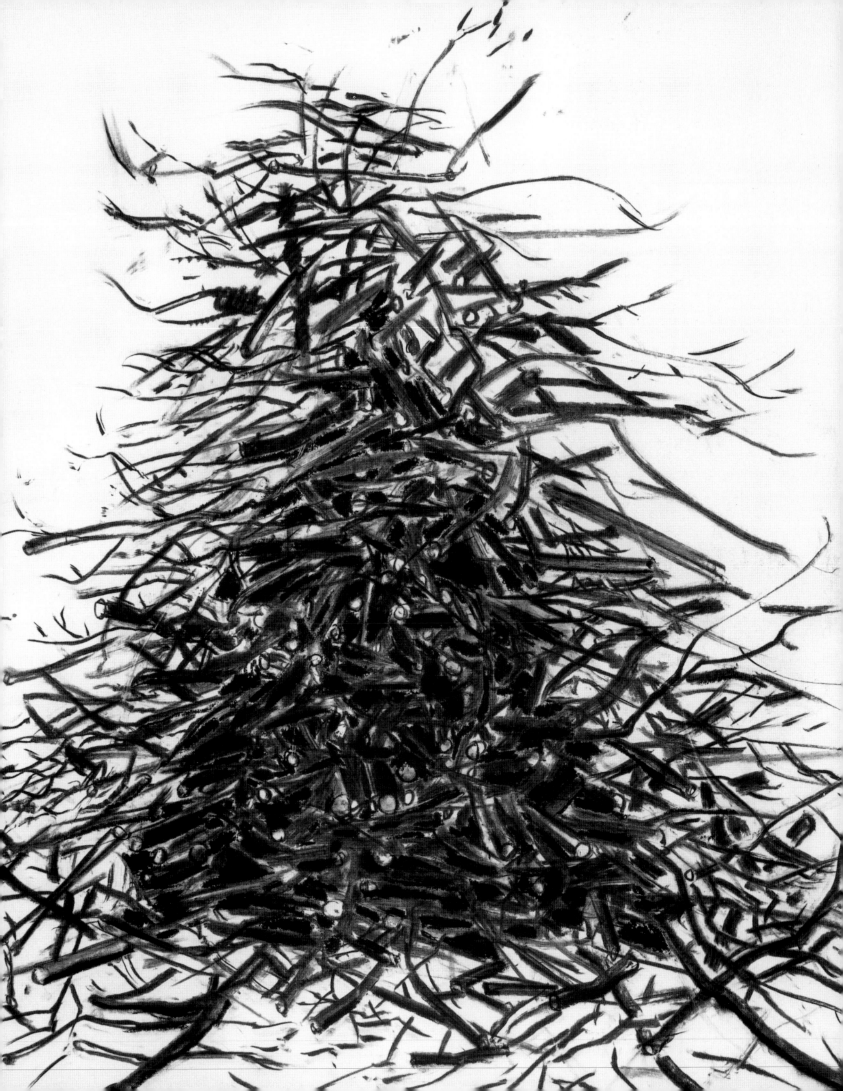

131 (overleaf) *Pyramid in the Sticks*, 1982, charcoal drawing, 102.5 × 121.5 cm (40 × 48 in)

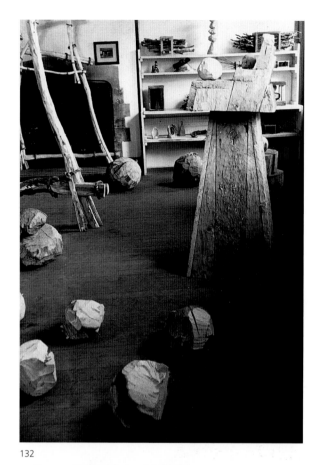

132 *Briefly Cooked Apples*, exhibition, Queen Elizabeth Hall, York, 1973, showing *Bonks on a Rostrum* (right)

132

133 Installation, Serpentine Gallery, London, 1976

133

134 *British Art Now: An American Perspective*, exhibition, Solomon R. Guggenheim Museum, New York, 1980

134

A member of the British Council's staff, Ian Barker, an Exhibition Officer in the Fine Arts Department in London, became an important catalyst in the growing international recognition of David Nash as a member of a new generation of British sculptors. Ian Barker was helping to organise itineraries round British galleries for the Curator of the Guggenheim Museum in New York, Diane Waldman. Mrs Waldman made several visits to Britain during 1979 to look at work by emerging artists, in order to select participants for a show she was planning of contemporary British Art. Among other exhibitions she saw was Nash's show at AIR Gallery, which impressed her. She and Barker visited Nash in Wales and she decided to include him in her group show, *British Art Now: An American Perspective*, the 1980 Exxon International Exhibition at the Guggenheim. Only eight artists were selected: Nash and another sculptor, Nicholas Pope, the painters Alan Green, John Edwards and Hugh O'Donnell, two artists working in photography, Simon Read and Tim Head, and Keith Milow who showed a series of wall-reliefs and drawings. It was a very individual, idiosyncratic selection, which – as the sub-title to the show clearly indicated – represented a personal view of some current developments rather than a definitive statement of the current British scene. Unfortunately a few commentators chose to wilfully ignore this, and the show ran into some criticism from writers who seemed to take offence that non-American artists could dare to show abstract art within the hallowed precincts of a New York museum – the painter Alan Green, for example, coming in for some unfair flak for his colour-field paintings, merely because this was felt to be an American preserve on which he had no right to trespass. In general, however, David Nash came out of the mêlée fairly well, since his works were not only interesting pieces, well selected, but resembled nothing on the current American scene. Hilton Kramer of the *New York Times* commented perceptively that 'this sculptor is at his best when he removes his "found" materials in the direction of a pastoral Minimalism (in the piece here called *Up, Flop and Jiggle* for example)',[11] while John Ashbery, in *New York* magazine,[12] felt Nash to be the most interesting artist in the show, finding his 'benevolent despotism more appealing than the Ozymandias pose struck by so many American workers in the genre' – the genre being earthworks and Land Art in general. The Australian critic Robert Hughes, writing in *Time* magazine, defined Nash's work as belonging 'in the general category of land art but . . . infused by a wit and sweetness usually absent from that genre'. He also commented on 'its unpretentious dialogue with natural shape, which Nash treats not as raw material but as an equal partner in conspiracy'.[13]

The exhibition continued to attract a lot of attention when it returned to London for a showing at the Royal Academy, where the artists presented new work. *The Observer* noted that Nash's sculptures: 'have both wit and

dignity restored at the RA . . . this is largely because there is a new selection of works, chunkier and more carpentered . . .'.[14] Interestingly, while American critics picked up on the minimalist quality to Nash's work which this book has emphasised, many British writers still tended to see his work more in terms of wood-craft, getting distracted by the nature of his branches and by the wit and humour, rather than considering the work in terms of strictly sculptural criteria. Regardless of this slight imbalance there is no doubt that this exhibition was an important milestone for Nash. He received invitations to take part in thirteen group exhibitions, including the Whitechapel survey *British Sculpture in the Twentieth Century* and the *Hayward Annual*, and eight solo exhibitions in the following three years. These latter shows included venues in New York (again), Ireland and the Netherlands.

Another visitor introduced to the work of David Nash by Ian Barker was Dr Rudi Oxenaar, Director of the Rijksmuseum Kröller-Müller at Otterlo, Netherlands, who made the trek up to Capel Rhiw in March 1979. On that visit he made the first significant purchase of a work by David Nash, when he bought *Elephant Passing the Window* for the collection of the museum. As a trustee of the Yorkshire Sculpture Park, where Nash had a residency in 1981, he had further opportunities to follow the development of the young sculptor's work, inviting him to hold a major exhibition – *Wood Quarry* – at Otterlo in 1982. On this occasion other important works were purchased by the Kröller-Müller and, in addition, Nash was commissioned to carry out two planted pieces in the parkland adjoining the museum. These were his first planting pieces created specially for venues outside Britain.

The group exhibitions included the first large survey of contemporary British art ever mounted in public museums in Japan, prepared by the British Council in conjunction with the Japanese Association of Art Museums. The Exhibition Officer responsible for working with the Japanese organisers on the selections for this show, which included eight older artists in an introductory section and twenty-five individual shows in the main section, was again Ian Barker. It was agreed that David Nash would carry out a working project in Japan, the results of which would form his room in the exhibition *Aspects of British Art Today*.

For Nash the experience of working in Japan in 1982 turned out to be not only successful in terms of the sculptures produced but deeply significant for him in terms of his working processes. It was also an important human experience for him, leading to continuing contacts with Japanese museum and gallery directors. In addition to short visits in connection with particular exhibitions, he made an extended visit to Japan with his family in the autumn of 1984, when he carried out working projects in four separate sites. Ten years later, in 1993–4, he worked over three successive seasons at the village of Otoineppu, in the northern province of Hokkaido, to

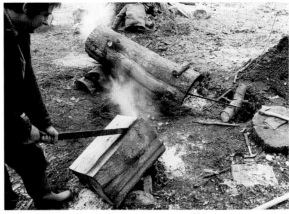

135

135 Work-site, Rijksmuseum Kröller-Müller, Otterlo, 1982

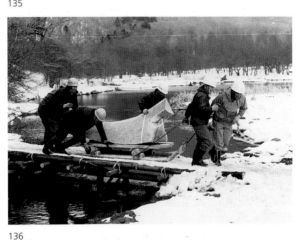

136

136 Moving *Wooden Fish*, 1982, Kotoku, Japan

137

137 Work-site, Pierre de Bresse, France

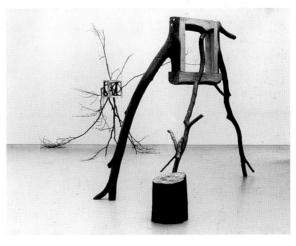

138

138 Installation, Rijksmuseum Kröller-Müller, Otterlo, showing *Branch Cube* (left) and *Standing Frame* (right)

ANOTHER PART OF THE WOOD **127**

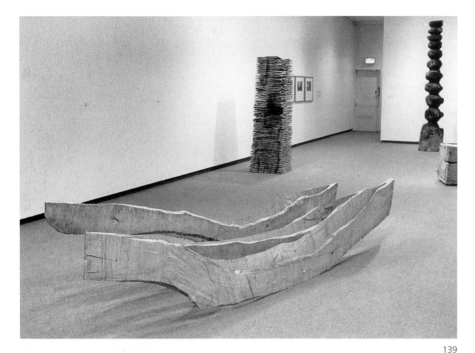

139

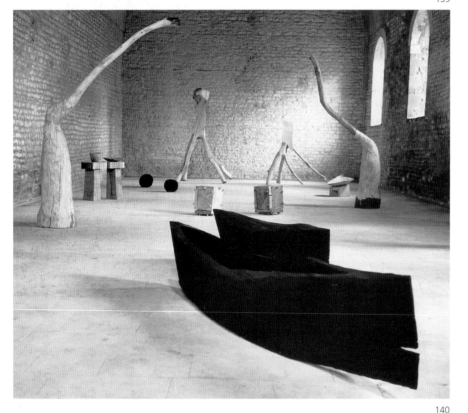

140

139 *A Quiet Revolution: British
Sculpture Since 1965*, exhibi-
tion, Museum of Contempo-
rary Art, Chicago, 1988,
showing (clockwise from
top): *Crack and Warp Column*,
Charred Column and *Three Long
Boats*

140 Installation, l'Abbaye de
Tournus, France, 1988

make works for a touring exhibition, *Spirit of Three
Seasons*.

The crucial difference for Nash, between the 1982
project in Japan and his previous projects, was that he
was provided with a team of skilled forestry workers and
their equipment. To his relief he found, within hours of
starting work with this group, that 'the language problem
did not exist since we all spoke the language of wood'.
He found the Japanese foresters instinctively understood
what he was trying to do, and often one of the team
would be at his elbow with precisely the tool he needed
without his having to ask for it. The Japanese organisers
had found for him a large mizunara (water-oak) tree that
had come down on a steep slope beside a river, 4000 feet
up in the mountainous national park of Upper Nikko. The
whole area was more than three feet deep in snow, with
the temperature in the daytime seldom rising above
minus ten centigrade, but Nash learned that Japanese
foresters make a point of moving timber in winter since
snow and ice make it easier to shift heavy tree-trunks. In
three weeks of intense work in these conditions, he pro-
duced a larger number of pieces than ever before from
one 'wood quarry', being filmed by a Japanese television
company who transmitted bulletins about his progress on
breakfast TV each morning. This publicity brought his
work, and the exhibition which was about to open in
Tokyo, to the notice of enormous audiences.

Nash realised that working with a team of appropriate
helpers, either forestry workers or art students, gave him
a resource which enabled him to save time on labour-
intensive work such as felling a diseased tree, cutting up
the trunk and carrying out the charring process on large
pieces of timber. The immediate result was that he felt
confident tackling works on a bigger scale than he had
attempted before, and this is reflected in many of the
sculptures he has produced from the mid-1980s: the
charred columns and stacks, the ascending and descend-
ing vessels (some of which have been made for specific
outdoor sites), and the tall thrones and shrines. From the
early 1980s on, whenever a working project has been
proposed in connection with an exhibition, Nash has felt
better able to plan it by insisting on certain conditions,
such as the availability of a suitable support team and the
necessary equipment – which may involve lifting gear or
tracked vehicles. He has also learned how to cost such
projects in advance so that these factors can be taken
into account when an exhibition budget is prepared. In
some countries Nash has developed a continuing relation-
ship with places and institutions to which he returns every
few years. In several of these he has been commissioned
to make planted works and the costs of his regular visits
to check the condition of the sculpture or make necessary
adjustments to it are now built into the original contract
for the piece. Mention has been made of his various pro-
jects in Japan, the most recent being the Otoineppu
Spirit of Three Seasons in 1993–4, but he has made suc-

cessful working visits to many American states, Australia, France, Poland, Denmark, Hawaii and Spain between 1982 and 1995, in addition to numerous other exhibitions, details of which are listed at the end of this volume. At the Djerassi Foundation in California he was given the opportunity, for the first time, to work with redwood, the monumental *Three Charred Forms* (1989) being one of his strongest works in the strictly formal geometric idiom.

More and more, as he has travelled the world to make sculptures and carry out working projects at specific sites, Nash has felt the need to familiarise himself thoroughly with each venue, before actually starting work. He first looks carefully at the museum, gallery, or exhibition space where the eventual products of his stay will be shown, preferring to have a mental image of this place already in his mind, before he goes to see trees and work-site that have been found for him. It is not simply a question of the size of the space: he needs to experience its nature and atmosphere, to allow the forms he will make to be prompted by those particular qualities.

In France in 1988, at the beautiful abbey of Tournus, one of the finest surviving early Romanesque buildings, several new themes developed. These included the extraordinary *Ubus*, surreal presences that looked as though they belonged naturally in the vaulted hall of the old refectory. The experience of working in this place, imbued with centuries of religious feeling, seems to have been the catalyst that inspired a number of works with more specifically spiritual, as well as domestic connotations, which are described in the final section of this book.

A more obvious result of Nash's extensive travels has been opportunities to work with varied kinds of wood, many of which can never be available to him in Europe. In addition to the Japanese mizunara and the Californian redwood already mentioned, Nash has worked successfully with madrone, live oak, red oak and maple in the United States, with wattle and eucalyptus in Australia, with Hawaiian ironwood, and most recently with palm and with Australian pine in Barcelona. Here the local horticultural department made available to him a variety of dead trees from their special nursery, into which trees and plants are brought, complete with roots, from the city centre, and where many of them are successfully rehabilitated from the effects of pollution or disease. In addition Nash has worked, over the years, with the many varieties of apparently common trees such as oak, elm and birch that exist in different parts of the world. As a result of working in varied surroundings, often with professional foresters, his own knowledge and understanding of forestry, and therefore of wood as a material, has increased immeasurably. This enables him to make use of the individual qualities of different trees to create sculptures which, like those made in Wales, are very specifically of their place, linking him in turn to that place, to its climate and conditions, and to the people with whom he made them. The concern he sometimes felt

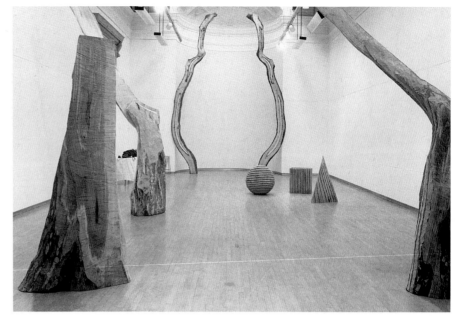

141

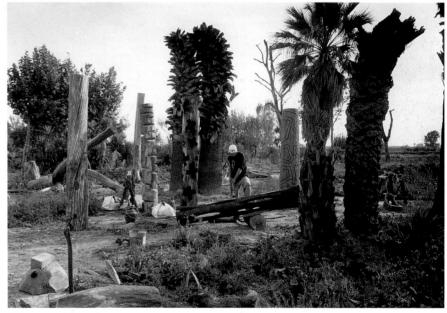

142

when young about the risk of sculptures looking out of place in natural surroundings, seldom applies in the case of his own works, which have been made and presented in a spirit of respect towards the material and sensitivity towards the place – wherever it may be.

141 Installation, Mappin Art Gallery, Sheffield, 1991

142 Work-site, Barcelona, 1995

10. *The Observer*, 19 November 1978

11. *New York Times*, 28 January 1980

12. *New York* magazine, 4 February 1980

13. *Time*, 11 February 1980

14. *The Observer*, 26 October 1980

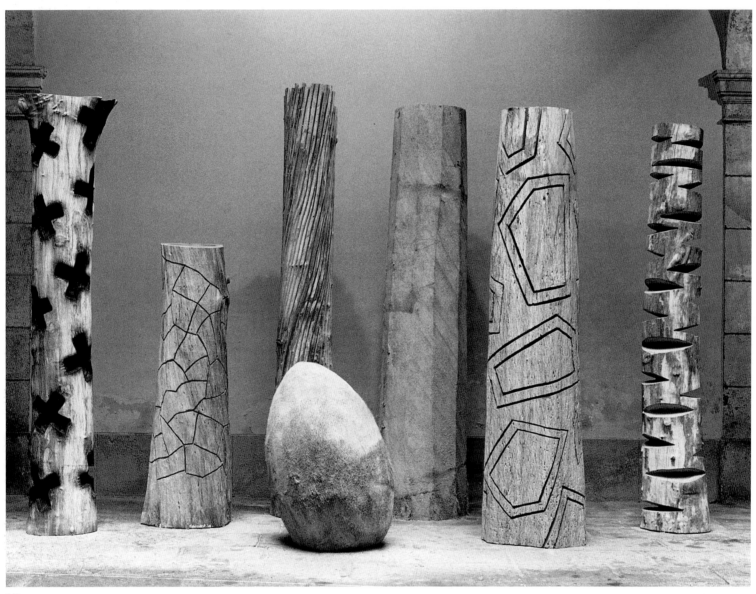

143

143 Installation, *Més enllà del bosc*, exhibition, Palau de la Virreina, Barcelona, 1995

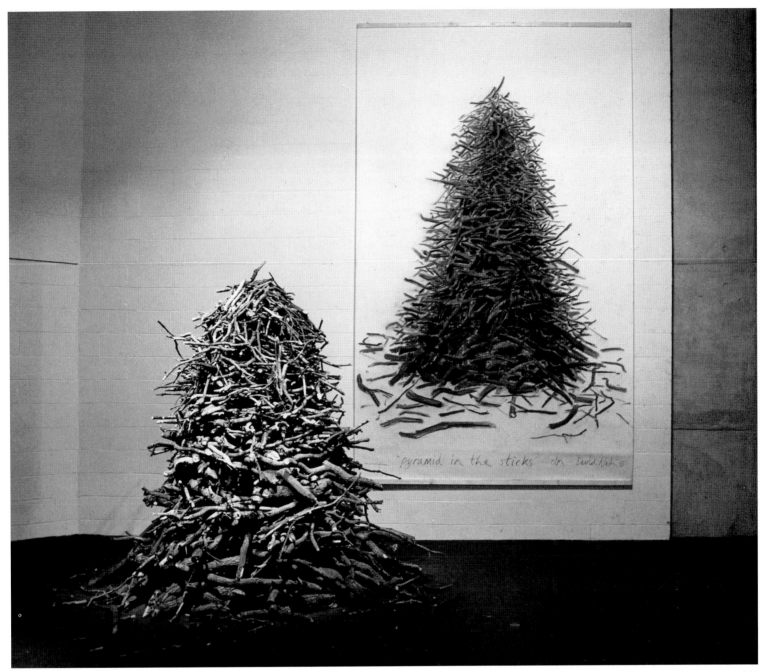

144 *Pyramid in the Sticks*,
1983, elm and charcoal on
paper, drawing
200 × 175 × 175 cm
(79 × 69 × 69 in),
wood 80 × 70 × 70 cm
$(31\frac{1}{2} × 27\frac{1}{2} × 27\frac{1}{2}$ in$)$

144 appears as a figure label top right of image

13

NATURE TO NATURE

The next sections of this book examine more recent developments in David Nash's sculpture, both his recurrent use of themes that first occurred many years – even decades – ago, and the growth of new subjects that have come to the surface, and which he is still exploring.

The ladder form first appeared in his work in 1977. It was developed further during his Grizedale residency the following year. His fascination with the effect of symmetry caused by splitting an uneven section of wood into matching halves and then joining them has already been described: the process naturally suggests the ladder shape. The biggest example he has made is *Big Ladder* (1984). It perfectly illustrates Claes Oldenburg's dictum about increasing a domestic object to a size that gives it a new dimension of reality: this piece does, in fact, bear a slight resemblance to the huge clothes-peg Oldenburg has installed in central Philadelphia.

Working with a dead, but still rooted elm tree in Ireland, Nash carved a flight of steps to create *Through the Trunk, Up the Branch* (1985). In another variant on

the ladder form he used a pattern of short, right-angled steps in a series of *Jacob* pieces in different woods, occasionally – as in *Apple Jacob* (1988) – bringing an animate quality to these works. The symbolism of staircases and flights of steps as metaphors for links between the earthly and spiritual worlds does not need to be stressed, but *Sylvan Steps* (1987) does have a strangely magical quality about it, inviting the visitor to rise beyond the point reached by the topmost step.

The practice of opening out a solid block and exploring its 'hidden' volume, analysed earlier, was taken a stage further in the mid-1980s with a series of sculptures in which Nash removed the entire central section of a standing form and then placed it beside the piece from which it had been cut. In effect, by emptying the volume he is emphasising the form. Such works, of which *Inside/Outside* (1986) is a typical example, can be read either as purely abstract visual games or as an echo of the Internal/External theme much explored by Henry Moore (itself a variant on his Mother and Child sculptures).

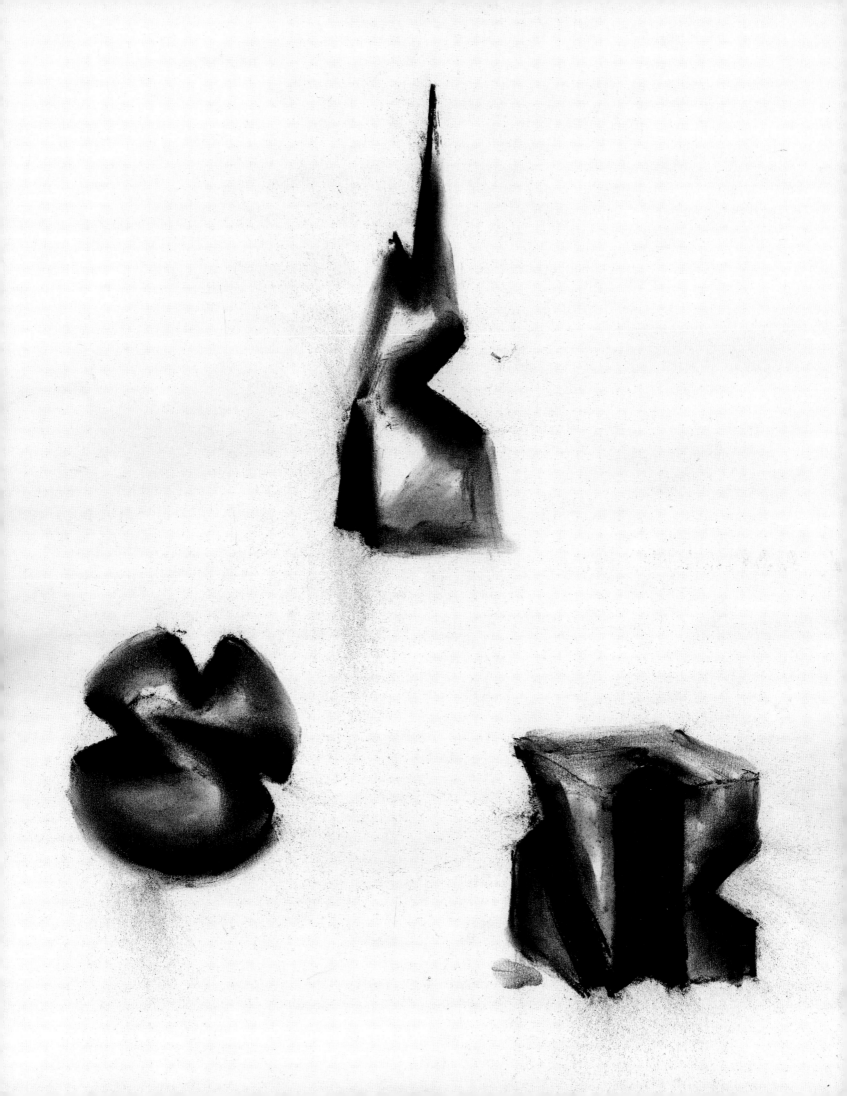

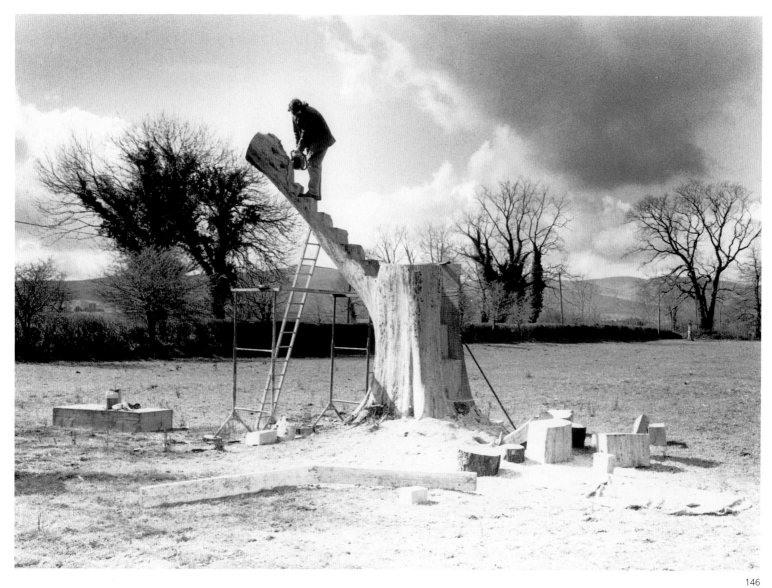

145 (overleaf) *Three Forms,
Three Cuts*, 1996, charcoal
drawing, 51 × 40 cm
(20 × 16 in)

146 *Through the Trunk, Up the
Branch*, 1985, elm, 360 × 390
× 165 cm (144 × 156 × 66 in)

147 *Sylvan Steps*, 1987,
redwood, 210 × 250 × 90 cm
(84 × 100 × 36 in)

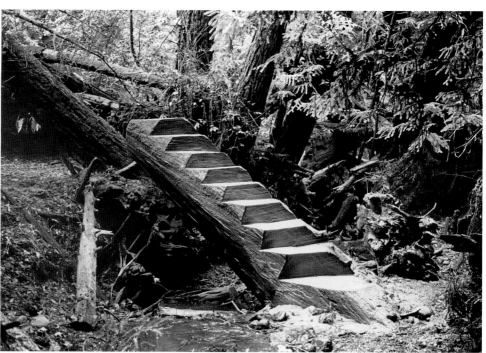

147

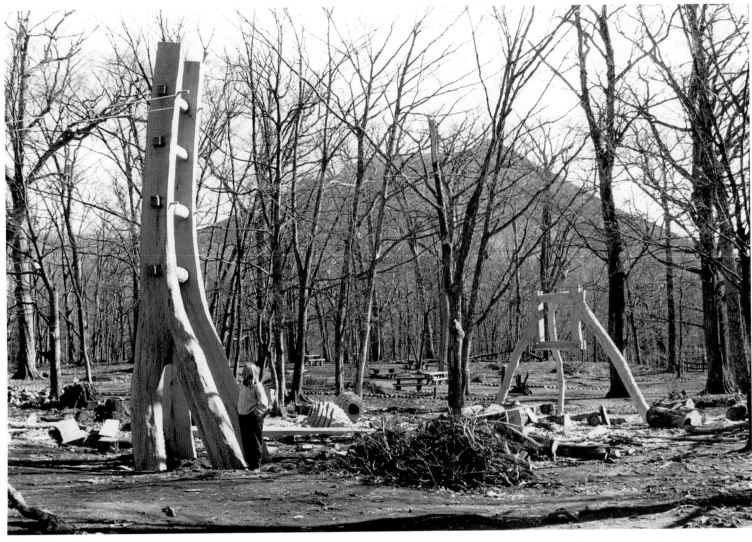

148

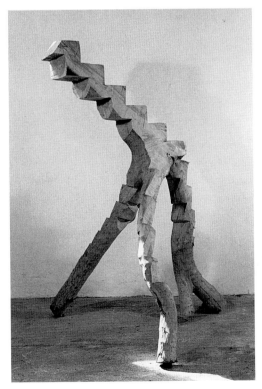

149

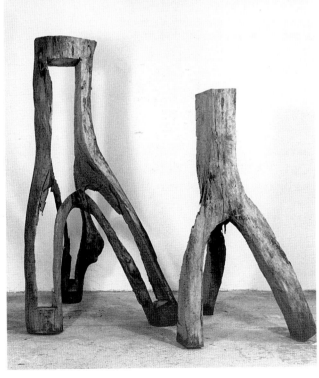

150

148 *Big Ladder*, 1984, oak,
525 × 185 × 150 cm
(210 × 74 × 60 in), Nikko
City, Japan

149 *Apple Jacob*, 1986, apple-
wood, 209 × 149 × 129 cm
(82 × 58 × 50 in)

150 *Inside Outside*, 1986,
elm, 2 elements:
200 × 107.5 × 127.5 cm
(80 × 40 × 51 in) and
160 × 87.5 × 107.5 cm
(64 × 35 × 43 in)

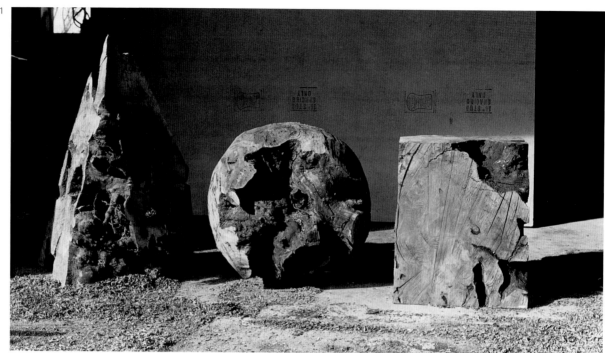

151 *Pyramid, Sphere, Cube: Madrone*, madrone, pyramid 76 × 51 × 46 cm (30 × 20 × 18 in), sphere diameter 51 cm (20 in), cube 51 × 46 × 46 cm (20 × 18 × 18 in)

152 *Vertical, Diagonal, Horizontal*, 1991, elm, cube 60 × 55 × 55 cm (24 × 22 × 22 in), sphere diameter 70 cm (28 in), pyramid 100 × 67.5 × 67.5 cm (40 × 27 × 27 in)

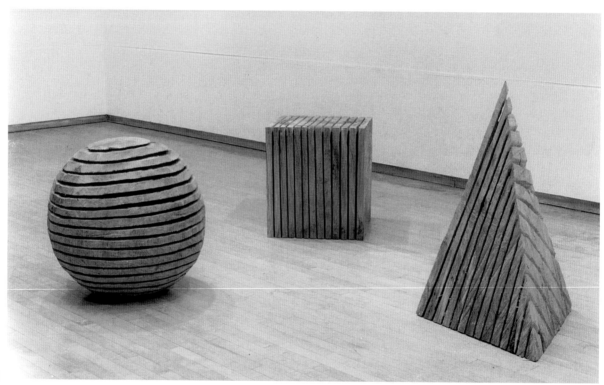

152

In his solid block pieces Nash returned, during his second working visit to Japan, to the basic geometric forms of cube, sphere and pyramid, placing the three elements of *Nature to Nature* (1984) into the dry bed of a river, with the intention that they should be washed down into different, unpredictable positions when the rainy season turned the rocky stream-bed into a torrent. The title of the work, of which a number of versions exist, was linked to the concept that all natural forms have an underlying geometric structure, whether in their crystals, their cell-patterns or their atomic and molecular structure. In some versions of this work Nash has shown his three-dimensional forms together with drawings of them, *Nature to Nature 4* (1990) and *Three Forms, Three Cuts* (1992) illustrating the effectiveness of such juxtapositions. The latter piece highlights the irregular cuts that have been taken out of the wooden elements, in strong charcoal drawings emphasising the void, rather than the

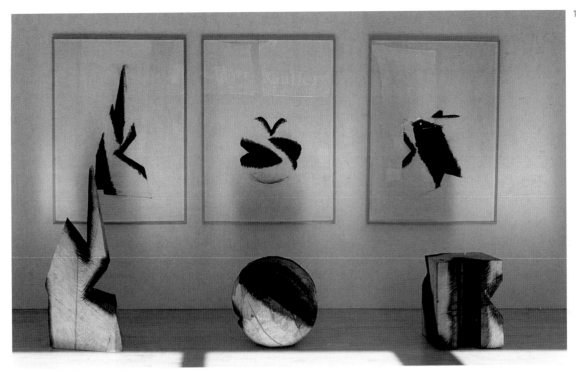

Three Forms, Three Cuts,
1992, ash, cube
57.5 × 45 × 45 cm
(23 × 18 × 18 in), sphere
diameter 60 cm (24 in),
pyramid 117.5 × 55 × 55 cm
(47 × 22 × 22 in)

154 *Nature to Nature 4*, 1990,
elm and charcoal on paper,
cube 55 × 45 × 45 cm
(22 × 18 × 18 in), sphere
diameter 60 cm (24 in), pyra-
mid 105 × 55 × 57.5 cm
(43 × 22 × 23 in), drawings
each 120 × 90 cm (48 × 32 in)

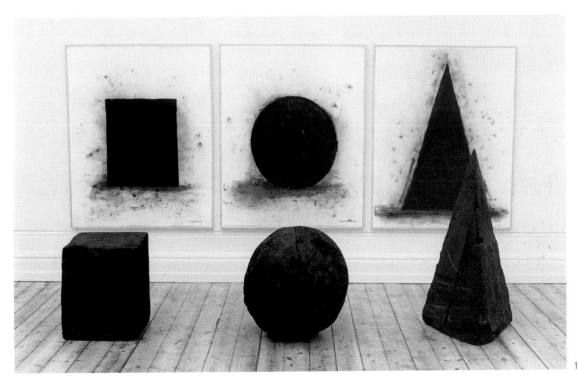

154

solid parts of the original forms. By putting a physical shape onto the floor contiguous to its own image on the wall, Nash induces two different kinds of comprehension in the viewer, enhancing both the solid object and its separate image. *Vertical, Diagonal, Horizontal* (1991), another variant, demonstrates the remarkably fine parallel cuts that Nash is, by now, effortlessly making with the chain-saw, while *Pyramid, Sphere, Cube: Madrone* (1995) shows him making deliberate use of naturally hollowed-

out blocks of madrone, a wood native to California, to illustrate the contrast of space and form which he had first explored in his very primal *Corner Block* pieces, some eighteen years earlier. In this whole series of *Nature to Nature* sculptures, Nash is bringing activity into elemental, geometric forms.

It was natural for an artist so concerned with the processes of nature, both in his material and in the forms he was making from it, to turn in due course to the most

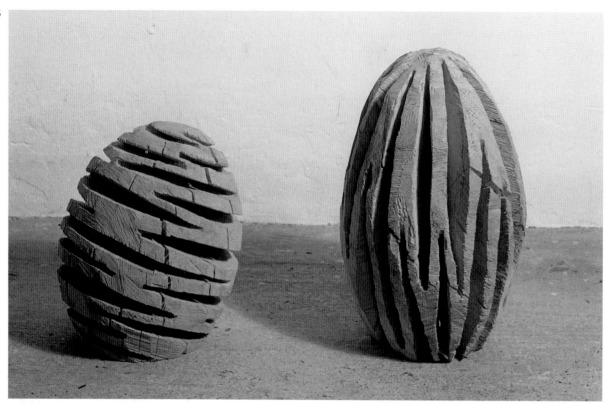

155 *Two Eggs, Longitude and Latitude*, 1990, oak, 62.5 × 30 × 30 cm (25 × 12 × 12 in) and 45 × 35 × 27.5 cm (18 × 14 × 11 in)

156 *Mosaic Egg*, 1988, white elm, 35 × 42.5 × 32.5 cm (14 × 17 × 13 in)

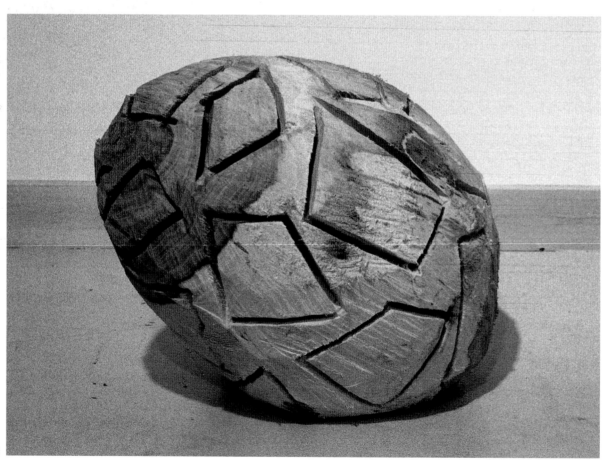

archetypal forms of all: the seed and the egg. *Celtic Seed* and *Celtic Bead*, both of 1988, were sparked off by an earlier version made in the same year in Pierre de Bresse, France. Nash had seen a tiny seed-like bead (which he learned was Celtic) at the Musée Rolin, in Autun, and had been studying the contrasting cuts the jeweller had made in it, using these on both the pieces mentioned and on a blackened version, *Charred Celtic Bead* (1991). The egg form Nash has explored in many versions, often as pairs with contrasting cuts in their surfaces, giving an effect of spinning or whirling. The first of the series was *Mosaic Egg* (1988) in which he carved a number of uneven diamond and rhomboid shapes into the surface of his egg-shaped block. The title of this work was used for the catalogue of an exhibition mounted by Annely Juda Fine Art in 1989, in which the following quotation by Nash appears:

Mosaic Egg
The Mosaic, a whole made up of many
The egg, whole in itself out of which
many may emanate

In this piece the design is surface decoration, leaving the perfect form of the egg inviolate, the mosaic pattern resembling those found on Russian Easter eggs. In most of his other egg sculptures Nash has cut deeply into the form to create a series of variations, sometimes – as with *Two Eggs, Longitude and Latitude* (1990) and *Enfolding Egg* (1993) – using the saw to create delicate openings and overlapping surfaces. In others, such as *Two Eggs, Sliced and Charred 2* (1991) and most recently in *Four Charred Cross Egg* (1994), he has used the charring process in addition to cutting. The first of these has had very deep slices cut into it before being totally charred; the second uses charring to emphasise the shape cut into it. This latter sculpture is one of a number of works made in 1994, discussed in the final section, in which Nash first began to make use of the formal cross shape.

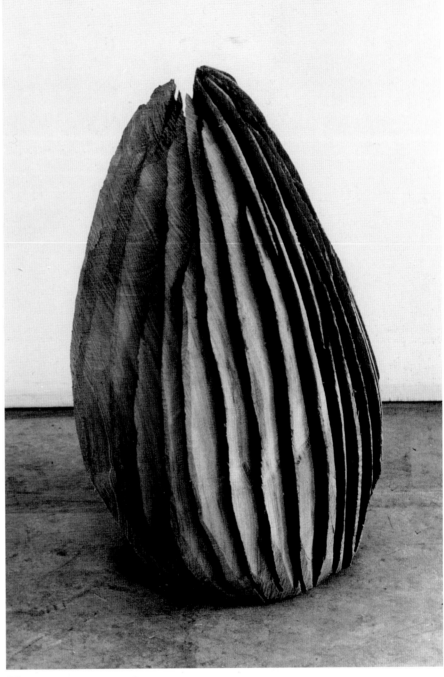

159

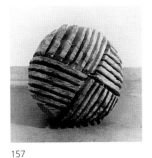

157

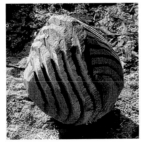

158

157 *Celtic Seed*, 1988, oak, height 54.5 cm (21½ in)

158 *Celtic Bead*, 1988, oak, height 85 cm (34 in)

159 *Enfolding Egg*, 1993, ash, 87 × 51 × 51 cm (34 × 20 × 20 in)

14

LENGTH AND LIMB

In the mid-1980s Nash was still exploring the possibilities of the branch form, in which a curving length rises out of a more solid section of tree-trunk, its origin clearly visible. His most ambitious developments of this 'length and limb' theme were first made during his residency at Pierre de Bresse, France, where the works he produced were shown in the vaulted space of the refectory in the eleventh-century Tournus Abbey. In these pieces, Nash has followed the line of the branch back into the solid block, but has retained a more substantial length of trunk. This not only gives a 'body' to the sculpture, but acts as a counterweight to the long waving 'arm' which extends out for a far greater length than that of the base section. The effect is not only animate but surreal, the sculptures recalling John Wyndham's shambling triffids, and Nash's choice of *Ubu* for their titles, taken from Alfred Jarry's *Ubu Roi*, was an inspired one. *Two Ubus* (1988) has two separate 'figures' made of oak and of ash, the 'chêne et frêne' that he had been given to work with, and were shaped specifically to reach into the vaulting of

the abbey roof. But Nash subsequently realised they worked well as a pair when shown in different spaces, and has kept them together.

The 'length and limb' principle is also followed in the various versions of the *Comet Ball*, one of which has already been described. In a beech version made in 1988 Nash has sliced the body of the piece into a sheaf-like pattern, while his most recent one, in elm, rises to a height of fourteen feet with a massive charred base. Similar in form to a *Comet Ball*, though lying on its side, is *Furrowed Oak*, made in Poland in 1991, which is a 'length and limb' piece with a strong, precise pattern of deep cuts carved into it. The combination of the strength of the form with the parallel lines of the cuts, gives this work a sense of springiness. The sculpture has had an unusual history. Following its initial showing in Warsaw it was charred, before going on to an exhibition in Belgium. Subsequently Nash decided to remove the charring, feeling that it obscured the contrast between the dark spaces of the cuts and the light surface of the block. The cuts had

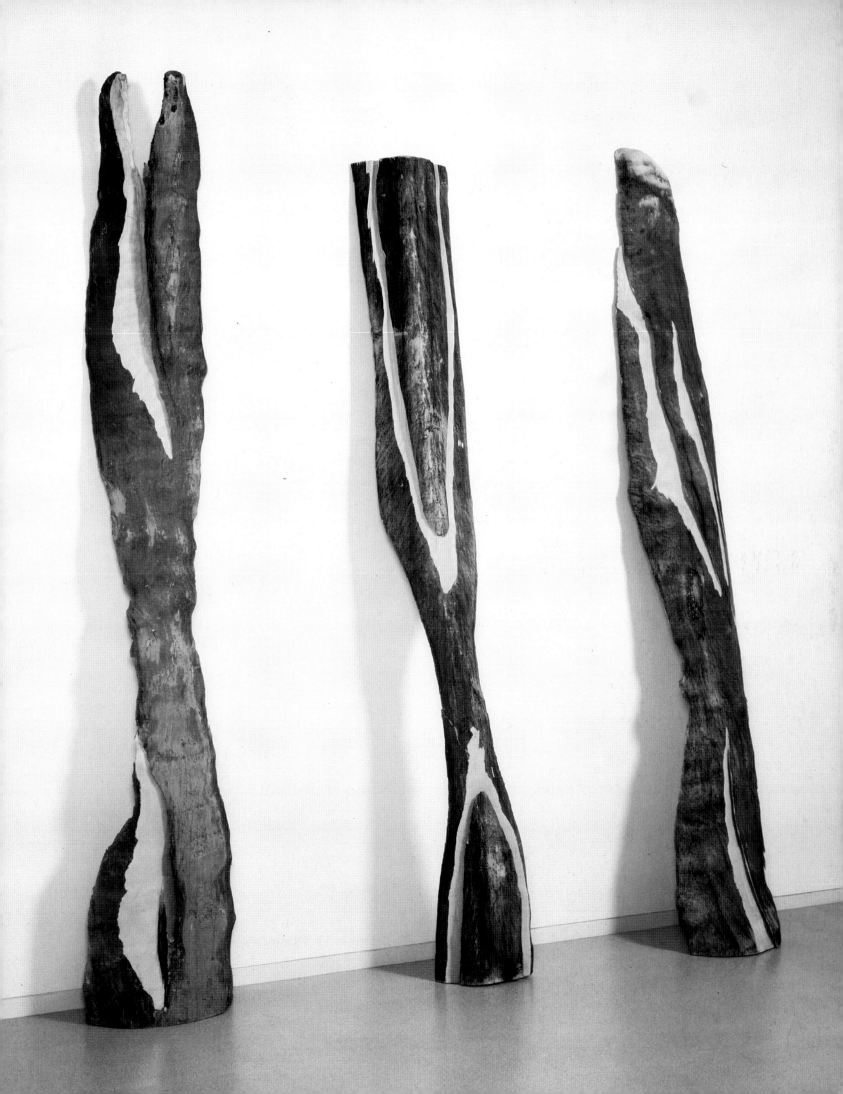

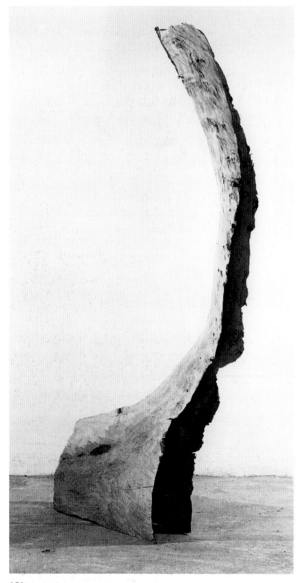

161

160 (overleaf) *Light in
Shadows*, 1993/4, birch,
3 elements: 316 × 60 × 20 cm
(124 × 24 × 8 in),
297 × 42 × 13 cm
(117 × 16½ × 5 in),
317 × 50 × 14 cm
(125 × 20 × 5½ in)

162

161 *Uppercut*, 1983/4,
limewood, 225 × 90 × 50 cm
(90 × 30 × 20 in)

162 *Skirted Beech*, 1985,
beech, 208 × 180 × 46 cm
(83 × 41 × 18½ in)

163

164

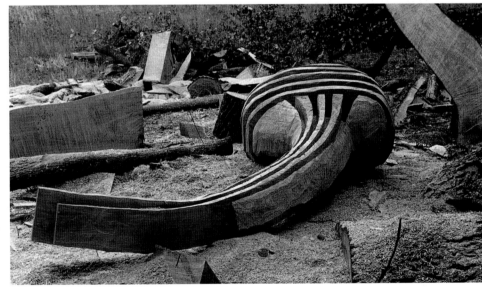

165

163 *Charred Fins*, 1987, oak,
81 × 163 × 41 cm
(32 × 66 × 16 in)

164 *Comet Ball*, 1995, elm,
420 × 85 × 85 cm
(168 × 34 × 34 in)

165 *Furrowed Oak*, 1991, oak,
81 × 112 × 325 cm
(32½ × 45 × 130 in)

167 *Rough Spirals*, 1989,
birch, 238 × 72 × 76 cm
(43 × 19 × 19½ in)

167

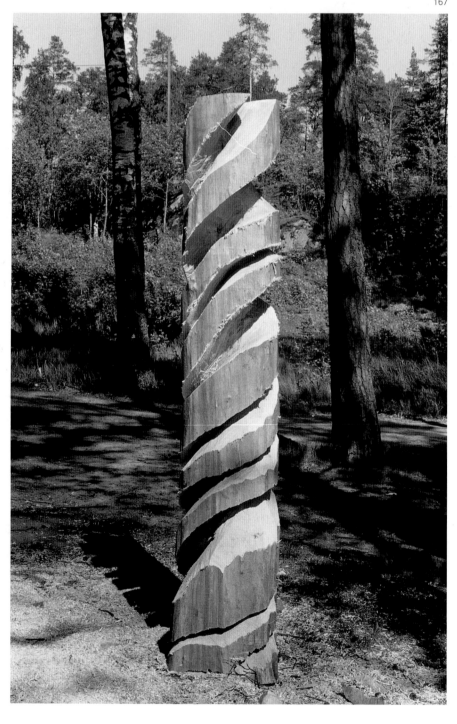

a special significance. In the district where Nash was making the piece the local farmers were ploughing their fields around him. The Polish painter Leon Tarasewicz, with whom he was collaborating, was making large paintings based on these fields. While a field is normally ploughed in parallel lines, some contrasting sweeps and right angles occur at corners, where the farmer has to wheel his horse or tractor round, in order to cover the edge of the field and get back to his original line. *Furrowed Oak* reflects these contrasting lines and curves.

Spiral forms begin to develop in 1987, with *Charred Fins*. A trunk, resting on a simple block, has had long sections cut from it which follow the natural line of the grain of the wood, slightly spiralling. The cuts have gone deeper than the radius of the trunk, so that the whole centre of the piece has been removed – except at the ends where, by making shallower cuts, Nash has effectively held the piece together, rounding off the exterior of the ends and then charring the sculpture. Another piece, *Rising Turning 2*, also from 1987, can be considered together with *Charred Fins*, the main difference being that Nash has made shallower cuts, thus leaving the solid centre intact. In this work he began with a heavy curved branch which then forked at one end. He deliberately cut open the wider arm of the fork, so that the right-hand end of the piece has three squared-off ends. These appear to have metamorphosed from the five we see on the left. This star shape, like a crystal, is also present on both ends of *Charred Fins*, but in *Rising Turning 2* Nash creates more of an optical illusion by apparently reducing five elements to three somewhere in the curve. *Rough Spirals* was made in Finland in 1989 and is simply a tall column of birch, of even diameter, into which deep spiral gouges have been cut. It resembles an enormous drill bit.

Saddle Tunnel (1990), like many of Nash's works, reflects the natural growth of the tree from which it has been cut. He has followed the curve of the annular rings when cutting out the centre of a trunk, to complete a piece which also plays on the juxtaposition of convex and concave forms within the same sculpture.

Finally within this group comes *Light in Shadows* (1993-4) in which three sections of Japanese birch were left out-of-doors to weather, so that the original pale wood turned a dark grey colour. Nash then brought the sections indoors before cutting uneven curved strips out of them, revealing bright golden wood inside. No longer exposed to the elements, these new surfaces will not change: the work therefore reflects not just the effect of time passing but the contrast between outdoor and indoor conditions.

After the experiences with *Cracking Box*, Nash decided to experiment with the use of fine cuts, which would enable him to create curves from apparently solid, chunky lengths of straight wood. In *Elm Spring Arch* (1984) he has used alternating cuts to create the effect of a stretched spring. In order to stabilise the piece, which would other-

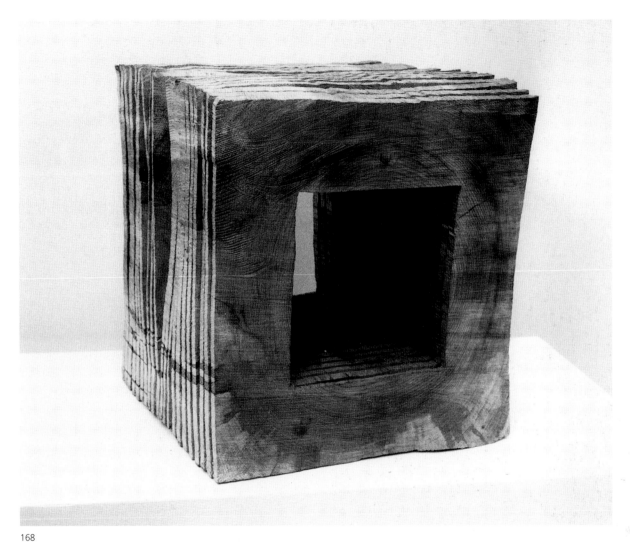

168

168 *Crack and Warp Frame*, 1994, elm, 46.5 × 44 × 43.5 cm (18½ × 17½ × 17½ in)

169 *Small Crack and Warp Stack*, 1985, ash, 87.5 × 27.5 × 27.5 cm (20 × 9 × 9 in)

170 *Elm Spring Arch*, 1984, elm, 117 × 160 × 38 cm (47 × 64 × 15 in)

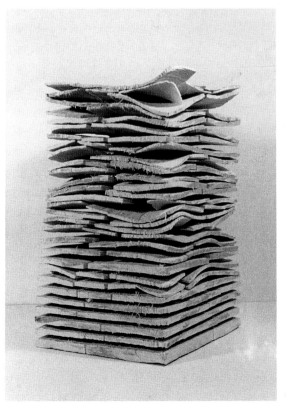

169

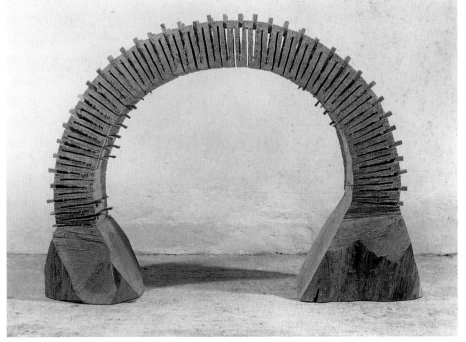

170

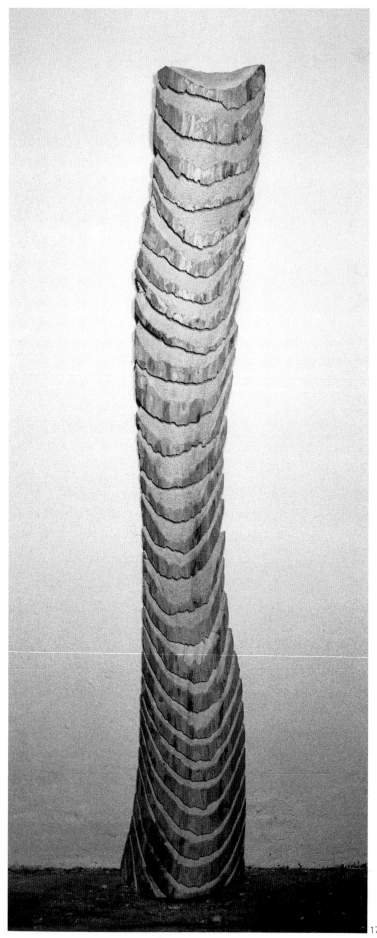

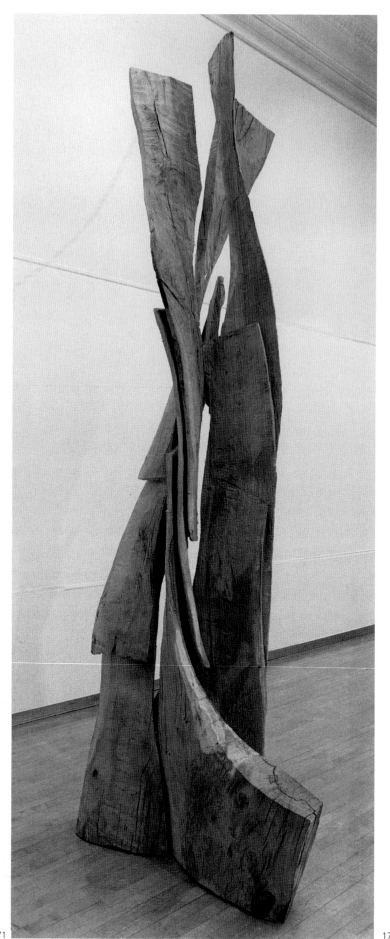

171

172

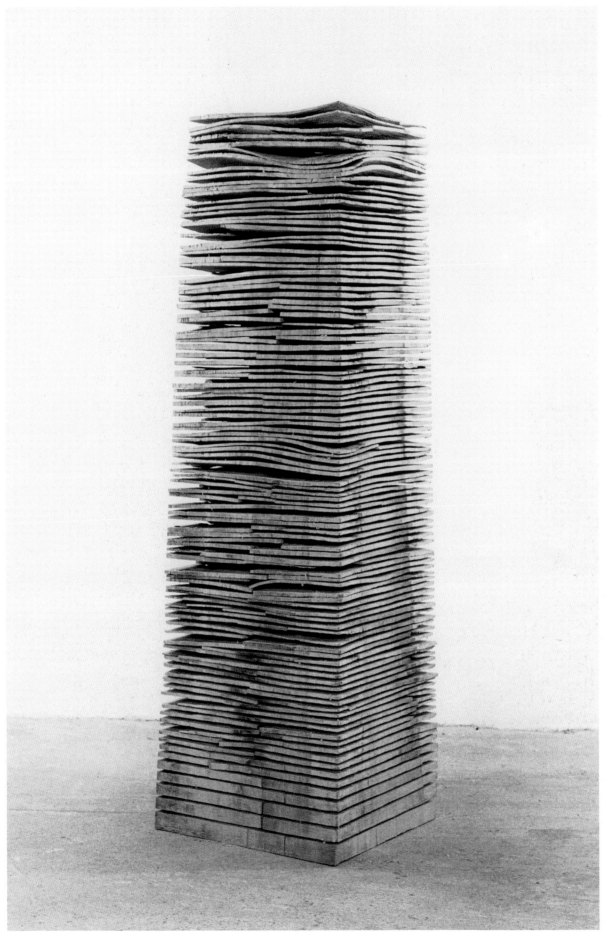

171 *Michaelmas Wall Piece*, 1987, ash, 240 × 39 × 14.5 cm (94 × 13 × 4 in)

172 *Spiral Sheaves*, 1990/1, oak, 300 × 117.5 × 70 cm (120 × 47 × 28 in)

173 *Crack and Warp Column*, 1985, ash, 198 × 61 × 61 cm (79 × 24½ × 24½ in)

173

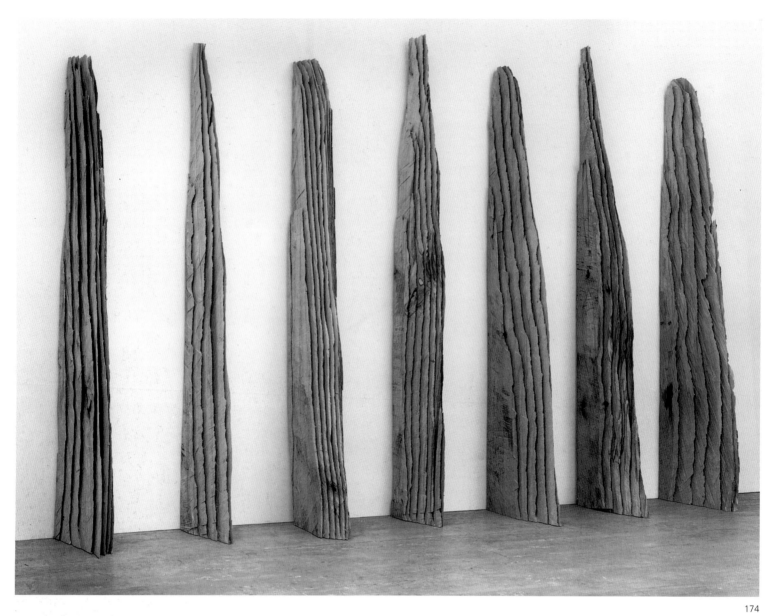

174

174 *Wall Sheaves*, 1993, beech, in 7 parts: height 270 cm (106 in)

175 *Two Leaning Beeches: Hidden Ziggurats*, 1995, beech, 49 × 18 × 13 cm (19½ × 7 × 5 in) and 50 × 18.5 × 18.5 cm (20 × 7½ × 7½ in)

176 *Two Sliced Menhirs*, 1989, beech, 195 × 55 × 27.5 cm (78 × 22 × 11 in) and 180 × 47.5 × 32.5 cm (72 × 19 × 13 in)

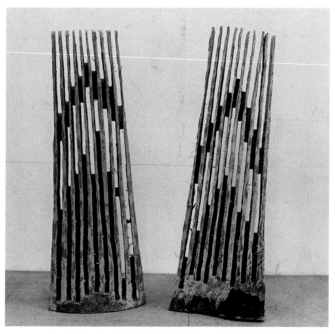

175

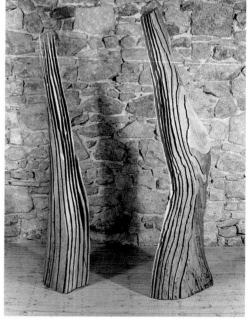

176

148 LENGTH AND LIMB

wise collapse, he has inserted small wooden wedges into all the exterior cuts – and some of the interior ones – cuts where support is required. The experience of making this piece was useful, in that he learned you cannot 'push' a form too far. Reflecting on the unpredictability of movement in wood, when sliced very thin, led him on to one of his most successful themes: the *Crack and Warp* pieces. In the first of these, *Small Crack and Warp Stack* (1985), he has squared off a section of trunk to create a slightly elongated, tapered cube, and has then made parallel cuts with the chain-saw into all four sides of the piece, leaving a small, invisible, solid column to hold the sculpture together. He also made his cuts at progressively narrower intervals as he moved up the piece, so that the 'slices' become thinner. Inevitably, when kept indoors in dry conditions, with warm air flowing between the slices, a process of warping, curving and, in extreme cases cracking, takes place. The fascination of such pieces is their unpredictability, the material visibly straining to resist the form that the sculptor has imposed on it, bringing curves, twists, unexpected lines and pools of darkness into what began as a precisely organised form. Oddly, one of the inspirations for *Small Crack and Warp Stack* was seeing a pile of poppadums in an Indian restaurant!

The fact that each different kind of wood moves, cracks and warps in a different way, has given Nash the stimulus to make these sculptures in many different venues, so observing variations in both process and result. *Crack and Warp Column* (1985), in ash, moved comparatively little compared to *Birch Crack and Warp Column* (1989; Plate 6). Made in France, its strong rounded sections at the base have hardly moved, but huge gaping openings in the central area (it is seven feet high) give a feeling of softness and flexibility. A recent piece, *Crack and Warp Frame* (1994), shows Nash linking the principles of movement to one of his earlier subjects, while *Skirted Beech* (1985) also seven feet tall, uses the slicing technique in the vertical, rather than horizontal mode, to create a sculpture which is tall, graceful, delicate – extremely feminine – while still conveying a sense of great strength. It is a piece which radiates confidence.

The following year Nash began applying the technique of slicing to rougher, heavier works in a series of sculptures to which he gave the generic name of 'sheaves'. The first of these was *Beech Sheaves*. A rougher, less evenly shaped block has been used, although the cuts are as symmetrical as in the *Crack and Warp* pieces. *Michaelmas Wall Piece* (1987) uses a similar, downward-slicing technique into a semi-circular trunk of ash. It is harder to 'read' at first, since in the positioning of the work against the wall the cuts are inverted. A delicate work in appearance, even though it is eight feet high, it has a succulent, fleshy quality, almost like a long slice of smoked salmon. *Two Sliced Menhirs* (1989) were made from beech in Bristol: Nash has used the curved shapes of the original branches to create two slightly ghostly

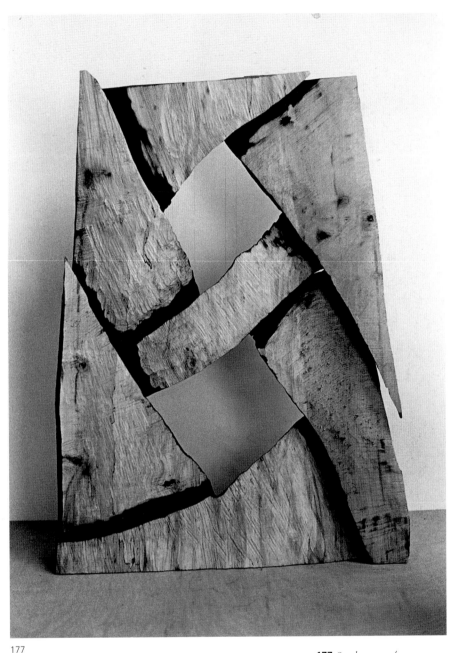

177

177 *Overlap*, 1993/4, lime-wood, 86 × 65 × 13 cm (34 × 25½ × 5 in)

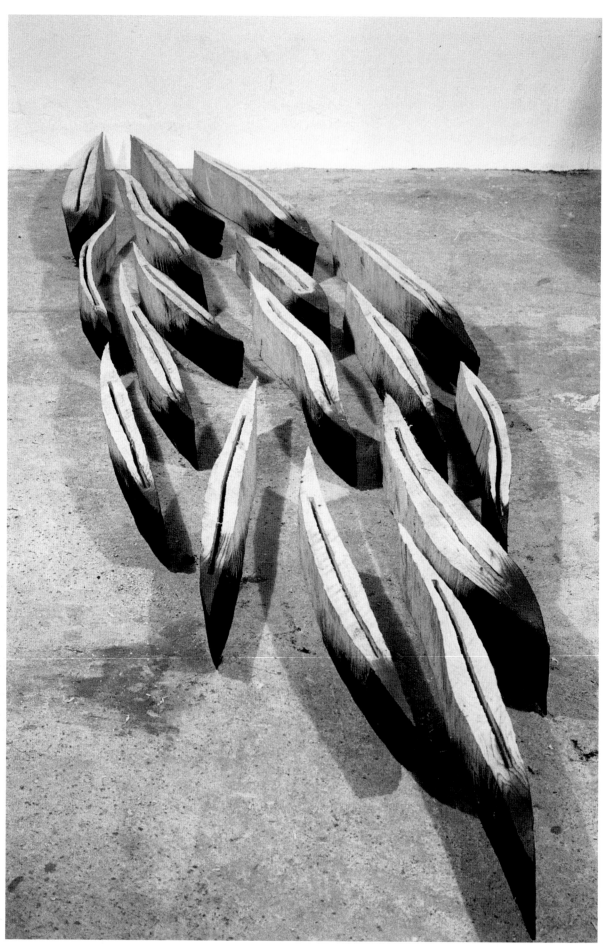

178

presences, echoes of his earlier *Ubu* pieces. *Ash Jag* (1992) is another variation on the pattern of slicing unevenly into a vertical form, echoing the artist's interest in basic geometric shapes. *Square Sheaves* (1989) is another version, using the simple cube.

Ascending/Descending Boards (1990), which is eight feet high, is a strong, almost figurative sculpture in its stance, using formal, rectangular sections, each several inches thick with spaces of equal width between them, rising from a pyramidal base. A sculpture that shows Nash's delight in the colour and texture of natural wood, in this case lime, it led on to an even more elaborate piece to which it is closely related. *Spiral Sheaves* (1991) is one of the most difficult and elaborate pieces Nash has attempted. The sculpture consists of three apparently separate columns which rise and twist out of each other, revealing space between them. This gives an effect of lightness to what is a very heavy sculpture, made – almost unbelievably – from a single piece of oak. Yet in works like this Nash is not trying to show off virtuosity for its own sake: the sinuous and elegant curves have an airy, nonchalant grace. It is a beautifully thought-out and successful adaptation of the material.

In *Wall Sheaves* (1993) Nash has made an installation work in which the repetition of the large elements seems to emphasise the delicacy of the lines carved into the beechwood. *Two Wall Sheaves*, only recently made, reverts to the pattern of pairing elements used in his *Menhir, King and Queen*, and *Ubu* pieces. He is here creating a visual contrast between the heavy forms of his two elements, and the finely traced, cut lines which emphasise the texture, physicality and colour of the wood.

A recent variation of slicing into a solid block is seen in the two *Overlap* pieces made in 1993 and 1994. Once again it is difficult, at first sight, to appreciate that these have been carved out of a single block of wood, since the complex way in which sections, levels, and corners overlap each other gives the impression they have been somehow woven together. The effect of light and shade serves to emphasise the rough surfaces of beech and lime that have been used for these formal, yet intimate works.

Several of the vessel sculptures Nash made in the mid-1980s have been discussed in the section of this book covering the charred works. They include examples of his vessel-and-volume format, a variation on the inside/outside theme, in which the central section of a sculpture acts as a reflection, or echo, of its container. *Serpentine Vessels* (1989; Plate 7) is an example of the type, each element being about ten feet long, but Nash has also made larger versions, and installations which use a number of elements to make a flotilla, or 'stream' of vessels. An installation shot of one such work, reproduced here, shows them apparently moving over the surface of a floor, like a shoal of fish, perhaps eels.

Descending Vessel (1986) is a key work, being one of

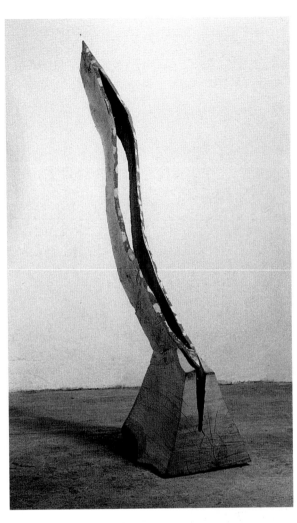

179

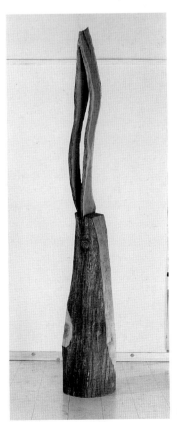

180

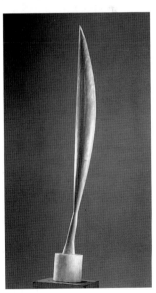

181

179 *Descending Vessel*, 1986, oak, 200 × 60 × 40 cm (80 × 24 × 16 in)

180 *Descending Vessel*, 1988, oak, 406 × 51 × 51 cm (160 × 20 × 20 in)

181 Constantin Brancusi, *Bird in Space*, 1925, marble, height 134 cm (52½ in)

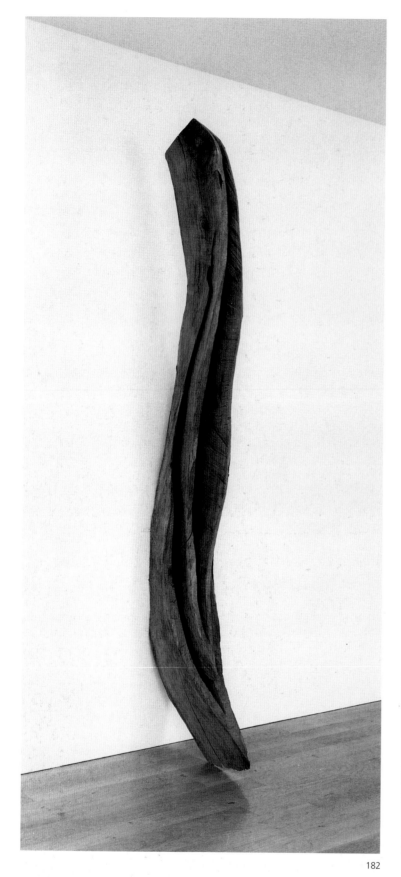

182

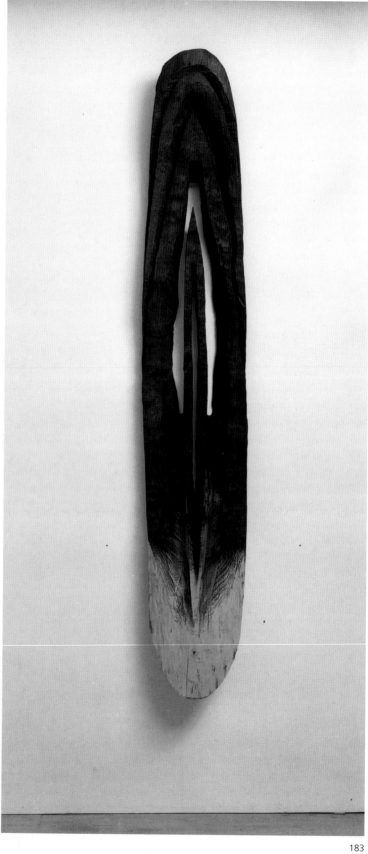

183

182 *Merging Vessels*, 1991,
cherry-wood,
276 × 66 × 27 cm
$(108\frac{1}{2} \times 26 \times 10\frac{1}{2}$ in$)$

183 *Vessel Shield*, 1991/2,
Polish oak, 209 × 36 × 15 cm
$(82 \times 14 \times 11\frac{1}{2}$ in$)$

the first occasions in which Nash made a vessel from his base-and-limb format (a branch extending from a section of trunk). The sinuous form of the rising section, accentuated by its delicate opened-out form, brings a new quality to the sculpture, which Nash gratefully received and made use of in a long series of developments on this theme. A vessel, in addition to being a container, can also act as a carrier or bearer of something, and Nash's *Descending Vessels*, pointing upwards while moving downwards towards the viewer, seem to be bringing messages, connecting the solid base to something higher. It is in these works, together with the bowls, shrines and thrones that follow, that a spiritual dimension, always immanent in the work of David Nash, becomes overt for the first time. The symbol of the vessel – or, for that matter, the tower, column, ladder, or tree – connecting earth and sky, descending and ascending at the same time, joining man to forces that he can apprehend, even though he may not see them – is an age-old one that recurs throughout history, brought to us by artists and visionaries from early icon-painters to William Blake and Samuel Palmer in the last century. In our present time there has been a reluctance to admit an interest in such matters so openly, particularly through the medium of art. As Norbert Lynton puts it, in his perceptive essay on Nash's work in the 1990 Serpentine Gallery catalogue: 'Not long ago it was impossible to refer to spiritual concerns in art without embarrassment'. This attitude is now changing, though slowly, but it has explained, in part, why the work of David Nash has for years been appreciated within a culture such as Japan, where an understanding of the links between natural and spiritual forces, expressed through trees and gardens, is so widespread.

Merging Vessels (1991) echoes Nash's very minimal 'leaner' pieces of the 1970s, since it rests casually against floor and wall. This sculpture has a double layer of vessel forms, one within the other, and it is works like these, as well as the more obvious seed and egg, that seem to reveal sexual allusions – a dimension Nash admits may exist without feeling any need to stress it.

He has made vessels on a monumental scale as well, two very large ones being placed as a recent commission in street sites for the city of Rouen. Works like these – and the beautiful, three-part work in oak *Three Descending Vessels* (1992) – prompt comparisons with Brancusi's *Bird in Space* sculptures of the 1920s and 1930s, though these were made in materials other than wood, usually with a highly polished surface.

More earthbound, and again with a definite sexual charge to it, is *Vessel Shield* (1991/2), a wall-mounted sculpture which is mainly charred, while in *Portal Vessel* (1993) he has followed the curving branch form right back into the trunk, to create a work which has a curiously hermaphroditic quality about it.

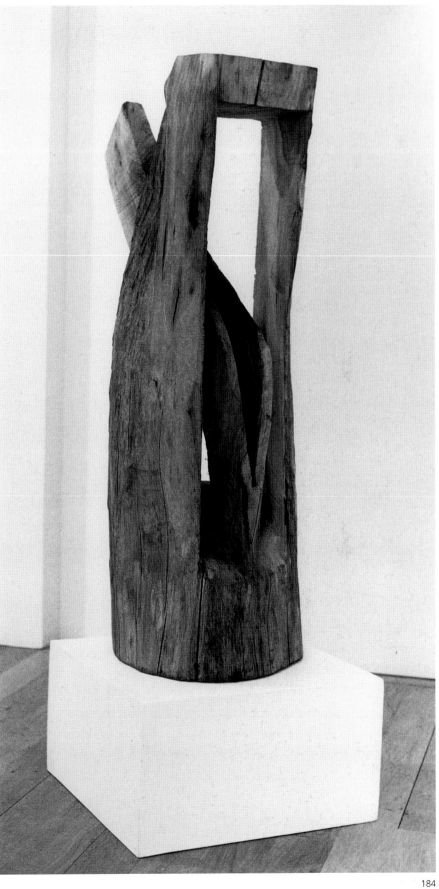

184

184 *Portal Vessel*, 1993, elm,
131 × 46 × 56 cm
(51 × 17½ × 22 in)

15

THE FIFTH ELEMENT

In 1988, during his stay at Pierre de Bresse, Nash discovered a new form. Working on the lower trunk section of an oak, he realised there was an area of the tree he had not exploited before, where the base of the trunk began to widen out just before the roots. This opening-out volume would, he realised, permit him to make an inverted bowl shape, rather wider than would have been the case if he had tried to cut it from the trunk further up. Studying the tree and making drawings of possibilities, he saw that by keeping his bowl attached to the trunk he could carve a base on which it would appear to rest, out of this higher section. *Oak Bowl* (1988) was the first of a series, being followed later the same year by a beautiful version in elm, made at the chapel in Blaenau Ffestiniog. Both these pieces relate to the original *Table with Cubes* made in 1971, his first solution to the problem of how to present objects on a surface. But also at Pierre de Bresse, conscious of the atmosphere of the abbey, he made a piece which has a direct reference to religious ceremony and sacramental functions: *Platter and Bowl* (1988). A basic

table form, made in two separate sections of oak, supports two vessels, each an integral part of the 'table' section from which it is carved. The impression it gives is of an altar, with communion vessels on it, awaiting the arrival of participants in the Eucharist. Bowls give out, as well as receiving, and Nash is conscious of the implied space that can be created by a vessel of this shape: his drawing of *A Bowl Catching Space* illustrates this point.

In *Elm Spiral* (1989) he has used a slicing technique to open out different levels of the bowl's surface, the sculpture giving the feel of a young girl exuberantly dancing, crossing her arms with skirts swirling. But he has developed the form on a large scale as well, his *Bowl* of 1994 being seven feet high and nearly five feet across. (In spite of its considerable weight this piece, which was on display in Kobe during the 1995 earthquake, was knocked over by the force of the shock and suffered some damage.)

Spoon shapes were a natural progression from bowls, in symbolic as well as sculptural terms. Spoons and ladles,

154

185 *Oak Bowl*, 1988, oak,
125 × 87 × 88 cm
(49 × 34 × 35 in)

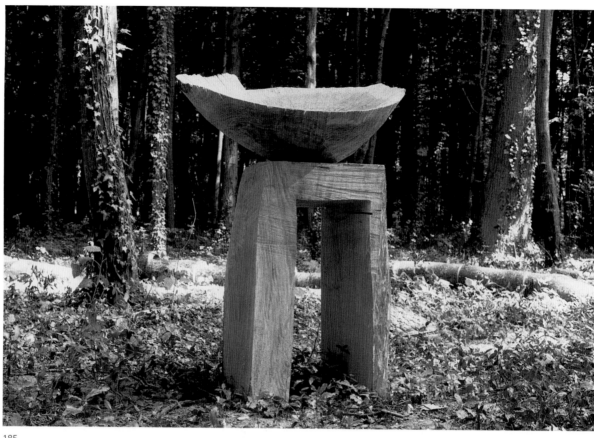

185

186 *Elm Spiral*, 1989, elm,
50 × 30 × 35 cm
(20 × 12 × 14 in)

187 *Platter and Bowl*, 1988,
oak, 111 × 116 × 50 cm
(44 × 46 × 20 in)

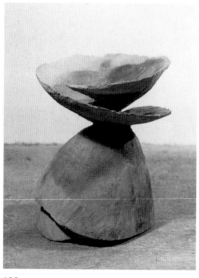

186

188 *Six Birch Spoons*, 1989,
birch, 185 × 300 × 100 cm
(74 × 120 × 40 in)

189 *Three Ladles*, 1989, oak,
43 × 180 × 48 cm
(17 × 72 × 19 in)

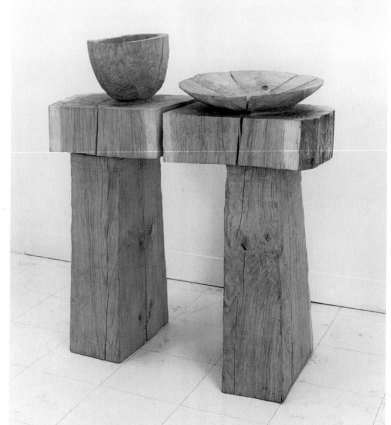

187

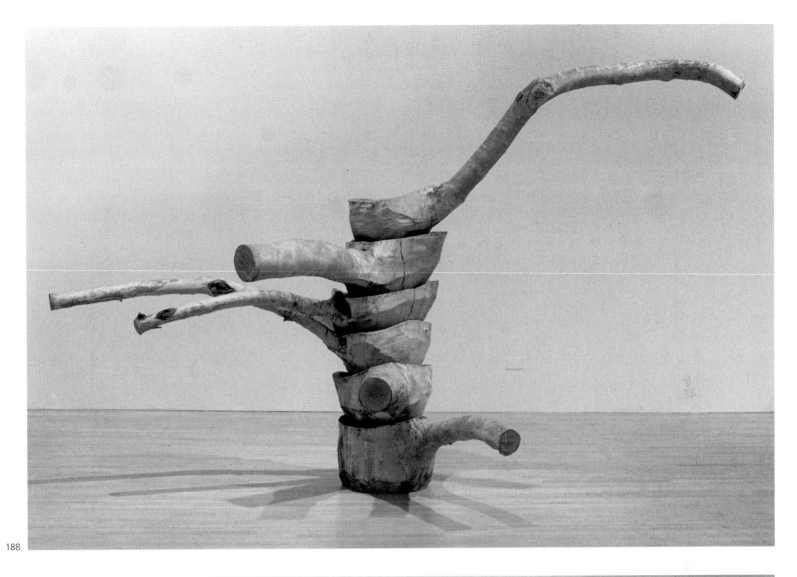

188

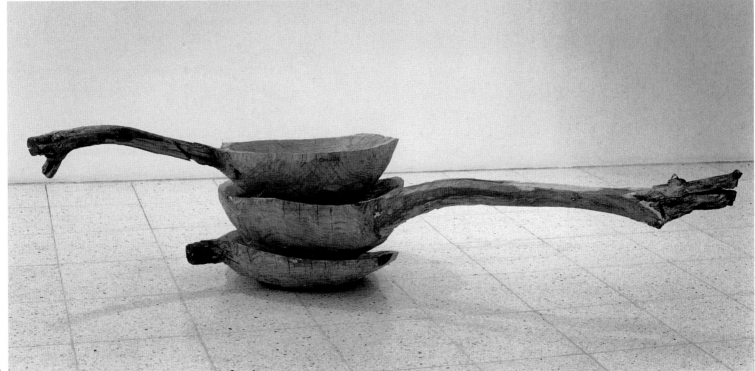

189

157

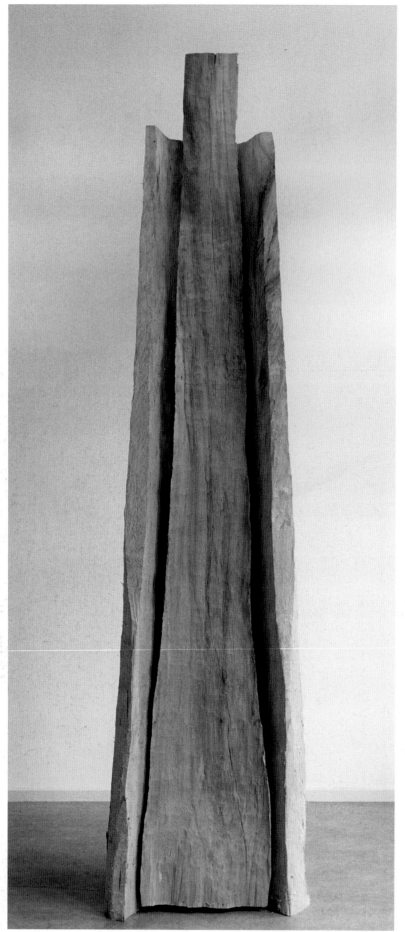

190

in addition to their domestic function, are used for ceremonial or ritual purposes. In *Three Ladles* (1989) Nash has carved three inter-connected spoon bowls out of a single trunk, leaving the protruding branches to create handles. These works hark back to his branch tables and chairs, which play with our perception of a familiar domestic object. *Four Oak Spoons* and *Six Birch Spoons*, both made at Ile de Vassivière in 1989, show delight in developing this theme. It represents part of a clearly defined progression: Table to Bowl, Bowl to Spoon, Spoon to Throne, Throne to Shrine, in which domestic, but nevertheless symbolic objects move steadily towards more overtly ritualistic and spiritual forms. *Black Double Spoon* (1993) is a one-off piece, perhaps something of an experiment, while *Scoop in a Bowl* (1990) is a transitional work, linking these sculptures to a series made on an altogether more dramatic scale.

Nash's first throne piece, *Red Throne* (1989) was made in California, from a fallen redwood, out of which he also made *Red Shrine*. Taking advantage of the huge volume of wood available, Nash made both these works on a grand scale. *Red Throne* rises to a height of thirteen feet, though it is only just over three feet across at its widest section. There are three elements to the sculpture. A heavy ladle shape rests on a solid formal block, while a long, more delicate, spoon-shaped vessel rises out of it, the top of this last section standing out well above the main body of the piece. If not a throne for a god it is certainly one for a very awesome presence. Its partner, *Red Shrine* (Plate 8), is equally impressive. More upright in format, though (at eight feet) not as tall, its two central elements, one within the other, seem to be enclosed within a strong protective wall, representing nearly half the circumference of the original trunk. Almost five feet wide it gives a sense of intimacy and respect, with almost the solemnity of a confessional. Later the same year he made *Veil* from a lime-tree he was given to work with in the Netherlands. It combines some of the features of the two works just described. Over nine feet tall, with two elements only (one enclosing the other), it has a feminine quality (Nash has sub-titled it *Queen*) while being minimal in form. It makes a striking contrast when seen together with *Folds*, the largest of the pieces made in 1990. Again, eight feet high and nearly five across, this work has an uneven form, the wood curving round on the right-hand side, gently enclosing and protecting the smaller element. The fact that it is also charred gives it the appearance of great age: indeed the colour and texture of the wood combined with the intimacy of the form recall the softness and warmth of mediaeval wood-carving. Few people remain untouched when they see *Folds*: it is one of the most powerful sculptures Nash has produced so far.

In 1991 Nash made another impressive *Throne* out of beechwood. Narrower in format than the redwood version it rises to a height of exactly twenty feet, while being just under three feet in width. Placed at the far end

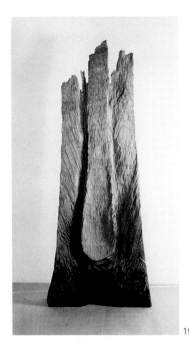

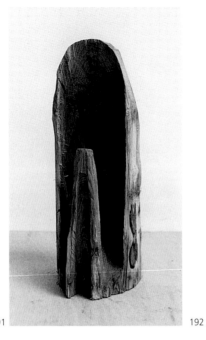

191

192

190 *Veil (Queen)*, 1990,
lime-wood, 282.5 × 70 × 65 cm
(113 × 28 × 26 in)

191 *Shrine*, 1992, Portugal
laurel, 84 × 33 × 10 cm
(33 × 13 × 4 in)

192 *Hooded Column*, 1995,
yew, 38 × 14 × 16 cm
(15 × 5½ × 6½ in)

193 Installation at Louver
Gallery, New York, 1993,
showing *Folds* and *Shrine*

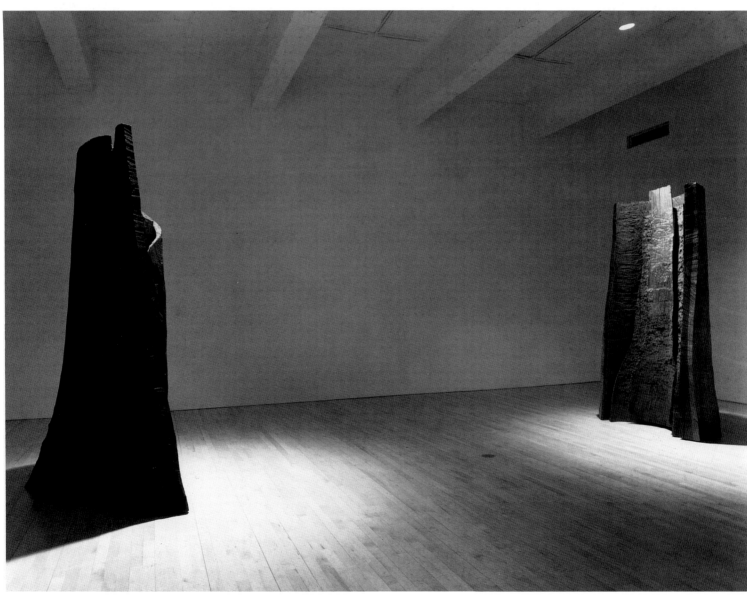

193

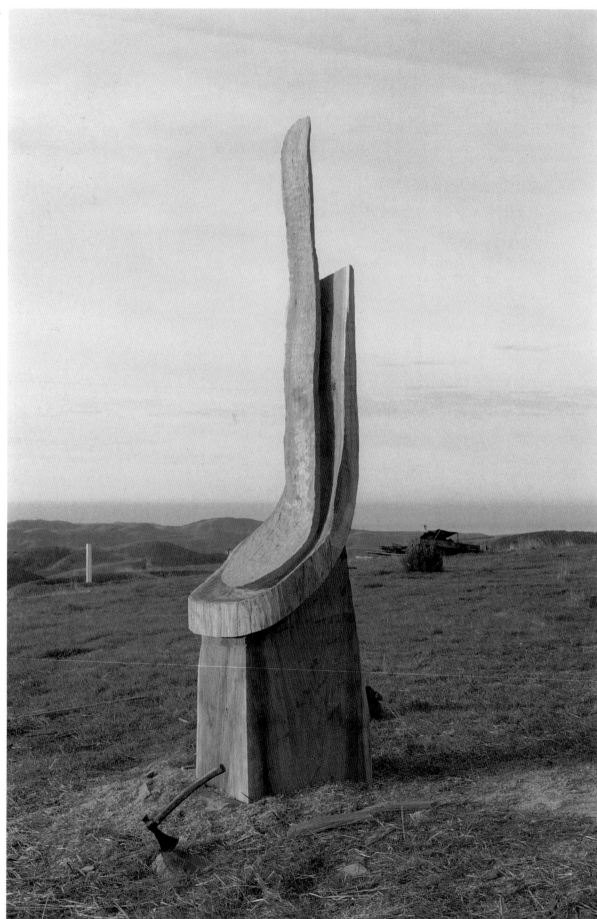

194 *Red Throne*, 1989,
redwood, 325 × 95 × 85 cm
(130 × 38 × 34 in)

195 *Four Charred Cross Egg*,
1994, beech, 48 × 41 × 36 cm
(19 × 16 × 14 in)

196 *Hornbeam Cross*, 1994,
hornbeam, 54 × 48 × 26 cm
(21 × 19 × 11 in)

of the chapel, against the curved arch with its scroll in Welsh, it is a metamorphosis of *The Waterfall* which stood in the same position twenty years earlier. Like a tall, narrow flame it rises to carry the words of blessing upwards, ready to receive whatever may come from above. Strong yet comforting, it is the right presence for this building which, though it may have lost its original worshippers, still receives many who draw sustenance from the contemplation of works of art.

There remain two smaller works to be described with the group of *Thrones* and *Shrines* which, together, represent a powerful burst of activity by Nash at the start of the 1990s. *Shrine* (1992), in charred Portugal laurel, is a work of rare texture and beauty, the lines of the cuts to right and left of the central element converging to meet the vertical grain of the wood. Only thirty-three inches high it nevertheless appears to be just as majestic as the huge versions described above – a 'lares et penates' version, perhaps? *Hooded Column* (1995), made in yew-wood, is only fifteen inches high, yet it has a powerful presence.

Throughout this book Nash's regular use of basic geometric forms has been stressed. In 1994 he reverted to another elemental form, which had interested him from an early stage in his work: the cross. A wooden cross is visible at the pinnacle of his second *Chelsea Tower*, made in 1970, and he used the shape again much later, when incising and charring patterns into some of his *Egg* sculptures. *Four Charred Cross Egg* (1994) is an example, the dark cross shape contrasting with the even curves of the sculpture which, Nash has noted, should be displayed not on the floor (as with some of the other *Egg* pieces) but at table-top height, so the viewer is confronted directly by the symbol as well as by the form.

The cross is a powerful symbol, a signifier loaded with different levels of meaning. To Nash it differs from the basic triangle, circle and square, which he sees as universals with a sense of completeness. 'The cross is an unresolved sign with many uses', he says. Where two lines cross, a reference point is created. For this reason the cross may be used to mark a place on a map, to denote error, to draw attention to a particular statement or sign, as a mathematical symbol or – in the Christian faith, – it can become a crucifix, a religious symbol. Nash himself marks trees or baulks of timber in a yard with a cross, in wax crayon, to indicate the ones he intends to use – or he may cut a simple cross with a saw.

To use the cross on sculptures, or within paintings, is a challenge for an artist. The cross can carry so much significance in itself, there is a risk it may 'overload' the artwork. Different associations are set up, also, depending on the sculptural form to which it is applied. In this final section examples are shown where the 'unresolved' nature of the cross shape is still in balance with the form. *Hornbeam Cross* (1994) is a small work, just under two feet high. A solid block, cut into an almost perfectly even cross form,

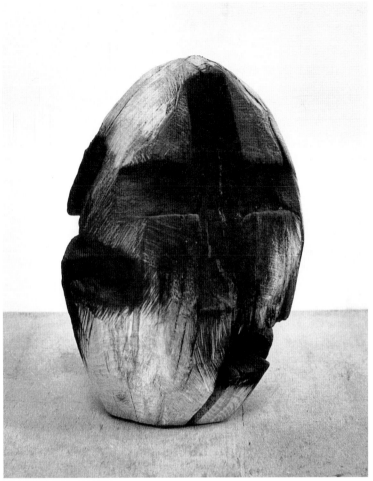

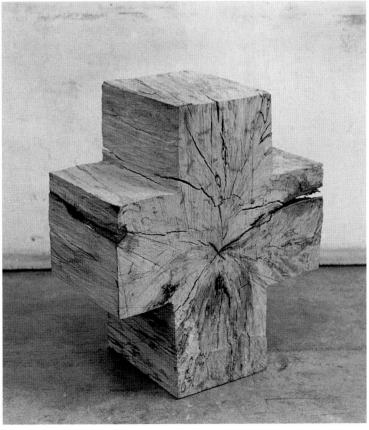

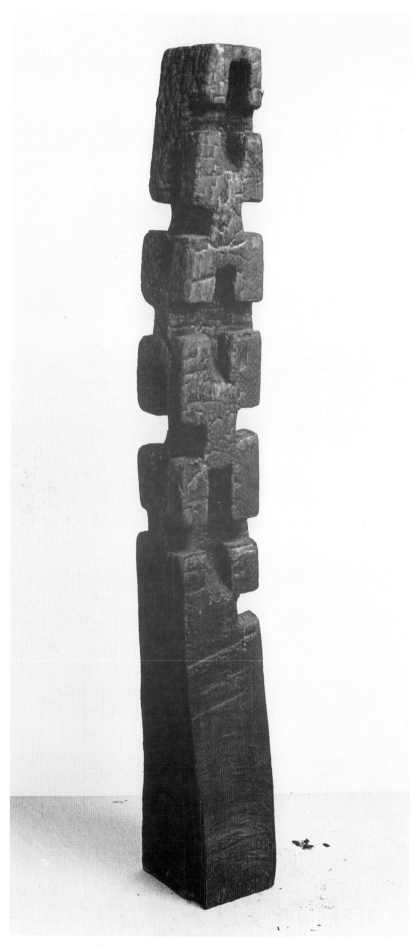

its regular shape is countered by the irregular pattern of cracks that have developed in it. From a central node in the piece the grain radiates outwards. Similar in concept to his minimal 'line of cut' works from the late 1970s, it challenges the viewer to read it as anything other than a purely abstract form. *Small Cross Column 2* (1994) is precisely the opposite, in that Nash is using the negative impression of the cross shape rather than the positive. In this column, reminiscent of a totem pole, Nash has cut cross shapes alternately into the four faces of the block. It therefore shows two different in-and-out-patterns rising up, depending on the side from which it is viewed. The fact that the piece has been totally charred helps to conceal the regularity of the pattern, so the work – originally an offcut from a much larger sculpture – has its own internal rhythm, or 'breathing'.

Gate: Black and Light (1994), made in Japan, is a monumental work made with two elements, each nearly nine feet high. Nash has given an evocative description of this piece: 'The "Gate" was made in Hokkaido as an entrance for a touring exhibition in Japan. A two-ton oak trunk cut in half to form two pillars – a cross shape cut right through on one pillar and a cross shape carved deeply into the other. To char the upper two-thirds, snow was empacked around the bases – and planks and kindling placed around on top of the snow. The sculptures were set on fire for thirty minutes to create two different experiences of the cross. On the one side one sees through the volume, on the other, into the volume. Black and light.'

Here again, as with so many of his sculptures, Nash is working with the elements – earth, air, fire and water – to create from the natural wood (which the ancient Chinese called 'the fifth element'), a work which has resonances going beyond the place and purpose for which it was made. As stated at the start of this essay, Nash is an artist in mid-career, continuing to find new forms and new expressions within his chosen language of material. Though rooted so strongly in the surroundings he has made his home, and his 'quarry' for ideas, his forms are not simply 'local' but have significance for people in the furthest quarters of the world. The 'universal' qualities in his art have come from the fact that he has shaped and adapted his own way of working to the materials, circumstances and relationships of each new situation. New forms continue to appear in a seemingly unending flow, revelations which emerge from the eternal language of wood.

197

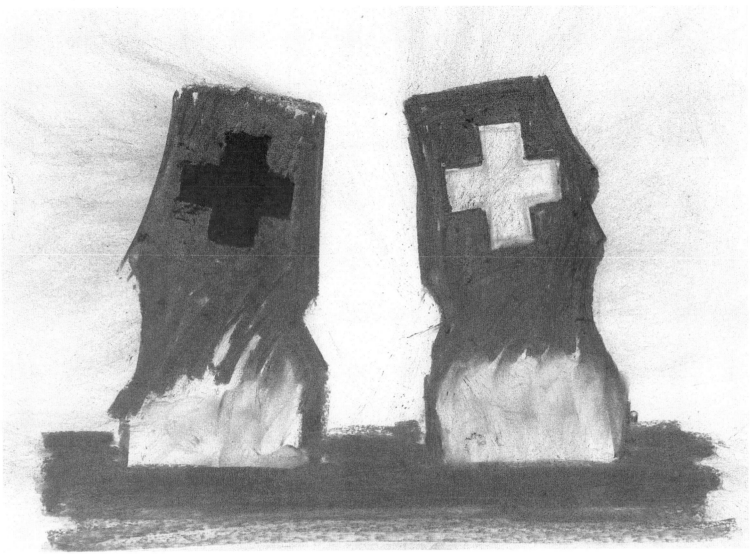

198

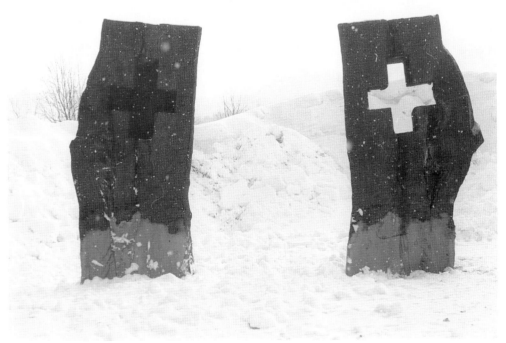

197 *Small Cross Column 2*,
1994, red pine,
96 × 20 × 20 cm
(38 × 8 × 8 in)

198 *Gate: Black and Light*,
1996, charcoal drawing,
42 × 48 cm (16½ × 19 in)

199 *Gate: Black and Light*,
1994, charred oak,
260 × 134 × 83 cm
(104 × 53½ × 33 in)

199

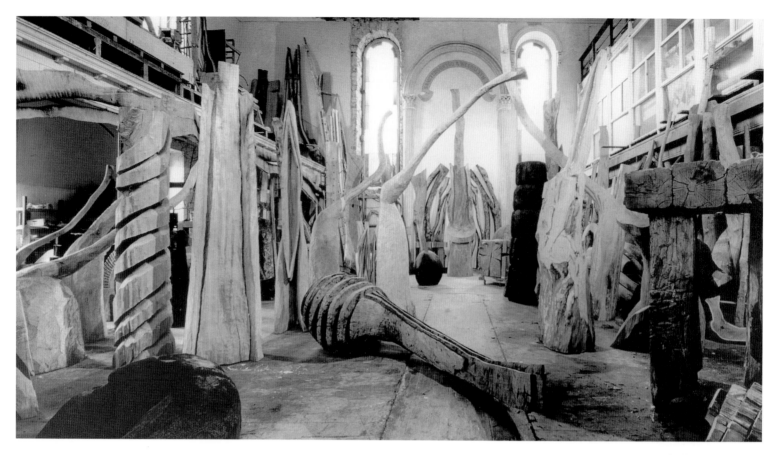

Capel Rhiw interior, 1994

CHRONOLOGY

1945

14 November: David Nash born in Esher, Surrey. Family home established in Weybridge, Surrey.

1949

Grandparents returned to North Wales, their original home, and bought Pen y Mount, a large house at Llan Ffestiniog.

1949–65

All holidays spent at Llan Ffestiniog.

1952–8

Attended boys' preparatory school, Wallop School, Weybridge.
Awarded an art scholarship on passing entrance exam for Brighton College, Sussex.

1958–63

Attended Brighton College.

1963–4

Kingston College of Art, Foundation course.

1964–5

Brighton College of Art, Painting School.
Visited Paris – first encounter with reconstruction of Brancusi's studio.

1965–7

Kingston College of Art, Sculpture Department.
Decided to establish a permanent base and studio in North Wales.

1966

Bought one semi-detached and one derelict detached cottage at Fuches Wen, Blaenau Ffestiniog for £300.

1967

Married Sue Irvine. Moved permanently to Blaenau Ffestiniog.
Began converting derelict cottage into studio.

'As a child I moved back and forth between two extremes of environment; from the insulated uniformity of a middle-class London suburb to the open and active presence of nature in N. Wales. Each season was experienced distinctly. I've known the wall of the Moelwyns and the domes of the Manods all my life.'

'Moving to Blaenau was economically possible for me. I could buy a house and studio for £300 – no rent, no mortgage, very low overheads – which gave me more time to find my way.'

Worked for 'Slate Products', producing household and craft items made from slate, using machinery.
Reread Malcolm Lowry's *Under the Volcano*.
Built first *Tower* at Fuches Wen, blown over in high winds.
Built second *Tower*, but was later forced to dismantle it by local authorities.
Painted *A Peaceful Village*.

'It was the structure of Lowry's book that I liked so much. The towers I built were like piles of sentences, each object suspended in space in loose relationship to each other. The first one blew over and broke the main piped TV cable to the town.'

1968

Separated from Sue Irvine (subsequently formally divorced).
Built first *Archway* at Pen y Mount.
Worked for Economic Forestry Group digging ditches and planting trees.
Taught art at evening classes in Penrhyndeudraeth, and later in Blaenau Ffestiniog.
Rented cellar of Maenofferen Hotel for a studio.
Sold the Fuches Wen cottages and bought Capel Rhiw, with its adjacent schoolhouse, for £200.

Manod Bach and Manod Mawr, North Wales

'Capel Rhiw was at the other end of town squatting like a big frog at the bottom of a slate tip. I got it for £200. All the pews were gone, it had no electricity or water. A big empty building. I made a home in one small room at the back of the vestry.'

1969

Completed sculpture *A Peaceful Village*, using materials recycled from previous works.
Stayed at Cistercian Abbey on Caldy Island.
Moved to London and began post-graduate year at Chelsea School of Art.

1969–70

Completed *Chelsea Towers 1, 2* and *3*.

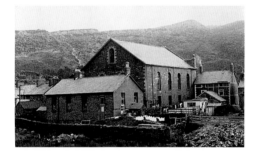

Capel Rhiw, Blaenau Ffestiniog

'Disenchanted with coloured surface and carpentry, I went for a more direct way of working, simplifying the image and the method. The towers simplified to columns. The columns were made from pitchpine beams from the derelict quarry workshops. When this source dried up I turned to unseasoned wood; there was an abundance of it around from a road-widening scheme going on then.'

1970

Chelsea Tower 3 shown in opening exhibition of Serpentine Gallery, Hyde Park, London.
Returned to North Wales.
Built *The Waterfall* on interior east wall in Capel Rhiw.
Made first carved works: *Nine Cracked Balls*, several *Columns* and the first *Bonk* pieces.
Began part-time teaching at Maidstone College of Art on 'block' basis (four days each month).

Nine Cracked Balls

'This was the next major step from the simplified towers. A small ash tree was cut down in the field opposite. I bought the trunk for £1. In the small yard in front of the chapel I cut through close to one end with an axe. When the piece finally parted from the trunk I didn't touch it again. I accepted it as an object that was the pure result of the action of its making. I kept my mind entirely on the action and not on the shape or texture of the object. I followed along the trunk, cutting through at intervals until I got to the other end: nine rough balls. (I was looking at the land then, using primary material (wood) in a primary way (axe).)

1971

Began working on piece of woodland at Cae'n-y-Coed, Maentwrog.

First roped works: *Arch*, and *Roped Tripod*.
Travelled in France staying in Toulouse and
the Pyrenees.
Visiting teacher at Newcastle Polytechnic and
Norwich School of Art.
Made first table sculpture, *Table with Cubes*.

1972

Built hut at Cae'n-y-Coed.
Travelled to the Orkney Islands.
Married Claire Langdown.

1973

Visited Paris. Revisited Brancusi's studio.
First solo exhibition: *Briefly Cooked Apples*, at
York Festival, subsequently shown in Bangor.
Wrote and produced his own leaflet to
accompany this show.
Son William born September.
Part-time teaching at Wolverhampton.

1974

Clive Adams from Arnolfini Gallery, Bristol
visited Capel Rhiw.
Carved *Clams on a Rack* and *Pods in a Trough*.
Part-time teaching at Wolverhampton and
visiting lecturer to several art colleges in Britain.
Began consciously to improve his drawing.

1975

Split and Held Across selected by
William Tucker for *Condition of Sculpture*
exhibition at Hayward Gallery, London.
Received Major Bursary from Welsh Arts
Council.

1976

Prepared the publication *Loosely Held Grain*
to accompany solo exhibition of the same title,
shown at Arnolfini Gallery, Bristol, in the
autumn.
Took part in *Summer Show III* at Serpentine
Gallery, London.

1977

Son Jack born in February.
Planted *Ash Dome* at Cae'n-y-Coed, March.

Table with Cubes

*'The splits in the "Bonks" intrigued me. The
black space in the crack gave more
information about the object's volume, a sense
of its interior. I applied this to the geometric
construction of a cube, the gap at the mitred
edges creating a black line running round the
object. The table came as a way of presenting
the cubes.'*

*'I had first seen Brancusi's studio in 1967.
Then, I was impressed by his living and
working in the same space. This time, I realised
how impressed I had been by the humanity of
the sculpture, and the wholeness experienced
from seeing it all together. This influenced the
way of showing my work in York later that
year.'*

*'I realised that my range of mark-making was
very limited: so, to extend it, I decided to draw
objectively from the landscape, learning to
make "equivalent" single marks of what I was
seeing. I'd walk looking for a "subject". When
a potential drawing appeared I'd work out its
shape, go home, cut appropriate size paper –
ten sheets – return to the place and learn its
marks.'*

Sawing beech, Cae'n-y-Coed, 1974

Drawing elephants at London Zoo for *Elephant Passing a Window*.
First visit to Sligo, Ireland.
Work included in *From Wales*, a selection of six artists working in Wales, shown at Fruitmarket Gallery, Edinburgh.
Made *Line of Cut* for exhibition *On Site* at Arnolfini Gallery, Bristol.
Made *Corner Block*.

Original drawing for *Ash Dome*, 1977

1978

Sculptor in residence at Grizedale Forest, Cumbria, funded by Northern Arts, February - June. During this period made *Running Table*, *Horned Tripod*, *Wooden Waterway*, *Willow Ladder* and *Larch Enclosure* (a planting piece).
Arts Council of Great Britain film *Woodman* made by Peter Francis Browne.
Prepared the publication *Fletched Over Ash* to accompany solo exhibition of the same title, shown at AIR Gallery, London and subsequently in Chester and Cardiff.
Attended Sculpture Symposium at Prilep, Yugoslavia and made a group of works there. (First experience of working outside the UK.)
Carved the *Wooden Boulder* at Bronturnor, and rolled it into a stream.
Visited by Diane Waldman, who was selecting artists for an exhibition at the Guggenheim Museum, New York.
Visited by Dr Rudi Oxenaar, who purchased *Elephant Passing a Window* for Rijksmuseum Kröller-Müller, Otterlo, Netherlands.
Taught one term at Liverpool School of Art.

1979

Sent *Prime Block* to *Corners* exhibition at Elise Meyer Gallery, New York.
Given freehold ownership of Cae'n-y-Coed, by his father.
Worked on Bronturnor oak, at Maentwrog.
Collaboration with sculptor Paul Neagu, works shown at the LYC Museum, Cumbria.

1980

Selected as one of eight artists for *British Art Now* at Guggenheim Museum, New York.
Exhibition subsequently moved to San Diego, Savannah and Austin.
Visited Vermont and West Virginia.
Planting commission at Southampton University.
Travelled with family in USA. Took part in International Sculpture Conference,

Elephant, Blaenau Ffestiniog

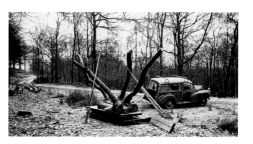

Grizedale Forest, Cumbria, 1978

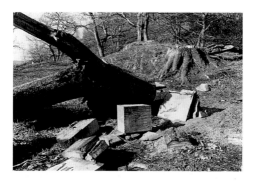

Prime Block, 1979

'We camped for three months in a damp unfurnished Forestry Commission house. It was a good experience after treeless Blaenau, being right inside a forest. It was also strange living in a house after the chapel. I chose February to May to experience the forest coming out of winter into spring.

 William went to a local school. Jack learned to walk.'

'Earlier I used the regular standard units from the woodmill, but I found them dumb as they did not tell of their origin, nor their destination. Now I get along better by going to the tree and responding to its time and space and to the circumstances of it being there and my being there. Size and length, cold and wet, far from home, all contribute to the situation. The tree becomes a quarry of new possibilities.'

Washington DC where he made *Washington Stove*.
Made *Capped Block (Emperor of China)*, and *Flying Frame*.
Exhibited in Rotterdam and in Venice.
British Art Now shown at Royal Academy, London.
Showed *Sea Stoves* in *Art and the Sea* exhibition, Glasgow.

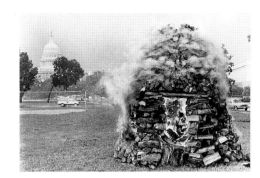

Washington Stove, 1980

1981

Carried out field trips with Dutch students of Rotterdam Academy in the Biesbos, Netherlands, and with students of Arnhem Academy near the Rhine.
Yorkshire Sculpture Park Fellowship.
Lived in Wakefield with his family from September until January 1982.
Carried out first *Wood Quarry* project as a deliberate dry-run for future projects planned for Japan and the Netherlands.
Showed work in *British Sculpture in the Twentieth Century Part II*, Whitechapel Art Gallery, London.

Working in the Biesbos, Netherlands, 1981

1982

Travelled to Japan for first time to carry out project *20 days with a Mizunara* in Kotoku, Upper Nikko province, with support from British Council.
Resulting works shown in *Aspects of British Art Today* exhibition at Tokyo Metropolitan Art Museum and later at Utsonomiya, Osaka, Fukuoka and Sapporo.
Numerous appearances on Japanese TV and radio.
Wood Quarry at Rijksmuseum Kröller-Müller, Otterlo, Netherlands.
Fellowship Exhibition, Yorkshire Sculpture Park.
Pyramids and Catapults: 20 days with an Elm was shown in Leeds and documented in his *Fellowship 81–82* published jointly with the Yorkshire Sculpture Park.
Showed 30-foot drawing of full-size larch trunk at the *Hayward Annual: British Drawing* exhibition.
Other exhibitions in New York, Cardiff, Carlisle, the LYC Museum, Cumbria and at five venues in Ireland.

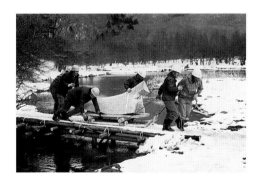

Wooden Fish being transported, Japan, 1982

'Rather than the laborious and expensive task of crating and shipping his sculpture, David Nash proposed that instead he should travel to Japan and make new work "on the spot", specifically for the exhibition. He asked for a tree that had been blown over or had to be cut down, an assistant/interpreter, and simple living accommodation, and if possible that the tree be in a rural situation.'

Note for *Aspects of British Art Today,* Tokyo 1982.

'The opportunity of working in Japan came at a perfect time. I felt that all my work to date had been a preparation for this project. Working on snow, big timbers were easy to move around, the local woodmen were willing and inventive. It was the first time I had worked with a team of assistants. Every day was very productive.'

1983

Flying Frame purchased by Tate Gallery, London.

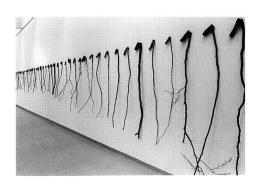

Shillelaghs, installation at Rijksmuseum Kröller-Müller, Otterlo, 1982

First fletch on *Ash Dome*.
Lime tree project at South Hill Park, Bracknell.
Made *Ancient Table*.
Sod Swap (Hyde Park and Cae'n-y-Coed) shown at Serpentine Gallery, London as part of *The Sculpture Show*, later transferred to Kenwood, Hampstead.
Project at Forest Park, St Louis, Missouri using red oak and maple. The first *Charred Column* made there.
Elm project (New Inn, Tipperary, Ireland). Joined with local parent group to research starting a Steiner Junior School.

1984

Represented in *Survey of Recent International Painting and Sculpture*, Museum of Modern Art, New York. Planted *Blue Ring*.
Participated in ROSC International Exhibition, Dublin.
Made *Bramble Ring* at Cae'n-y-Coed, Maentwrog.
September–December: travelled with his family in Japan making works at several venues and exhibiting in Tokyo, Shiga, Miyagi, Tochigi and Fukuoka.

1985

Made *Ice Stove* at the confluence of the Mississippi and Missouri rivers.
Planting commissions *Divided Oaks* and *Turning Pines* at Rijksmuseum Kröller-Müller, Otterlo, Netherlands.
Project and exhibition with Sogetsu Kaiken Ikebana School in Tokyo.
Showed *Crack and Warp Column* at *Hayward Annual*, London.
Ysgol Steiner Eryri, the Steiner School at Tremadoc, opened with forty-five children.
Elm, Wattle, Gum exhibition and publication at Heide Art Gallery, Melbourne, Australia. Other projects and exhibitions in Japan, Ireland and Belgium.

1986

Made *Black Dome* pieces at Allt Goch, Ffestiniog and in the Forest of Dean.
Tree to Vessel, first solo exhibition at Juda Rowan Gallery, London.
Made *Seven Charred Rings* for a private collection in South Wales.

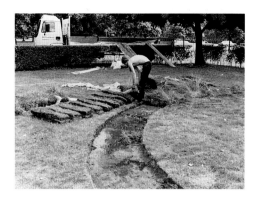

Sod Swap, Serpentine Gallery, London, 1983

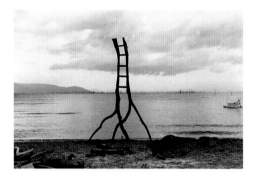

Ladder, Lake Biwa, Japan, 1984

Black Dome, 1985/6

Corner Pyramid, 1985

'Children bring new experiences to their parents. Our two sons had been doing well in the local primary school but as time went by they became more and more dulled. We had heard about the art-based curriculum of the Steiner schools and had started to research the possibility of moving to be near one. Other parents in our area were recognising the same needs with their children and Claire and I found ourselves part of a small group determined to start a Steiner school in N. Wales. This involved studying Rudolph Steiner's understanding of child development and its underpinning philosophy of Anthroposophy. I had the experience of form and articulation being given to notions that had previously seemed to live as vague intuitions in the back of my mind.'

'For the British Sculpture Show I was offered a lawn outside the Serpentine Gallery. I wanted to contribute a work that genuinely engaged with the natural conditions of "outside" and that had a built-in presence of where it came from. The solution was to swap wild sods from N. Wales with mown turf from London.'

'To work in Australia I flew out of our autumn into their early spring. Suddenly there were no leaves on the trees; bluebells were out; the sun was in the north, a completely different pattern of stars at night; different bird song, big fluting sounds; and profoundly different trees. Over the six weeks I could feel something inside me turning round to cope with this new orientation.'

1987

One of six artists selected for *A Quiet Revolution: British Sculpture since 1965* shown in Chicago, San Francisco, Newport Beach, Washington DC and Buffalo, USA. Made *Sylvan Steps* at Djerassi Foundation, California.
Wood Primer published by Bedford Press.
First solo exhibition at L.A. Louver Gallery, Los Angeles.
Black Light - White Shadow, sculpture exhibition commission for Hiroshima Fine Art Museum.
Standing Frame, white oak, commission for Walker Art Center, Minneapolis, Minnesota.
One of seventeen artists selected for *Viewpoint*, a survey of contemporary British art at the Musées Royaux des Beaux-Arts de Belgique, Brussels.

1988

Channel 4 Television film: *Stoves and Hearths*.
Above the Waters of Leith, planting commission from Scottish National Gallery of Modern Art, Edinburgh.
Built open-sided barn and working area behind Capel Rhiw.
Project in Minnesota, USA: *Bowl and Comet Ball*.
Project and exhibition *Chêne et Frêne* in refectory of Tournus Abbey.
Made first *Ubus* and *Vessel and Volume* pieces.
Ardennes project, Belgium. Exhibition at Galerij S65, Aalst, Belgium.
Participated in *Britannica: Trente Ans de Sculpture*, Le Havre, France.
Drawings exhibition at Nishimura Gallery, Tokyo.
Planted *Serpentine Sycamores* and *Oak Bowl* at Cae'n-y-Coed, Maentwrog.
Transplanted curved larches at Cae'n-y-Coed into six groups.

1989

Made first spiral pieces: *Spiral Bowl* and *Elm Spiral*.
Monkton House project, Sussex.
Kurasaari Island project and Helsinki exhibition, *Oak and Birch*, Finland.
Mosaic Egg exhibition, Annely Juda Fine Art, London.
Project and exhibition at Ile de Vassivière, France: made *Charred Wood and Green Moss*, *Six Birch Spoons,* and *Seven Charred Shapes*.

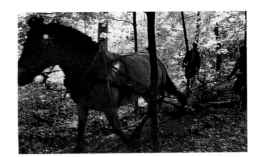

'Bob', Minneapolis, 1987

Work-site, Pierre de Bresse, France, 1988

Drawing of four sculptures in *Oak and Birch* exhibition, Helsinki, 1989

'In autumn 1987 a new version of Standing Frame *was commissioned for the Walker Art Center. An artist living an hour out of Minneapolis had suitable oak on his land and the facilities for construction. To avoid having to use a tractor to extract the wood from the forest he worked with a horse, "Bob", to haul out the timber – a practice that has been used all over the world for centuries but is now rare in Western technical cultures, and it was the first time for me. The presence of the horse brought a different quality to the work site and to the work itself. There was more sense of coaxing the form into existence rather than demanding it.'*

'Wood primer: *Initially this was an idea of Simon Cutts of Coracle Press – for each participant in the* Quiet Revolution *show in America to make an artist's book. I designed the book but Coracle were unable to follow through. But by one of those Angel-led series of chance meetings via Carl Djerassi and Stephen Vincent, Bedford Press published it as their first book. I wanted a picture book that illustrated the origin and results of twelve ideas – "themes".'*

Chêne et Frêne / Pierre de Bresse

'*These sculptures came out of responding to an invitation from Marie Lapalus of the Musée Greuze to prepare an exhibition for the Abbey refectory in Tournus, a tall, long, profoundly quiet vaulted space. An oak and ash were available too within Pierre de Bresse.*
 Into this "given" situation I worked with recurring themes, my current aesthetic concerns and an imagination of the Abbey refectory as it might have been, benches, tables, bowls, spoons, a monk reading aloud while his brothers listened or followed their own thoughts. Ash and oak contributed their particular qualities and personalities; sun-soaked ash, fractious and bright; oak, stubborn, enduring and resonant.'

Karhusaari - Finland

Two dead oaks, carved and charred at the edge of the Baltic. Lived in a Sauna. Late spring, leaves and people unfurling. Northern light long and soft. Revered birch and slowly grown oak.

Ashton Court Beech project, Bristol.
Drawings exhibition at L.A. Louver Gallery, Los Angeles.
Worked with redwood in California, making *Strong Box*, *Red Throne* and *Charred Forms in Charred Stumps*.

1990

Exhibition *Chêne et Frêne* shown at Musée des Beaux-Arts, Calais, France.
Exhibition at Louver Gallery, New York.
Retrospective exhibition 1971–90 shown at Serpentine Gallery, London, National Museum of Wales, Cardiff and Scottish National Gallery of Modern Art, Edinburgh.
Exhibitions in Paris and Amsterdam.

1991

Wood Quarry project and exhibition, Mappin Art Gallery, Sheffield.
Converted derelict shop near Capel Rhiw into drawing studio.
David Nash Sculpture, Mostyn Art Gallery, Llandudno, North Wales.
Exhibition at Criccieth Festival, North Wales.
Comet Ball booklet and CD, produced in conjunction with Sound Events.
Exhibition at L.A. Louver Gallery, Venice, California.
Walily project at Radunin, Poland, together with Leon Tarasewicz.
Exhibition at Centre of Contemporary Art, Warsaw, Poland.
Poland Project exhibition at Galerij S65, Aalst, Belgium.

1992

Exhibition *David Nash: The Planted Works*, at Louver Gallery, New York.
Exhibitions in Kansas City and Dallas.
Exhibition at Peter Pears Gallery, Snape Maltings, for the 1992 Aldeburgh Festival.

1993

New Drawing and Sculpture, Oriel Friary, Cardiff.
The Planted Works, Manchester City Art Gallery.
Worked in village of Otoineppu, northern Hokkaido, Japan in spring and summer.
At the Edge of the Forest, BBC film made by Richard Trayler-Smith.

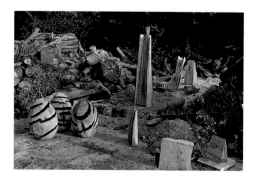

Work-site, Haarlemhout, the Netherlands, 1990

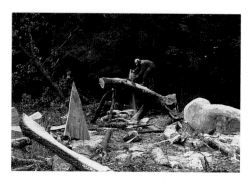

Work-site, Radunin, Poland, 1991

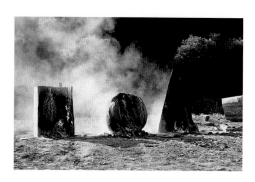

Work-site, Otoineppu, Hokkaido, Japan, 1993

Radunin – Poland

'The Byelorussian painter Leon Tarasewicz and I first encountered each other's work at a group show in the Ikon Gallery in Birmingham in 1986. What he had painted on the wall and what I had placed on the floor enriched each other, a correspondence we both felt worth exploring. Five years later Leon found a War-saw venue for a joint exhibition.

Working in a Byelorussian area of Poland where Leon had been born and had his studio there was a strong sense of centuries of agri-cultural continuity, horse's pace, rolling fields, wooden villages: cabbage soup, dirt roads, and relentless cycle of the year. The forest floor was deeply pitted with craters from the First World War.'

Otoineppu - Northern Hokkaido

In Otoineppu the long months of winter snow and thaw suddenly give way to a vigorous spring in May with everything growing and blooming at the same time, a speed of growth I have never experienced before. Nightingales had arrived, the older ones with clear mature song and the younger ones still learning the phrases. Deep in the forest, a bird sang like a thumping heart-beat. Two crows always visit-ed the work-site at 7 am and again in the evening, clattering about in the birch-trees or on the roof of our hut. We worked through mixed weather, a cold wind and rain, then sun; nightingales sang, insects bit us, and fish spawned in the river.

Many aspects of the Otoineppu community supported the project. The village post office, forestry office, local businesses and individuals provided materials, tools, fuel, labour, accom-modation and transport. Between project visits, works in progress were displayed in the High School exhibition hall, alongside students' work. Working demonstrations and slide lectures were given to school classes – most of the finished work was photographed in the school gymnasium. Other pieces too large to take inside were photographed on the hoop-ball pitch of the Hot Spring Hotel.'

Drawings at Nishimura Gallery, Tokyo.
Project at Laumeier Sculpture Park, St Louis, Missouri.
Sheep Spaces, installation at Tickon, Langeland, Denmark.
Project at Kunsthallen Brandts Klaedefabrik, Odense, Denmark.
At the Edge of the Forest exhibition at Annely Juda Fine Art, London.

1994

February: worked again in northern Hokkaido, Japan.
Otoineppu: Spirit of Three Seasons exhibition opened in June in Hokkaido and toured to Nagoya, Kobe, Saitama, Kamakura and Tsukuba. Exhibition damaged in Kobe earthquake.
Voyages and Vessels exhibition opened in Omaha, and toured to San Diego, Honolulu and Madison.
Nagoya commission *Descending Vessel*.
Exhibition at Nishimura Gallery, Tokyo.
Exhibition at Museum of Contemporary Art, Santa Monica, California.

1995

Projects in Hawaii and in California.
Exhibition at Refusalon Gallery, San Francisco.
Project in Barcelona, Spain, *Més enllà del bosc*.
Exhibitions in Barcelona and Palma de Mallorca, Spain.
14 November: David Nash's fiftieth birthday.

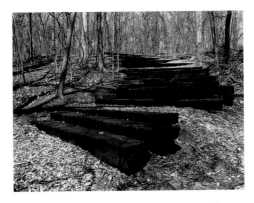

Black Through Green, Laumeier Sculpture Park, St Louis, 1993

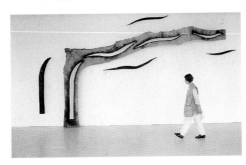

Braendt Eg, Odense, Denmark, 1993

Work-site, Barcelona, 1995

February visit to northern Hokkaido

'We still needed some large carved works as the sculptures made earlier were mostly linear. If the exhibition was a zoo we did not have any elephants. A winter visit was agreed. Two mizunara trunks were found and worked in the village as our summer work-site was under three metres of snow. We were thus able to bring to the exhibition and catalogue the image of Hokkaido snow and a feeling of the changing seasons.'

'Barcelona city has a tree hospital in the suburbs – ailing trees are hard pruned and moved to this site to be nurtured back to health. Eighty per cent recover and eventually are returned to the city. The other twenty per cent were available to resurrect as sculpture.'

SOLO EXHIBITIONS

1973
Briefly Cooked Apples, Queen Elizabeth Hall, York
and Oriel, Bangor

1976
Oriel, Bangor
Loosely Held Grain, Arnolfini Gallery, Bristol

1978
Fletched Over Ash, AIR Gallery, London,
and later at
 Arts Centre, Chester
 Chapter Gallery, Cardiff

1979
Arnolfini Gallery, Bristol
Parnham House, Sussex

1980
Southampton University Gallery
Wood Quarry, Elise Meyer Gallery, New York
Galleria Cavallino, Venice, Italy

1981
Pyramids and Catapults, St Paul's Gallery, Leeds

1982
Two Views of Nature, Elise Meyer Gallery, New York
Oriel, The Friary, Cardiff
Wood Quarry, Rijksmuseum Kröller-Müller, Otterlo,
Netherlands
Yorkshire Sculpture Park (*Fellowship Exhibition*),
Bretton Hall, Yorkshire
Kilkenny Art Gallery, Ireland

1983
Sixty Seasons, Third Eye Centre, Glasgow,
and later at
 Fruitmarket Gallery, Edinburgh
 Mostyn Art Gallery, Llandudno
 Glynn Vivian Art Gallery and Museum, Swansea
 City Museum and Art Gallery, Stoke-on-Trent
 Douglas Hyde Gallery, Dublin
Removals and Conversions, South Hill Park Arts
Centre, Bracknell

1984–5
Ki no Inochi, Ki no Katachi exhibition held in Japan
(Tokyo, Shiga, Miyagi, Tochigi and Fukuoka) as part
of working visit sponsored by the Japanese
Association of Art Museums and the British Council
Ki no, Kamakura Gallery, Tokyo

1985
Kamakura Gallery, Tokyo
Sogetsu Kiakan, Tokyo
Hoge Veluwe, Rijksmuseum Kröller-Müller, Otterlo,
Netherlands (with Sjoerd Buisman)
Bixby Gallery, Washington University, St Louis,
Missouri
Elm, Wattle, Gum, Heide Art Gallery, Melbourne,
Australia
Galerij S65, Aalst, Belgium

1986
Tree to Vessel, Juda Rowan Gallery, London

1987
Sculpture from the Djerassi Foundation, L.A. Louver
Gallery, Venice, California
L.A. Louver Gallery, Los Angeles, California

1988
Ardennes Project, Galerij S65, Aalst, Belgium
Chêne et Frêne, Réfectoire de l'Abbaye de Tournus,
Musée Greuze, Tournus, France
Vaughan and Vaughan, Minneapolis, Minnesota
Drawings, Nishimura Gallery, Tokyo

1989
Mosaic Egg: Sculpture and Projects 1986–1989,
Annely Juda Fine Art, London
Oak and Birch, Galleria Sculptor, Helsinki, Finland
Centre d'art contemporain, Ile de Vassivière,
Limousin, France
David Nash, Ashton Court, Bristol

1990
Drawings, L.A. Louver Gallery, Venice, California
Drawings and Sculpture, de Andino Fine Arts,
Washington DC
Chêne et Frêne, Musée des Beaux-Arts, Calais,
France
David Nash: Sculpture, Louver Gallery, New York
Sculpture 1971–90, Serpentine Gallery, London,
and later at
 National Museum of Wales, Cardiff
 Scottish National Gallery of Modern Art,
 Edinburgh
Galerie Philippe Casini, Paris
Art Affairs, Amsterdam

1991
Walily, Ujazdowski Castle, Warsaw, Poland
(with Leon Tarasewicz)
Poland Project, Galerij S65, Aalst, Belgium
Criccieth Festival, North Wales
Planted and Carved, Nishimura Gallery, Tokyo
Five New Sculptures, L.A. Louver Gallery, Venice,
California
Mostyn Art Gallery, Llandudno, North Wales
Wood Quarry, Mappin Art Gallery, Sheffield

1992
The Planted Works 1977–1992, Louver Gallery,
New York
Jan Weiner Gallery, Kansas City, Missouri
Sounding Form: New Sculptures and Drawings,
Peter Pears Gallery, Snape Maltings, Aldeburgh
Sculpture and Drawings, Gerald Peters Gallery,
Dallas, Texas

1993
New Drawings and Sculpture, Oriel, The Friary,
Cardiff
The Planted Works 1977–1992, Manchester City Art
Gallery
Laumeier Sculpture Park, St Louis, Missouri
At the Edge of the Forest, Annely Juda Fine Art,
London
Drawings, Nishimura Gallery, Tokyo
David Nash: Braendt Eg, Kunsthallen Brandts
Klaedefabrik, Odense, Denmark

1994
Voyages and Vessels, Joslyn Art Museum, Omaha,
Nebraska,
and later at
 Museum of Contemporary Art, San Diego,
 California
 Contemporary Museum, Honolulu, Hawaii
 Madison Art Center, Madison, Wisconsin
Otoineppu: Spirit of Three Seasons, Asahikawa
Museum of Art, Hokkaido, Japan,
and later at
 Nagoya City Art Museum
 Ashiya City Museum of Art and History, Kobe
 The Museum of Modern Art, Saitama
 The Museum of Modern Art, Kamakura
 Tsukuba Museum of Art, Ibaraki
Nishimura Gallery, Tokyo
Museum of Contemporary Art, Santa Monica,
California

1995
Més enllà del bosc, Palau de la Virreina, Barcelona
Gianni Giacobbi Arte Contemporaneo, Palma de
Mallorca, Spain

1996
David Nash: New Sculptures and Drawings,
Art Affairs, Amsterdam
Three Places: David Nash, Cairn Gallery, Nailsworth,
Gloucestershire
Croesau, Wyan, Llestr, Pasg, 1996, Oriel y Ddraig,
Blaenau Ffestiniog
Green Fuse, Mead Gallery, Warwick Art Centre,
Coventry
Line of Cut, Henry Moore Institute, Leeds
Elements of Drawing, Leeds City Art Gallery
Survey Show 1971–1996, Museum van
Hedendaagse Kunst, Antwerp, Belgium
Recent Sculpture and Drawing, Galerij S65,
Aalst, Belgium
David Nash: Sculptures from Japan, Annely Juda Fine
Art, London

GROUP EXHIBITIONS

1970
Chelsea Tower 3 shown in inaugural exhibition
*Post-diploma work from Manchester, Birmingham
and Chelsea*, Serpentine Gallery, London

1975
The Condition of Sculpture, Hayward Gallery, London

1976
Summer Show III, Serpentine Gallery, London

1977
From Wales, Fruitmarket Gallery, Edinburgh
On Site, Arnolfini Gallery, Bristol

1979
Collaborative works with sculptor Paul Neagu
exhibited in LYC Museum, Cumbria
Corners, Elise Meyer Gallery, New York

1979–80
Wood, Yorkshire Sculpture Park, Bretton Hall, Yorkshire

1980
British Art Now: An American Perspective
Solomon R. Guggenheim Museum, New York, and later at
San Diego, California
Savannah, Georgia
Austin, Texas
Royal Academy, London
Mixage, de Lantaren, Rotterdam, Netherlands

1981
Art and the Sea, Third Eye Centre, Glasgow and tour
British Sculpture in the Twentieth Century Part II, Whitechapel Art Gallery, London
Cleveland Drawing Biennale, Middlesbrough
A Wood Exhibition, The Minories, Colchester

1982
Presences of Nature, Carlisle Art Gallery and Museum, and tour
Aspects of British Art Today, Tokyo Metropolitan Art Museum,
and later at
Tochigi Prefectural Museum of Fine Arts, Utsonomiya
National Museum of Art, Osaka
Fukuoka Art Museum
Hokkaido Museum of Modern Art, Sapporo
Hayward Annual: British Drawing, Hayward Gallery, London
Object-Subject, LYC Museum, Cumbria
4th Biennale of Sydney, Australia
Through Children's Eyes, Arts Council Touring Exhibition
Word, Midland Group, Nottingham

1983
The Sculpture Show, Serpentine and Hayward Galleries, London
Tongue and Groove, Coracle Press, London
53–83: Three Decades of Artists from Inner London Art Schools, Royal Academy, London

1984
Survey of Recent International Painting and Sculpture, Museum of Modern Art, New York
ROSC International Exhibition, Dublin, Ireland
Haarlem Hout, Frans Hals Museum, Haarlem, Netherlands

1985
Hayward Annual, Hayward Gallery, London
25 Years: Three Decades of Contemporary Art: The Eighties, Juda Rowan Gallery, London
Transformations: American and European Sculpture 1945–1985, Solomon R. Guggenheim Museum, New York

1986
Overland, Ikon Gallery, Birmingham
Landscape – Place, Nature, Material, Kettle's Yard, Cambridge
Forest of Dean Project, Arnolfini Gallery, Bristol
Japonisme, Northern Centre for Contemporary Art, Sunderland

American/European Paintings and Sculpture, L.A. Louver Gallery, Venice, California
Naivety in Art, Setagaya Art Museum, Tokyo
Contemporary British Sculpture, Exchange Square Gallery, Hong Kong

1987
Unpainted Landscape, Maclaurin Gallery, Ayr, Scotland and tour
Inside Outside, Inaugural exhibition, Museum van Hedendaagse Kunst, Antwerp, Belgium
Sculpture and Sculptors' Drawings, Juda Rowan Gallery, London
Mathematik der Kunst, Wilhelm-Hack-Museum, Ludwigshafen, Germany
Viewpoint: L'Art Contemporain en Grande-Bretagne, Musées Royaux des Beaux-Arts de Belgique, Brussels

1987–8
A Quiet Revolution: British Sculpture since 1965, Museum of Contemporary Art, Chicago, and later at
Museum of Modern Art, San Francisco, California
Newport Harbor Art Museum, Newport Beach, California
Hirshhorn Museum and Sculpture Garden, Washington DC
Albright Knox Art Gallery, Buffalo, New York

1988
Britannica: Trente Ans de Sculpture, Musée du Havre, Le Havre, France
Beeldhouwers Tekenen, Rijksmuseum Kröller-Müller, Otterlo, Netherlands
Three Artists in Wales, Oriel, Cardiff
Royal Academy Summer Exhibition, Royal Academy, London
Artists in National Parks, Victoria and Albert Museum, London
Innovations in Sculpture 1985–88, Aldrich Museum of Contemporary Art, Ridgefield, Connecticut

1989
David Nash, Andy Goldsworthy, Thomas Joshua Cooper, L.A. Louver Gallery, Venice, California
Eco-Art, Centre for Contemporary Art, Ujazdowski Castle, Warsaw, Poland
Art Landmarks, Ashton Court, Bristol

1990
Roger Ackling, David Nash, Diane Samuels, Mincher/Wilcox Gallery, San Francisco, California
The Forces of Nature, Manchester City Art Gallery
A Natural Order, Hudson River Museum, Yonkers, New York

1991
Europäische Werkstatt Ruhrgebiet '91, Kunsthalle Recklinghausen, Germany
Charred Sculptures, Museum Folkwang, Essen, Germany
Kunst Europa '91, Kunstverein Heidelberg, Germany
Espace, The Royal Hibernian Academy Gallery, Dublin, Ireland
Criccieth Festival, North Wales
Hortus Cambrensis, Erddig, Clwyd, Wales and tour

1992
The Artist's Hand, Phoenix Art Museum, Phoenix, Arizona
David Nash, Therese Oulton, John Virtue, L.A. Louver Gallery, Venice, California
Millfield British 20th Century Sculpture Exhibition, Millfield, Somerset

1993
Différentes Natures, Espace Art Défense, Paris

1994
Disclosures, Mostyn Art Gallery, Llandudno, Wales and tour
In Pursuit of Lost Time, Barbara Knakow Gallery, Boston, Massachusetts

1995
The Edge of Town, Joseloff Gallery, Hartford, Connecticut
Here and Now, Serpentine Gallery, London
Drawn Together, Works on paper from the Contemporary Art Society and the Arnolfini Trust, Middlesbrough Art Gallery

1995–6
Sculptors' Drawings: 1945–90, Metropolitan Museum of Art, New York

1996
Sightlines, Honiton Festival, Honiton
Place to Place, Parish Maps, Common Ground, Barbican Centre, London
Bi-Annual Exhibition of Contemporary Sculpture, Jesus College, Cambridge
Paul Gees, Ludwig Vandevelde, David Nash, De Vishal, Haarlem
Confrontation with Creation, Kunsthallen Brandts Klaedefabrik, Odense, Denmark

SELECTED BOOKS AND EXHIBITION CATALOGUES

1980
British Art Now: An American Perspective, exh cat, Solomon R. Guggenheim Museum, New York. Essay by Diane Waldman
Environmental Art Projects, Morris Museum, Morristown, New Jersey. Introduction by Gail Gelburd

1982
Aspects of British Art Today, exh cat, Asahi Shimbun, Tokyo/The British Council

1984
John Beardsley, *Earthworks and Beyond: Contemporary Art in the Landscape*, Abbeville Press, New York
Peter Davies and Tony Knipe, *A Sense of Place: Sculpture in Landscape*, Ceolfrith Press, Sunderland
Richard Mabey (ed.), *Second Nature*, Jonathan Cape, London
David Nash, exh cat, Kamakura Gallery, Tokyo. Introduction by Seiji Oshima

1987
Unpainted Landscape, Coracle Press,
London/Scottish Arts Council/Graeme Murray
Gallery, Edinburgh
Graham Beal and Mary Jane Jacob, *A Quiet
Revolution: British Sculpture since 1965*, Thames and
Hudson, London
Viewpoint: L'Art Contemporain en Grande-Bretagne,
Musées Royaux des Beaux-Arts de Belgique, Brussels

1990
David Nash: *Chêne et Frêne*, exh cat, Musée des
Beaux-Arts, Calais, France
David Nash: Sculpture 1971–90, exh cat, Serpentine
Gallery, London
*The Sculpted Forest, sculptures in the Forest of
Dean*, Rupert Martin Redcliffe, Bristol

1991
David Nash: Planted and Carved, exh cat, Nishimura
Gallery, Tokyo

1994
David Nash: Otoineppu: Spirit of Three Seasons,
exh cat, Tokyo Shimbun, Japan
Graham Beal and Marina Warner, *Voyages and
Vessels*, exh cat, Joslyn Art Museum, Omaha,
Nebraska

1995
Més enllà del bosc, exh cat, Palau de la Virreina,
Barcelona. Essay by Liliana Albertazzi

1996
Green Fuse, exh cat, Mead Gallery, Warwick Art
Centre, Coventry

PUBLICATIONS BY THE ARTIST

1973
Briefly Cooked Apples,
York Festival

1976
Loosely Held Grain,
Arnolfini Gallery, Bristol

1978
Fletched Over Ash,
AIR Gallery, London

1980
Wood Quarry,
Elise Meyer Gallery, New York

1982
Fellowship '81–'82,
Yorkshire Sculpture Park, Bretton Hall
Stoves and Hearths,
Duke Street Gallery, London
Wood Quarry Otterlo,
Rijksmuseum Kröller-Müller, Otterlo, Netherlands

Forest Poems, Forest Drawings
(with Anthony Barnett),
Ferry Press, London

1983
Sixty Seasons,
Third Eye Centre, Glasgow

1984
Ki no Inochi, Ki no Katachi
Japan Association of Art Museums, Tokyo

1985
Elm, Wattle, Gum,
Heide Art Gallery, Melbourne, Australia
Hoge Veluwe (with Sjoerd Buisman),
Rijksmuseum Kröller-Müller, Otterlo, Netherlands

1986
Tree to Vessel,
Juda Rowan Gallery, London

1987
Wood Primer,
Bedford Press, San Francisco, California/Annely Juda
Fine Art, London

1988
David Nash, Ardennes Project,
Galerij S65, Aalst, Belgium
Chêne et Frêne,
Musée Greuze, Tournus, France

1989
Mosaic Egg,
Annely Juda Fine Art, London

1991
Walily: Smoke and Turpentine (with
Leon Tarasewicz), Centre for Contemporary Art,
Warsaw, Poland
David Nash: Ardennes Project and Poland,
Galerij S65 Aalst, Belgium

1993
At the Edge of the Forest,
Annely Juda Fine Art, London
David Nash: Braendt Eg,
Kunsthallen Brandts Klaedefabrik, Odense, Denmark

1996
David Nash: Forms into Time (with Marina Warner),
Academy Editions, London

FILMS AND DOCUMENTARIES

1978
Woodman, directed by Peter Francis Browne,
Arts Council of Great Britain

1982
Wooden Boulder, made by the artist,
Welsh Arts Council

1984
Sunday Morning Programme, NHK TV Tokyo

1988
Stoves and Hearths, Alter Image, Channel 4
Television

1993
At the Edge of the Forest, directed by
Richard Trayler Smith, BBC TV Wales

WORKS IN PUBLIC COLLECTIONS

AUSTRALIA
Art Gallery of Western Australia, Perth
Heide Art Gallery, Melbourne

BELGIUM
Stedelijk Museum, Alst
Museum van Hedendaagse Kunst, Antwerp

CANADA
McMaster Art Gallery, Hamilton, Ontario

DENMARK
Louisiana Museum, Humlebaek
Tickon Environmental Sculpture Park, Langeland

ENGLAND
Arts Council of Great Britain, London
Bristol Museum and Art Gallery
British Council, London
Camden Library, London
Contemporary Art Society, London
Forest of Dean Sculpture Trail
Government Art Collection, London
Grizedale Forest, Cumbria
Leeds City Art Gallery
Leicestershire Museums, Arts and Records Services
Manchester City Council, Birchfield Park
Mappin Art Gallery, Sheffield
Portsmouth City Museums and Records Services
Sheffield Development Corporation
Southampton Art Gallery
Southampton University
Tate Gallery, London
Towner Art Gallery, Eastbourne
Victoria and Albert Museum, London
Yorkshire Sculpture Park, West Bretton

FINLAND
Espoo Karhusaari, Helsinki

FRANCE
Fonds Régional d'Art Contemporain, Corsica
Fonds Régional d'Art Contemporain, Limousin
Ile de Vassivière, Limousin
L'Ecomusée de Pierre de Bresse
Musée des Beaux-Arts, Calais
Rouen City Métrobus de l'agglomération Rouennaise

GERMANY
Kunsthalle Recklinghausen

IRELAND
National Museum, Dublin

ITALY
Uffizi Gallery, Florence

JAPAN
Fukuoka Art Museum
Hiroshima Fine Art Museum
Hokkaido Asahikawa Museum of Art
Ichikawa Museum of Art
Iwaki City Museum
Nagoya City Museum
Nikko City
Setagaya Art Museum, Tokyo
Tochigi Prefectural Museum of Art, Utsonomiya
Tokyo Metropolitan Art Museum

KOREA
Hoam City Museum, Seoul
National Museum of Contemporary Art, Seoul

MACEDONIA
Tobacco Museum, Prilep

NETHERLANDS
Frans Hals Museum, Haarlem
Hoge Veluwe, Otterlo
Rijksmuseum Kröller-Müller, Otterlo

POLAND
Ujazdowski Castle, Warsaw

SCOTLAND
Aberdeen Art Gallery
Ayr Art Gallery
Edinburgh City
Scottish National Museum of Modern Art, Edinburgh

UNITED STATES OF AMERICA
Djerassi Resident Artists Program, California
General Mills, Minneapolis, Minnesota
Honolulu Airport, Hawaii
Indianapolis Museum of Art, Indiana
Joslyn Art Museum, Omaha, Nebraska
Laumeier Sculpture Park, St Louis, Missouri
Madison Art Center, Wisconsin
Metropolitan Museum of Art, New York
Morris Museum, Morristown, New Jersey
Museum of Contemporary Art, Los Angeles, California
San Diego Museum of Contemporary Art, California
San Jose Museum of Art, California
Solomon R. Guggenheim Museum, New York
The Contemporary Museum, Honolulu, Hawaii
Walker Art Center, Minneapolis, Minnesota

VENEZUELA
Museum of Modern Art, Caracas

WALES
Margam Sculpture Park, Newport
National Museum of Wales, Cardiff
The Conway Centre, Anglesey
University of Wales, Bangor
Welsh Contemporary Art Society, Cardiff

WORKS IN OPEN SPACES

BELGIUM
Aalst
Stedelijk Museum
Beech Crown 1986
(*Stepping the Crown*)

DENMARK
Langeland
Tickon Environmental Sculpture Park
Sheep Spaces 1993

ENGLAND
Eastbourne
Manor Gardens, Towner Art Gallery
Eighteen Thousand Tides 1996

Gloucestershire
Forest of Dean Sculpture Trail
Black Dome 1986
River Vessels 1986

Cumbria
Grizedale Forest
Running Table 3 1978
Wooden Waterway 1978

Manchester
Manchester City Council, Birchfield Park
(Realised by Manchester City Engineers, from an original concept by David Nash)
City Stones 1995

Sheffield
Sheffield Development Corporation
The Eye of the Needle 1992

Southampton
University
Boldrewood Sweep (planted sculpture) 1980

West Bretton, Yorkshire
Yorkshire Sculpture Park
Three Stones, Three Trees (planted sculpture) 1981
Block of Coal 1982

FINLAND
Helsinki
Espoo Karhusaari
Karhusaari Ladder 1989

FRANCE
Ile de Vassivière, Limousin
Descending Vessel 1989
Charred Wood and Green Moss 1989

Pierre de Bresse, Saône-et-Loire
L'Ecomusée de Pierre de Bresse
Oak Ladder 1988
Descending Vessel, Poplar 1989

Rouen
Station Garibaldi, Sotteville-les-Rouen
Descending Vessel 1994
Station J.F. Kennedy, Grand Quevilly
Descending Vessel 1994

JAPAN
Nagoya
Nagoya City Museum
Descending Vessel 1994

NETHERLANDS
Otterlo
Hoge Veluwe
Divided Oaks (planted sculpture) 1985
Turning Pines (planted sculpture) 1985

SCOTLAND
Edinburgh
Above the Waters of Leith (planted sculpture) 1988

UNITED STATES OF AMERICA
California
Djerassi Resident Artists Program
Sylvan Steps 1987
Three Charred Forms 1989

Honolulu, Hawaii
Airport
Ironwood Sheaves 1995

Minneapolis, Minnesota
General Mills
Boulders and Birches (planted sculpture) 1994
Walker Art Center
Standing Frame 1987

St Louis, Missouri
Laumeier Sculpture Park
Black through Green (planted sculpture) 1993

WALES
Anglesey
The Conway Centre
(Cheshire Education Services)
Portal Vessel 1993

Cardiff
National Museum of Wales
Two Charred Forms 1993

Newport
Margam Sculpture Park
Descending Vessel 1993

LIST OF ILLUSTRATIONS

136 Moving *Wooden Fish*, 1982, Kotoku, Japan

137 Work-site, Pierre de Bresse, France

138 Installation, Rijksmuseum Kröller-Müller, Otterlo, showing *Branch Cube* (left) and *Standing Frame* (right)

139 *A Quiet Revolution: British Sculpture Since 1965*, exhibition, Museum of Contemporary Art, Chicago, 1988, showing (clockwise from top): *Crack and Warp Column, Charred Column* and *Three Long Boats*

140 Installation, l'Abbaye de Tournus, France, 1988

141 Installation, Mappin Art Gallery, Sheffield, 1991

142 Work-site, Barcelona, 1995

143 Installation, *Més enllà del bosc*, exhibition, Palau de la Virreina, Barcelona, 1995

144 *Pyramid in the Sticks*, 1983, elm and charcoal on paper, drawing 200 × 175 × 175 cm (79 × 69 × 69 in), wood 80 × 70 × 70 cm (31½ × 27½ × 27½ in), Douglas Hyde Art Gallery, Dublin

13 NATURE TO NATURE

145 *Three Forms, Three Cuts*, 1996, charcoal drawing, 51 × 40 cm (20 × 16 in), Annely Juda Fine Art, London

146 *Through the Trunk, Up the Branch*, 1985, elm, 360 × 390 × 165 cm (144 × 156 × 66 in), private collection, Ireland

147 *Sylvan Steps*, 1987, redwood, 210 × 250 × 90 cm (84 × 100 × 36 in), Djerassi Resident Artists Program, California

148 *Big Ladder*, 1984, oak, 525 × 185 × 150 cm (210 × 74 × 60 in), Nikko City, Japan

149 *Apple Jacob*, 1986, apple-wood, 209 × 149 × 129 cm (82 × 58 × 50 in), Annely Juda Fine Art, London

150 *Inside Outside*, 1986, elm, 2 elements: 200 × 107.5 × 127.5 cm (80 × 40 × 51 in) and 160 × 87.5 × 107.5 cm (64 × 35 × 43 in), private collection, USA

151 *Pyramid, Sphere, Cube: Madrone*, madrone, pyramid 76 × 51 × 46 cm (30 × 20 × 18 in), sphere diameter 51 cm (20 in), cube 51 × 46 × 46 cm (20 × 18 × 18 in), private collection, USA

152 *Vertical, Diagonal, Horizontal*, 1991, elm, cube 60 × 55 × 55 cm (24 × 22 × 22 in), sphere diameter 70 cm (28 in), pyramid 100 × 67.5 × 67.5 cm (40 × 27 × 27 in), private collection, Japan

153 *Three Forms, Three Cuts*, 1992, ash, cube 57.5 × 45 × 45 cm (23 × 18 × 18 in), sphere diameter 60 cm (24 in), pyramid 117.5 × 55 × 55 cm (47 × 22 × 22 in), Josyln Art Museum, Omaha, Nebraska, USA

154 *Nature to Nature 4*, 1990, elm and charcoal on paper, cube 55 × 45 × 45 cm (22 × 18 × 18 in), sphere diameter 60 cm (24 in), pyramid 105 × 55 × 57.5 cm (43 × 22 × 23 in), drawings each 120 × 90 cm (48 × 32 in), collection Capel Rhiw

155 *Two Eggs, Longitude and Latitude*, 1990, oak, 62.5 × 30 × 30 cm (25 × 12 × 12 in) and 45 × 35 × 27.5 cm (18 × 14 × 11 in), private collection, Japan

156 *Mosaic Egg,* 1988, white elm, 35 × 42.5 × 32.5 cm (14 × 17 × 13 in), collection Capel Rhiw

157 *Celtic Seed*, 1988, oak, height 54.5 cm (21½ in), private collection, Belgium

158 *Celtic Bead*, 1988, oak, height 85 cm (34 in), private collection, Belgium

159 *Enfolding Egg*, 1993, ash, 87 × 51 × 51 cm (34 × 20 × 20 in), Government Art Collection, London

14 LENGTH AND LIMB

160 *Light in Shadows*, 1993/4, birch, 3 elements: 316 × 60 × 20 cm (124 × 24 × 8 in), 297 × 42 × 13 cm (117 × 16½ × 5 in), 317 × 50 × 14 cm (125 × 20 × 5½ in), Annely Juda Fine Art, London

161 *Uppercut*, 1983/4, lime-wood, 225 × 90 × 50 cm (90 × 30 × 20 in), private collection, USA

162 *Skirted Beech*, 1985, beech, 208 × 180 × 46 cm (83 × 41 × 18½ in), private collection, Switzerland

163 *Charred Fins*, 1987, oak, 81 × 163 × 41 cm (32 × 66 × 16 in), private collection, Canada

164 *Comet Ball*, 1995, elm, 420 × 85 × 85 cm (168 × 34 × 34 in), collection Capel Rhiw

165 *Furrowed Oak*, 1991, oak, 81 × 112 × 325 cm (32½ × 45 × 130 in), collection Capel Rhiw

166 Pile of poppadums

167 *Rough Spirals*, 1989, birch, 238 × 72 × 76 cm (43 × 19 × 19½ in), Annely Juda Fine Art, London

168 *Crack and Warp Frame*, 1994, elm, 46.5 × 44 × 43.5 cm (18½ × 17½ × 17½ in), private collection

169 *Small Crack and Warp Stack*, 1985, ash, 87.5 × 27.5 × 27.5 cm (20 × 9 × 9 in), private collection

170 *Elm Spring Arch*, 1984, elm, 117 × 160 × 38 cm (47 × 64 × 15 in), private collection, England

171 *Michaelmas Wall Piece*, 1987, ash, 240 × 39 × 14.5 cm (94 × 13 × 4 in), private collection, USA

172 *Spiral Sheaves*, 1990/1, oak, 300 × 117.5 × 70 cm (120 × 47 × 28 in), Annely Juda Fine Art, London

173 *Crack and Warp Column*, 1985, ash, 198 × 61 × 61 cm (79 × 24½ × 24½ in), private collection, England

174 *Wall Sheaves*, 1993, beech, in 7 parts: height 270 cm (106 in), Annely Juda Fine Art, London

175 *Two Leaning Beeches: Hidden Ziggurats*, 1995, beech, 49 × 18 × 13 cm (19½ × 7 × 5 in) and 50 × 18.5 × 18.5 cm (20 × 7½ × 7½ in), Gallery S65, Aalst, Belgium

176 *Two Sliced Menhirs*, 1989, beech, 195 × 55 × 27.5 cm (78 × 22 × 11 in) and 180 × 47.5 × 32.5 cm (72 × 19 × 13 in), private collection, USA

177 *Overlap*, 1993/4, lime-wood, 86 × 65 × 13 cm (34 × 25½ × 5 in), private collection

178 *Stream of Vessels*, 1991, oak, installation, 330 × 152 × 15 cm (130 × 60 × 6 in), collection Capel Rhiw

179 *Descending Vessel*, 1986, oak, 200 × 60 × 40 cm (80 × 24 × 16 in), private collection, Belgium

180 Descending Vessel, 1988, oak, 406 × 51 × 51 cm (160 × 20 × 20 in), private collection, USA

181 Constantin Brancusi, *Bird in Space*, 1925, marble, height 134 cm (52½ in) Kunsthaus, Zurich, Society of Zurich Friends of Art, © ADAGP, Paris and DACS, London 1996

182 *Merging Vessels*, 1991, Portugal laurel, 276 × 66 × 27 cm (108½ × 26 × 10½ in), Annely Juda Fine Art, London

183 *Vessel Shield*, 1991/2, Polish oak, 209 × 36 × 15 cm (82 × 14 × 11½ in), private collection, USA

184 *Portal Vessel*, 1993, elm, 131 × 46 × 56 cm (51 × 17½ × 22 in), Annely Juda Fine Art, London

15 THE FIFTH ELEMENT

185 *Oak Bowl*, 1988, oak, 125 × 87 × 88 cm (49 × 34 × 35 in), Musée Greuze, Tournus, France

186 *Platter and Bowl*, 1988, oak, 111 × 116 × 50 cm (44 × 46 × 20 in), collection Capel Rhiw

187 *Elm Spiral*, 1989, elm, 50 × 30 × 35 cm (20 × 12 × 14 in), Annely Juda Fine Art, London

188 *Six Birch Spoons*, 1989, birch, 185 × 300 × 100 cm (74 × 120 × 40 in), private collection, USA

189 *Three Ladles*, 1989, oak, 43 × 180 × 48 cm (17 × 72 × 19 in), private collection, USA

190 *Veil (Queen)*, 1990, lime-wood, 282.5 × 70 × 65 cm (113 × 28 × 26 in), collection Capel Rhiw

191 *Shrine*, 1992, Portugal laurel, 84 × 33 × 10 cm (33 × 13 × 4 in), private collection

192 *Hooded Column*, 1995, yew, 38 × 14 × 16 cm (15 × 5½ × 6½ in), collection Capel Rhiw

193 Installation at Louver Gallery, New York, 1993, showing *Folds* and *Shrine*

194 *Red Throne*, 1989, redwood, 325 × 95 × 85 cm (130 × 38 × 34 in), private collection, USA

195 *Four Charred Cross Egg*, 1994, beech, 48 × 41 × 36 cm (19 × 16 × 14 in), Gallery S65, Aalst, Belgium

196 *Hornbeam Cross*, 1994, hornbeam, 54 × 48 × 26 cm (21 × 19 × 11 in), private collection, Germany

197 *Small Cross Column 2*, 1994, red pine, 96 × 20 × 20 cm (38 × 8 × 8 in), collection Capel Rhiw

198 *Gate: Black and Light*, 1996, charcoal drawing, 42 × 48 cm (16½ × 19 in), collection Capel Rhiw

199 *Gate: Black and Light*, 1994, charred oak, 260 × 134 × 83 cm (104 × 53½ × 33 in), Annely Juda Fine Art, London